Moira Roth

Published with the assistance of the Getty Grant Program.

The publisher also gratefully acknowledges the generous contribution to this book provided by the Art Endowment Fund of the University of California Press Associates, which is supported by a major gift from the Ahmanson Foundation.

FRESH TALK
DARING GAZES

UNIVERSITY OF CALIFORNIA PRESS

Berkeley Los Angeles London

FRESH TALK
DARING GAZES

Elaine H. Kim

Margo Machida

Sharon Mizota

WITH A FOREWORD BY LISA LOWE

University of California Press
Berkeley and Los Angeles, California

University of California Press, Ltd.
London, England

Library of Congress Cataloging-in-Publication Data

Kim, Elaine H.
Fresh talk, daring gazes : conversations on Asian American art /
Elaine H. Kim, Margo Machida, Sharon Mizota ; with a foreword
by Lisa Lowe.
p. cm.
Includes bibliographical references and index.
ISBN 0-520-23535-5 (alk. paper)
1. Asian American art—20th century. 2. Asian American
artists—Biography. I. Machida, Margo. II. Mizota, Sharon.
III. Title.
N6538.A83 K56 2003
704.03'95073'0904—dc21

 2003001854

Manufactured in Canada

12 11 10 09 08 07 06 05 04 03
10 9 8 7 6 5 4 3 2 1

The paper used in this publication meets the minimum requirements
of ANSI/NISO Z39 0.48-1992 (R 1997) (*Permanence of Paper*).

To Godzookie, long may s/he live,

and to the creative spirit that inhabits

Asian American artists and viewers

CONTENTS

ACKNOWLEDGMENTS

THIS BOOK, WHICH BEGAN AS A SIMPLE CATALOG OF ARTISTS' NAMES AND LISTINGS OF THEIR work, is the product of more than a decade of talking, looking, and thinking. During those years, multiculturalist trends in the American art world came and went, flourishing in New York for a brief period between the late 1980s and the early 1990s and all but collapsing after the 1993 Whitney Biennial. Between 1989 and the present, our ideas about what kind of book we should try to produce shifted with changes in the ways Asian American visual art was being viewed and received and shifts in artists' views of their own artistic identities.

A number of people who care very deeply about Asian American art made invaluable contributions to this book. We are especially grateful to Betty Kano, who helped originate the project because she so clearly understood the need for it, and Moira Roth, who was endlessly generous in providing ideas, resources, inspiration, encouragement, and excellent editorial suggestions. Without the persevering spirit, useful critiques, and conscientious work of Jodi Kim, who helped prepare the final manuscript and visuals for production, there would be no book at all. We are deeply grateful to Eungie Joo for sharing her ideas and her knowledge about contemporary American art and Asian American cultural politics; Giulia Fabi for her excellent suggestions and unwavering faith in the project; Amy Sadao for her conceptual and organizational contributions; Diane Wai for devoting two years to interviewing, transcribing, and conducting library research for the book; Eithne Luibheid for her thorough transcriptions, library research, and helpful editorial suggestions; Karin Higa for her advice and assistance; Pam Della, Kimi Kodani Hill, Nancy Hom, and Li-Lan for supplying important information and visual materials; and Sandra Liu for creating a CD-ROM disk that made our work easier. We are very grateful to Allan deSouza and Yong Soon Min for their sustained support, to Richard Fung for his encour-

agement, to Theresa Tensuan and Paul Phojanakong for their feedback and support in the writing of the captions, to Iyko Day for her critical readings and suggestions, to Rico Reyes for his enthusiastic interst, and to Oliver Newman for being, as always, both kind and wise. We especially appreciate the generous help of Eric Fong of the Asian American Studies program of the Ethnic Studies Department, Livit Callentine of the Graduate Division, and the Committee on Research at the University of California, Berkeley, and we warmly thank Deborah Kirshman, Nicole Hayward, Sue Heinemann, Erin Marietta, and Jennie Sutton of the University of California Press, for helping in so many different ways to bring this book into print.

VISUAL ART AND THE
IMAGINING OF ASIAN AMERICA
An Editorial View

FRESH TALK / DARING GAZES PROVIDES A FORUM FOR WIDE-RANGING DIALOGUE ABOUT art produced by people of Asian heritage in the United States. Exploratory in orientation and extending over a number of years, *Fresh Talk* is the result of a bicoastal collaboration that reflects the rewards and considerable challenges of bringing together differing editorial visions and a diverse group of artists and writers in a joint endeavor. At its core is a collection of short interpretive essays by twenty-four commentators, each paired with an Asian American visual artist. The contributors are cultural critics, artists, social activists, curators, and scholars whose responses range from the theoretical and political to the highly personal. These relatively brief reflections are juxtaposed with more extended essays by Lisa Lowe and Elaine Kim, who offer their perspectives on Asian American cultural production, as well as with captions by Sharon Mizota, intended to bring forward salient themes in the featured artists' work.

The narratives and voices convened in this volume may at times seem cacophonous. Yet the connections and overlapping interests, as well as the discontinuities and disjunctions, evident among these writings reflect the multivalent nature of discourse in and about present-day Asian America. In such an extraordinarily complex and continually expanding community, embracing a wide range of ethnic, national, cultural, and religious her-

itages as well as divergent migration histories and experiences in this nation, no single standpoint, defining motif, or ideology predominates.

Beyond being an occasion for everyone involved to think broadly and imaginatively, *Fresh Talk* can best be understood as a locus for intertextual dialogue and debate. The book has been substantially restructured since it was launched in the early 1990s as a pictorial reference work intended to document art produced by individuals of Asian background. As a cultural critic and curator specializing in this area of research, I was invited to join the editorial team in 1995, shortly after I had organized the nationally touring exhibition *ASIA/AMERICA: Identities in Contemporary Asian American Art* for the Asia Society Galleries in New York City. This thematic group show featured twenty immigrant and refugee artists from China, Japan, Korea, the Philippines, Thailand, Laos, Vietnam, and India whose work addressed questions of identity formation that arise in the process of traversing cultures and situating oneself in a new country. *ASIA/AMERICA* enabled me to discern the broad contours of cultural production arising from the experiences of Asian-born artists in the U.S. diaspora.

The highly polarized critical debate surrounding that show underscored the extent to which Asian American art, especially when it addresses issues of identity, may be associated with seemingly intractable problems linked to domestic race politics and the rhetoric of victimization. As a result, artists of Asian background are all too often perceived as yet another minoritized group encasing themselves in an exclusionary cultural armor while also clamoring for mainstream recognition. Despite the fact that the art may address issues of migration, border crossing, cultural difference, historical connections between the United States and Asia, the politics of representation, and a host of other concerns that potentially affect everyone, framing those issues through an Asian American lens continues to be widely regarded as parochial and self-marginalizing. While certainly cognizant of such arguments, I maintain that there is nothing inherently restrictive, essentialist, or balkanizing about concepts like difference and identity; rather, they can be as capacious and supple as our imaginations will allow. However, many commentators tend to collapse important distinctions by equating any interest in cultural specificity with cultural essentialism and cultural nationalism, thereby narrowing the scope of critical thought rather than inviting further investigation.

Coming to this project after *ASIA/AMERICA,* I was acutely aware of how profoundly the intellectual and ideological climate that informed the original editors had shifted. Given the mounting criticism of multiculturalism and identity politics in the mainstream and minoritized arts communities alike that began in the 1980s, as well as the impact of critical theory in all areas of artistic discourse and cultural production, I believed that simply reproducing images of Asian American art without also seeking new means to interpret and to contextualize it would be problematic. Certainly to the extent that historical and cultural accounts of a period will tend to reflect the standpoints and needs of the dominant group, minoritized communities must push to place their images and ideas before the public. However, I would argue that to effect change at the level of discourse, the challenge for scholarship is not only to present Asian American visual art, but also to develop strategies to make the sweep of the perspectives and emotions that animate it more *intel-*

ligible to art audiences, thereby extending its producers' insights to a broader public and rendering that art socially useful and influential beyond narrow circles of specialists.

The domestic experience, by more and more reflecting an international circulation of peoples and ideas, is impelling growing numbers of individuals of all backgrounds to confront fundamental questions surrounding cultural identity, citizenship, and their sense of place in the world. As the American art world, like society in general, becomes an increasingly hybrid, transnational environment, fundamental issues of meaning and cultural translation are assuming an ever more prominent position. This fact is eloquently noted by Homi K. Bhabha, whose 1998 conversation with artist Shahzia Sikander appears in this collection: "Supposing we don't want an exoticism, we don't want an orientalism . . . what kind of intercultural knowledge is necessary? . . . What must I know? . . . What must I be as a citizen spectator?"

In this atmosphere, a pivotal question has been how to situate a project like *Fresh Talk,* which by definition does foreground certain ethnic identities, while at the same time signaling the clear intention to move beyond extant rhetorics of race and ethnicity in framing the art. In this, it is not simply a politics of inclusion that informs our efforts (i.e., for Asian Americans to put forward images they create as a counterweight to imposed stereotypes and omissions), but rather an interest in generating *new ways of thinking* about this art.

By opening up new lines of communication and cross-identification, *Fresh Talk*'s framework is a manifestation of these guiding concerns. It provides the grounds for direct engagement with members of other groups in acts of meaning-making, and thus extends the discourse arising from contemporary Asian American experience to broader publics. Much as some in Asian American studies actively position the Asian presence in more broadly relational and globalized terms, thereby challenging racialized discourses that reify schisms between groups in the domestic sphere, the editors of *Fresh Talk* are particularly interested in fomenting exchange among members of minoritized communities who have had too few opportunities to reflect on one another's cultural production. The decision to solicit primarily (although not exclusively) writers of other non-European heritages (African American, Latino, and Native American)—a number of whom had never previously written about Asian American artists—was informed by a double commitment: to advance significant interchange between Asians and other peoples of color, and to put forward perspectives and analysis that can challenge Eurocentric interpretations.

Encountering artists and works of art with which they were largely unfamiliar afforded the writers in *Fresh Talk* an unusual opportunity to reflect on how they construct meaning when looking at and writing about art, and on what culturally and historically specific frames of reference they bring to that process. Many richly configured cross-readings have resulted, such as Jolene Rickard's interpretation of Japanese American printmaker and installation artist Tomie Arai's work refracted through the prism of her Native American spiritual and cultural practices, or Nigerian-born artist and critic Odili Donald Odita's invocation of his own family's forced migration during the Biafran civil war in situating the work of Vietnamese refugee photographer Pipo Nguyen-Duy. Some essayists engage with the artists directly; others focus on the artworks themselves. Whatever form those in-

terpretive exchanges may take, they are in microcosm the types of efforts we must make in a polycultural society that requires ever increasing negotiations of multiple realms of difference.

The Selection Process

Early in the project, there was an open call for submissions of slides. Drawing on that original material as well as our own research, the editorial team submitted visual works for joint review, balancing concern with artists' ethnic background, gender, geographic location, and the type of issues addressed in their work. The editors then solicited the participating artists to determine whether there were particular individuals with whom they especially wanted to be in conversation.

Dialogue and collaboration, therefore, not only provide a conceptual scaffold for the book itself, but also constitute the working method integral to its organization as the contributors, like the featured artists, were jointly selected by the editorial team through a painstaking process of deliberation and negotiation. Writers with differing orientations and approaches known for their broad interests in visual art and cultural politics, who could bring sharply honed and distinctive insights to this project, were identified and solicited. Notably, a number of the essayists are artist-scholar-activists who have played a pivotal role in the development of their own fields in the last few decades, and as a result were especially responsive to the project. In addition to such established figures, the editors believed it was also crucial to bring in younger writers to engage in intergenerational conversation.

Clearly such a process is difficult at best, as many commentators as well as artists deserving of recognition could not be included or were unable to participate. It must be emphasized, therefore, that *Fresh Talk* is not intended to offer a comprehensive overview of the field. Rather it points to certain intriguing lines of inquiry and currents of cross-identification that contemporary Asian American artists and cultural critics are now pursuing.

Fresh Talk as a Communitarian Project

While the writers and artists assembled here do not necessarily know or maintain ongoing contact with one another, and their backgrounds and concerns vary substantially, they all committed themselves to an experimental project that places primary importance on acts of interpretation across registers of difference. It is our hope that making Asian American visual art the center of this expansive, often unruly discussion has functioned as a form of communitarian endeavor, one that permits the participating artists and writers to see themselves as active agents and fellow contributors to a larger continuum of knowledge around common subjects.

In invoking communitarianism, I recognize that current notions of community are neither transparent nor static. As traditional assumptions of communities based on nationality, ethnicity, familial ties, or continuous presence in one place are increasingly destabilized and challenged, new concepts and approaches are needed to point to emerging lines of affiliation, channels of communication, and spaces of transmission that have the po-

tential to expand our notions of how such ideas are conceived and enacted. Literary scholar and oral historian Rina Benmayor cogently observes that there are no overriding reasons to view community as something "restricted to geographic location or national homogeneity. Rather, community consists of collective formations of individuals tied together through common bonds of interest and solidarity."[1]

In the arena of the arts, as feminist art historian Arlene Raven notes, "The critical context is part of the concept of 'community.' Unlike standard definitions of community as individuals with common interests based on location alone (such as a state or commonwealth), the community that consists of artists and audience for artworks contains, as well, the commentative structure in which the audience and artist may view the process and product of art making."[2]

To foreground such emerging connections, I offer the term *communities of imagination* as a flexible and porous conception of community in which the sense of sharing something with others, whether based in common lived experiences, belief systems, or membership in a culture or polity, is made tangible through the visual arts. While *communities of imagination* plays off *Imagined Communities,* the title of Benedict Anderson's groundbreaking work on the development of the modern nation-state, my use of the term is not intended to suggest a systemic or deconstructionist approach to the notion of community. Rather, the inverted phrasing is meant to evoke something more elusive, the generative capacity of the artistic imagination in producing a sense of collectivity or affiliation among people, both as groups and as individuals, through themes and narratives requisite to conceptions of community and culture.[3] As a communicative act, a work of art projects the maker's images, ideas, and meanings into the sphere of the social imagination, where it circulates among other conversations that overlap and cut across traditionally accepted lines of identification. In giving concrete form to an individual's sensibilities and experience, art objects are readily perceptible points of identification capturing and extending the imagination of viewers, allowing them to better recognize aspects of themselves and their lives through engagement with the work.

In the long run, interchanges like these have the power to produce a kindling effect, sparking new ways to think and write about art. As the artists, artworks, and essays in *Fresh Talk* attest, we live in a fully intra-contextual social terrain. Since the geography of Asian America is ultimately both real and imagined, interactive and open-ended projects like *Fresh Talk* are valuable in providing different levels of focalization through which to consider and respond to the myriad public and private circumstances, discourses, and imaginative transactions that simultaneously vex and bind the lives of Asians in this country.

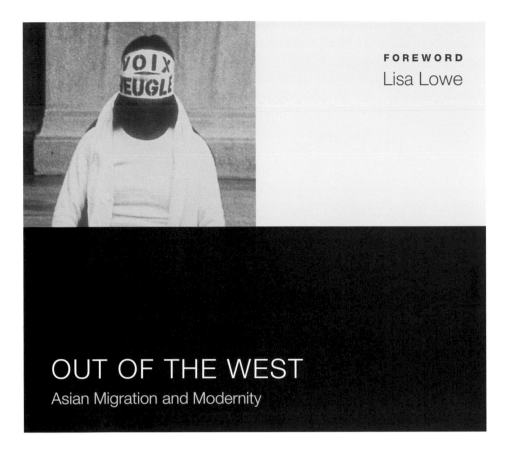

OUT OF THE WEST
Asian Migration and Modernity

FRESH TALK / DARING GAZES COLLECTS THE WORK OF TWENTY-FOUR CONTEMPORARY Asian American / Asian diasporic visual artists, pairing them with responses provocatively drawn from cultural critics, other artists, activists, and intellectuals. The artistic works include paintings, graphics, photography, installations, and a variety of mixed-media constructions. Their themes encompass geographical movement, the sexuality of Asian bodies, colonization, miscegenation, hybrid forms of immigrant cultures, the loss of home, war, history, and memory. The response pieces comment in ways that are alternately personal, intellectual, aesthetic, and political; written by subjects themselves often parts of African, Latin American, or Caribbean diaspora, the pieces offer diverse entries into the works from locations that may be at some distance from them. In a sense, *Fresh Talk / Daring Gazes* is a set of dialogues, simultaneously visual and textual, gathered around the representation of Asians in the West. As such, these dialogues might best be understood if situated within the modern history of Asian encounter with and migration to the West. We can also consider these artists' works in relation to the debates about the politics of representation that have been so lively in the past three decades.

At the turn of the twenty-first century, Asian immigrant settlement in the United States, and in the West generally, is not a new phenomenon—we are well aware of a history dat-

ing back centuries—but since the Immigration and Nationality Act of 1965, which lifted the immigration restrictions and bars to citizenship that existed from 1850 to World War II, there has been a dramatic increase of Asian settlement in the United States. In the past half-century, too, there has been much greater Asian migration worldwide, with significant Asian settlements in the Middle East, in Latin America, in Australia. We inhabit a moment of global migrations in which the degree of contact, conflict, and mixture of Asians with the cultures of the West is unprecedented. The artists' works collected here are a part of this global moment. But of course they do not represent anything like a smooth, even development of cross-cultural mixture. Rather, these works emerge from a modern social formation we might name "geohistorical," to borrow a term from Peter Taylor,[1] one that gives rise to artistic and cultural representations that imagine, remember, and trace the more complex, longer genealogies of colonial encounter, war, occupation, and forced displacements that are antecedents to Asian migration to the West.

In what sense is the "modern" world of which these artworks speak "geohistorical"? And how is Asian migration to the West a constitutive dimension of "modernity"?

It seems quite natural for us to call ourselves "modern." It means following the latest fashions, possessing the newest technologies, participating in modern institutions. It is closely connected to "progress": the idea of development in time, discovery, growth, and expansion. Understanding ourselves as modern assumes the posture of having arrived at a temporal location that permits us to look back, assess, to know differently than before. And this implies that the "modern" did not always exist; it emerged as a mode of being and understanding human community that distinguished itself from other earlier ways of life. It has a history, which is, in part, a history of the Western world and its way of knowing itself through others. Yet the "modern" has been equally made by the worlds that the West has sought to "Westernize." The emergence of modernity is what has been formed in the long history of this encounter.

Writers, philosophers, scientists, and historians have defined the "origins" of the modern in different ways. Historians point to the French Revolution of 1789 as a key event in the shift from feudal aristocracies to democratic nation-states; philosophers herald the Enlightenment and the gradual displacement of religious explanation by secular scientific rationalism. Economists focus on the industrial revolution; sociologists attend to the birth of modern bureaucracies; and political scientists look at citizenship within the modern state. Anthropologists once studied "traditional" non-Western cultures; this assumption that the West was modern in opposition to the "primitive" or "traditional" non-West emerged during the height of European colonial expansion in Africa, Asia, and the Americas in the late nineteenth and early twentieth centuries. Since decolonization and the end of the cold war, most anthropologists no longer assume that "modernity" is the discrete possession of the West; some discuss instead what could be called a transnational public sphere, and study the contacts and hybridities of traditional and modern practices around the world.

Yet while the "modern" is often presumed to be a "positive" development, modern forms of human subjectivity and society have always included cautions against modernization and radical skepticism about the abstract promises of modernity. Industry, sci-

ence, and even democracy have always had their critics, particularly among artists, writers, activists, and intellectuals. These dissident voices have pointed out that although the abstract ideals of modernity have been the pursuit of universal human freedom through modernization, the processes employed in this pursuit—accelerated growth through mass production, urbanization, and colonial expansion—have themselves brought new forms of "unfreedom": new, different forms of exploitation, disease, crime, and inhumanity. These deformations of human freedom in the pursuit of human freedom were observed both in the metropolitan West and in the worlds that the West named "developing." The nineteenth-century discourse of Western civilization that justified European colonialism in Asia, Africa, and the Caribbean included a social Darwinist narrative of natural selection that argued there was an inevitable evolution of militant, primitive tribal societies into democratic rights–based ones: the modern West represented the apex of this development. By the turn of the century, and certainly by World War I, writers, intellectuals, and even statesmen warned against the "re-barbarization" of the West, the dangerous return to militant savagery. The belief that Western civilization always brought increasing reason, health, and democracy was contested by both nationalist independence movements in the colonies and by modernist visions of the breakdown of progress and rationality in the United States and Europe themselves. One way of characterizing "modernism" is to suggest that it is the aesthetic, literary, and philosophical representation of the "legitimacy crisis" of modernity.

By World War II, in a world shaken by fascism, the Holocaust, and the atomic bombing of Hiroshima and Nagasaki, discussions of the links between civilization and barbarism had articulate spokespersons among both conservative and radical critics in the West, from the poet T. S. Eliot to the Frankfurt School in Germany. On the one hand, in *Notes towards a Definition of Culture* (1949), Eliot lamented the decline of high culture and declared Western civilization to be at risk of encroachment from both non-Western peoples and democratic mass society. On the other, in *The Dialectic of Enlightenment* (1944), Max Horkheimer and Theodor Adorno warned that human life would become completely degraded when all traditional activities were reduced to commodity form or to their exchange value in the marketplace, but they put the responsibility for this on modern industrial economy. For Horkheimer and Adorno, modernity had replaced the earlier barbarism of superstition with a "new" barbarism that included new forms of misery, terror, and inhumanity. This irreversible link between modern progress and new forms of terror led Walter Benjamin to declare that there is no document of civilization that is not simultaneously a document of barbarism.[2]

The contemporary Asian artists in the West collected here give us particular windows onto the contradictions of modernity, the simultaneous imbrication of civilization and barbarism. Albert Chong, an immigrant from Jamaica, creates sculptures out of everyday objects and materials that allude to his African and Chinese ancestry, to slaves and indentured laborers in the Caribbean. In his series *Tales of Yellow Skin,* Long Nguyen depicts a man whose arm probes his own flayed yellow flesh. Do-Ho Suh creates installations—row after row of headless, uniformed students—that represent the surveillance and reduction of human activity within authoritarian spaces. Survivors of the Vietnam War, of colonialism

in the Philippines, or of the bombing of Hiroshima, artists like Pipo Nguyen-Duy, Carlos Villa, or Mitsuo Toshida, cast the modern predicament as layered, contradictory, unresolved. As migrants to the West, they are, as Dilip Menon nicely puts it, "hitchhikers on the grand narrative of western civilization," or "illegal immigrants in the project of modernity."[3] All of the artists' works collected here suggest that modernity includes *both* the promise of human freedom through modernization *and* the historical contradictions that make that human freedom irregularly and unevenly experienced across the globe. Their visions require us, I think, to reconceive our history of the modern—as the progressive achievement of human freedom—so that it includes the criticisms articulated by its contemporaries and its heirs, so that it exposes modernization as a form of Westernization. While electronic media and mass migrations within the past three decades have created an unprecedented, discernible sense of global community, it is evidently not as if the world has suddenly become "global" at the end of the twentieth century. What we have come to call the "modern" world has always been "geohistorical." The emergence of the modern world is a complicated story that braids together promise and destruction, humanity and inhumanity, barbarism and civilization. Modernity varies in time and location, it takes place differently in rural Vietnam than it does in Tokyo or Berlin; there are multiple modern spaces related through logics at once political, economic, and cultural. Each space and temporality—from Indonesian sweatshops to the Whitney Museum—figures in the making, sustaining, and transformation of the modern. It includes the transnational businessman, the subway conductor, and the farmwoman, and is observed unevenly from the different perspectives encompassed by it. It cannot be captured simply, or totally, by a single perspective on who, what, or where is the modern, but requires more complicated reflection on how a singular vision has come to predominate, how a certain model of humanity has come to be accepted as the ideal of cultivated personhood in the modern community.

These artists' works, and the response pieces by other "hitchhikers" and "illegal immigrants," testify that the modern, within the longer duration of its emergence, has always been geohistorical and has been made and remade both "inside" and "outside" of the West. Depicting the processes of Asian encounter with the West, these works displace the West as the exclusive subject of the teleology of civilization, and they reveal different historical pasts with other subjects, communities, and histories. These artworks, to elaborate a concept from the English cultural critic Raymond Williams, constitute a modern "structure of feeling," a medium that gives us a record of "the culture of a period," a site in which a society in ferment reflects upon itself. A "structure of feeling" is not simply the affective world of a society; it is a crucial place for an epoch's self-criticism.[4] These artworks, as a modern structure of feeling, translate the consciousness of geohistorical modernity. They offer an alternative "map" of the modern: as global, as cosmopolitan, as unevenly yet simultaneously experienced across the globe. Yong Soon Min's photographs of Korean women's bodies marked as U.S. territories or Sung Ho Choi's installation of a suitcase with kimchi jars stuffed with clippings from the *New York Times* convey the complicated legacy, for Korean Americans, of the uneven power between the United States and Korea. They call to our attention other memories obscured by the singular history ruled a uniform concept of the citizen of the U.S. nation.

Asian immigration to the United States before World War II was greatly restricted by laws that named Chinese, Japanese, South Asians, and Filipinos as "aliens ineligible to citizenship," thereby including Asians as workers in the economic sphere yet barring them from participation in the cultural and political spheres. At the same time, Asia was a site for U.S. expansion—from the colonization of the Philippines, to the military occupation of Japan, to the wars in Korea and Vietnam. A social movement organized by Asian Americans emerged in the late 1960s and early 1970s, in the context of the civil rights movement and other ethnic studies initiatives, as a project for educational space, social transformation, and civil rights. Coming out of this social movement, Asian American studies has been concerned with bringing forward the buried history within which, prior to World War II, Asian immigrant laborers were racialized and barred from citizenship as "nonwhites" in relation to the economic need for low-wage non-citizen labor. The social movement has been concerned to extend the civil rights of Asian immigrants and political representation of Asian Americans and to work for their inclusion in all spheres of civil society. In relation to cultural and artistic representation, the movement has struggled for access to means of representation in order to create alternatives to the stereotypical or fetishistic images of Asians as barbaric, sexualized, or unassimilable foreigners.

We might say that the artists' work collected here comes out of the cultural politics of the 1960s and 1970s, by which I mean that a collection such as this precisely marks a distinct gain in access to modes of cultural and artistic representation. This access is certainly a result of the struggles of that social movement. At the same time, this collection indicates some significant departures from an earlier Asian American project—not only because the artists are not exclusively "Asian American" but are from the global Asian diaspora, but also because we can observe that the aesthetic strategies collected here diverge from that of countering negative images, something that had been named as a necessary task of the earlier historical moment. This is not to say that the need to counter anti-Asian stereotypes has disappeared, but rather that within the past three decades, the profile of Asians within the West has so greatly diversified that there has been something like a shift in the politics of representation. I am reminded of Stuart Hall's very important essay "New Ethnicities," in which he commented about a shift in Black cultural politics within Thatcherite Britain. Hall wrote that there is no sense in which a new phase in Black cultural politics—"a shift from a struggle over the relations of representation to a politics of representation itself"—could ever replace the earlier one. It is rather that "as the struggle moves forward and assumes new forms, it does to some degree displace, reorganize, and reposition the different cultural strategies in relation to one another."[5] For Asian immigrants and Asian Americans at the beginning of the twenty-first century, the critique of the politics of racial representation within a single nation-state has not disappeared, but persists simultaneously with new strategies that seek to address the changing status and diversification of Asians within the global economy.

The influx of new Asian immigrants in the past three decades has made it more or less axiomatic to state that Asian Americans and Asian immigrants are a heterogeneous group in terms of national origin, class, gender, sexuality, language, religion, and generation. This has led scholars to be critical of racial essentialism and cultural nationalist formations of

identity within the context of a single nation-state, and it has led activists to question whether ethnic identity always and in every instance leads to a progressive politics aimed at social transformation. At this point, scholars are reconceptualizing the phenomenon of Asian migration to the West in order to grasp the role of this migration in the emergence of a global or transnational economy. The object of this effort is to supplement a notion of Asian American formation within one nation-state with an understanding of the multiple contexts of colonialism and its various extensions within the uneven development of the global economy, in order to inquire into the significance of the "Asian" within local situations and material conditions—in Asia, in the Asian diaspora in the West, as well as in the Asian diaspora in the non-West. To be quite concrete: Asian migration has been closely tied to both labor and capital flows within the emergence of the transnational economy, and it is no longer possible to generalize a single profile of "the Asian American." Whereas the U.S. economy before World War II used Asian male non-citizen labor, the United States now participates in a transnational economy that currently exploits the labor of Asian and other neocolonized immigrant women. But this transnational economy also employs Asian managers within Asian-owned factories in the Mexican export-processing zones, or *maquiladoras;* Asian capital develops the tourist industry in Hawai'i; and middle-class Asian Americans are enfranchised and have access to higher education throughout the United States.

In the face of the radical nonidentity of Asians globally, we have developed new understandings of the role of Asians within transnational capitalism, rather than relying exclusively on earlier models of cultural or nationalist identity. This requires understanding that local specificities mediate and are indices of global conditions, and that while Asian migrancy is an index of the present social formation of transnational capitalism, it is dialectically linked with the forcible lack of migrancy of other groups in different parts of the world, whether women in Africa or Latin America or the unemployed or incarcerated Black population within the United States. That is, transnational capitalism currently links the diasporic movements of Asian labor and capital with the non-migrant women who cannot escape the patriarchal violence of an authoritarian state or the local communities that have been dislocated from indigenous forms of economy. These groups are "the other of the question of diaspora," as Gayatri Spivak has put it; subaltern women of the South, incarcerated communities, or unemployed racialized communities are the "other" of the Asian migrant.[6] Within a global cartography in which capital is consolidated in the North through the exploitation of the South, the Asian bourgeoisie becoming migrant in the West is now less a "minority discourse" and more part of a narrative of the consolidation of transnational capitalism. The dialogues between Asian and non-Asian artists and critics constitute a crucial resistance to this consolidation.

Thus, the works collected here—alternately beautiful, haunting, disturbing, inspiring—and the response pieces to these works together call for another understanding of history, one no longer ruled by a concept of the human whose movement and destiny conforms to that of the West. The works insist that we uncover and imagine the episodic, diverse perspectives of other humanities that lie beneath the assumption of Western personhood as the universal human. So replete is our understanding of art with assumptions about the

centrality of Western civilization that it has been difficult to imagine and visualize the history and presence of other subjects, memories, and communities. Within this context, the artists collected in *Fresh Talk / Daring Gazes* provide us with alternative visions, complicated reflections on the emergence of modernity, in which what has been previously foreclosed as invisible is forever saturating the what-can-be-seen. These artists visualize and imagine other humanities within the received tradition of the human.

INTERSTITIAL SUBJECTS

Asian American Visual Art as a
Site for New Cultural Conversations

THOUGH THEY BEGAN IMMIGRATING TO THE UNITED STATES A CENTURY AND A HALF AGO,
wherever significant numbers of Asian Americans settled, racial segregation practices kept
them largely confined within ethnic communities and limited their economic and politi-
cal activities until the civil rights movements of the 1960s. Nevertheless, even the earliest
Asians in the United States showed an active interest in creating visual art. According to
Peter E. Palmquist, Chinese immigrant photographers flourished in San Francisco, Port-
land, and Seattle in the middle of the nineteenth century, and Japanese-born salon pho-
tographers were active in Seattle and in many California cities after 1900.[1] Early work by
Asian immigrant photographers consists largely of portraits that contract workers wanted
to send home to their families. Although many of these may still exist in family albums,
very few can be found in public collections, and what little we know about the photogra-
phers themselves must be gleaned from a few lines in newspapers of the period. For in-
stance, an unidentified journalist wrote of a Chinese immigrant portrait photographer in
the San Francisco–based *Daily California Chronicle* in 1854, "Daguerreotypists, look out!
John Chinaman, so famous for his imitative powers is in the field. . . . 'Ka Chau' has opened
a 'Daguerrean Establishment' [on Sacramento Street]. . . . There, the passers by will ob-
serve on the street wall some very beautiful specimens of Ka Chau's handwork, many of

which are of course portraits of Chinese men and women."[2] We know about photographer and portrait painter Lai Yong, who had a studio in San Francisco by the mid-1860s, because he is mentioned in the *San Francisco Chronicle* in 1877 as follows: "Lai Yung [*sic*], our only Mongolian artist, is painting 'heep plicture Melican man,' and charging 'Melican man's' price for the same. His principal success is in portraits."[3]

Though Asian immigration and labor in Pacific Coast fields and factories was bitterly opposed by white American workers from the mid-nineteenth to the mid-twentieth centuries, it seems that Asian immigrants could find a degree of acceptance not only in domestic service and ethnic enterprises, such as restaurant and laundry work, but also in the arts. The *Daily California Chronicle* writer who made mention of Ka Chau's work adds, "There is no reason why Chinamen should not enter and succeed in any profession among us which requires nice manipulation. If some of the better class from China would only learn the English language, discard a few of their now exclusive national customs, and enter into ordinary business as handicraftsmen . . . we think the public opinion against the race would soon be materially modified in California."[4]

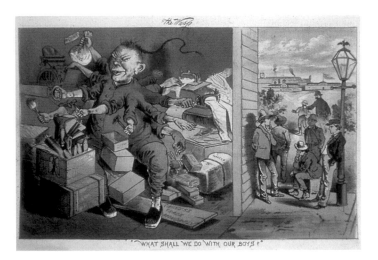

"WHAT SHALL WE DO WITH OUR BOYS?"

Figure 1.
"What Shall We Do with Our Boys?"
Political cartoon in *The Wasp,* ca. 1870s, pp. 136–137, reprinted in Philip P. Choy, Lorraine Dong, and Marlon K. Hom, eds., *The Coming Man: Nineteenth Century American Perceptions of the Chinese* (Hong Kong: Ngai Kwong Printing Co., 1994), 88–89.

Noting that significant numbers of Asian American artists were included in museum and gallery exhibitions in California and other Western states by the 1920s, art historian Karin Higa suggests that the arts establishment was receptive to Asians in a way that other institutions were not: "In San Francisco, Los Angeles and Seattle, Asian Americans were involved in important roles as leaders, organizers and teachers of art. The participation of artists of Asian ancestry in such roles on the West Coast suggests an alternative picture to the one painted on the legislative front."[5]

At a time when many Americans were clamoring against East, South, and Southeast Asian immigration and settlement in this country, Asian American visual artists in the Western United States may have been able to exhibit their work because they were few and not considered competitive with or threatening to white labor, especially if they made "oriental art." Visual art was probably not particularly significant during the hard-driving nation-building years of land and capital acquisition, when for many the arts connoted decorative and ornamental frivolity, femininity, luxury, and the extraneous—qualities associated with "orientals" and "the orient"—as contrasted with elements considered quintessentially American, such as technology, masculinity, and progress. Asian artistic ability, like African American musical talent, has traditionally been viewed in the United States as a harmless racial and cultural attribute passed down as if through the genes, without further development, from ancient Asian civilizations that, American school children still learn, produced intricate and exotic art objects until decadence and corruption

brought about their political collapse and economic ruin in modern times. Attitudes toward Asian American artistic ability during the period Higa discusses are seen in the suggestions of psychologists, social workers, and scholars about how Asians born and educated in the United States might best find employment opportunities when faced with race discrimination.

In his 1934 book titled *The Second-Generation Japanese Problem,* Edward K. Strong, designer of the Strong Vocational Preference Tests, addressed Japanese Americans' desire to move out of agricultural labor, gardening, and domestic service in the 1920s and 1930s, when most white Americans opposed their entry into white collar and professional occupations. According to Strong, instead of business, engineering, and medicine, agricultural work continued to offer the greatest opportunity because "here, the Japanese are wanted, for they are among the best workers and come into the least competition with the Occidental elements of the population." They could be successful raising vegetables, while other occupations would require that they deal with resentful white workers.[6] Besides agricultural work, Strong recommended watch repair, where their "agile fingers" would put them at an advantage; photography, which calls for artistic ability; or import-export businesses, retail outlets offering "oriental" curios, novel eating places, and other enterprises that would allow them to capitalize on the exotic appearance and the eagerness to serve that were associated with their ethnicity:

> The mere fact of being a Japanese is an asset in itself in certain situations, particularly if it is accompanied by a pleasing personality. Certain exclusive retail organizations employ Japanese to lend "atmosphere" to an establishment. Alert and pleasing proprietors of such undertakings as florist shops, stores for vending fancy fruits and vegetables, etc., have already gained an enviable popularity. Specialty shops of all sorts seem to hold similar promise for the striking personality further distinguished by Japanese attributes. Varieties of domestic service also seem feasible. . . . There should similarly be a few such openings in the amusement industry.[7]

It appears that an early sort of racial profiling encouraged even U.S.-born Asian Americans to peddle orientalia rather than produce fine art.

Although some early artists were able to cross boundaries that other Asian Americans could not, they found themselves being taken as "oriental" artists whose work could not be thought of as belonging to the same category as important American art because it was just too different from it.[8] Certainly one of the most important early immigrant artists was Chiura Obata (1885–1975), who studied ink painting in Japan before immigrating to the United States in 1903, and who has been recognized for his lifelong interest in bringing together Eastern and Western art traditions.[9] Obata employed the *sumi-e* (Japanese ink painting) style, painted from the traditional Japanese twelve-color watercolor box, and used both silk and *sanzenbo* distemper, a medium made from the skin of the Japanese white deer. However "oriental" it might have seemed in California, Obata's work was considered avant-garde in Japan, since he was deploying the techniques of modern Japanese, not "ancient oriental," painting when he combined traditional Japanese brush and ink painting with

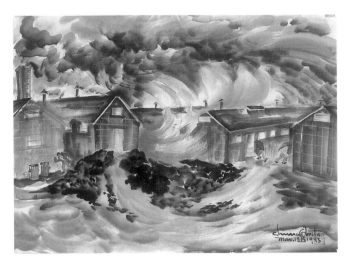

Figure 2.
Chiura Obata
Dust Storm, Topaz, 1943,
watercolor on paper, 14$\frac{1}{4}$ ×
19$\frac{1}{4}$ in. Obata Family Collection.
(PHOTO: KIM HARRINGTON)

Western naturalism and perspective to represent the vastness and scale of the California landscape and contribute to what Kimi Kodani Hill calls "one of the distinctive characteristics of the California Watercolor School."[10]

American cultural expression is still seen by many as being properly rooted in European artistic traditions that Asian Americans are not permitted to claim. Thus Asian American art has customarily been susceptible to comparison with Chinese and Japanese art as it was known in the West, where art audiences have focused almost exclusively on the ancient as opposed to the contemporary. Even today, modern Asian art is frequently thought of as too derivative of Western art forms to be as interesting as the more anthropologically and commercially appealing Asian art of the distant past. Even when Asian American artists deploy forms and materials associated with traditional Asian art, like calligraphic techniques, materials like rice paper, and tropes that are recognized in the West as "Asian," such as ornate dragon imagery, long black hair, and the like, their work risks being dismissed as "inauthentic," temporally and spatially too distant from the "source." At the same time, critics have often read Asian American artists whose work engages with American art forms as merely imitative or derivative, in keeping with old stereotypes of Asians as mimics and technicians rather than originators and creators.

Art historians routinely look for Asian art influences in the work of Asian American artists, but it turns out that Asian American art has been no more "oriental" than it has been extraneous. Paradoxically, while many Americans might have viewed Asian immigrants as inexorably alien or, as H. H. Bancroft described the Chinese, as "queer little specimens of petrified progress," they might be more aptly described as quintessentially modern in spirit, progressive and pioneering risk-takers who leapt eagerly into the future when they crossed thousands of miles of ocean to seek their fortunes in an unknown world.[11] Though the artists, like Asian American writers, might have been better appreciated had they tried to represent Asia or to serve as cultural bridges between East and West through their art,[12] most Asian American artists, also like Asian American writers, were interested in and produced art with distinctly American spirit and sensibility.[13] Beyond merely ap-

ing Western art practices by manipulating Western technologies, early Asian American visual artists not only engaged with but also extended them. Palmquist suggests that nineteenth-century Chinese and early-twentieth-century Japanese immigrant photographers contributed to the development of what he calls "a regionalized 'West Coast' consciousness concerning photography and art generally," based on interest in new technologies, the photographic possibilities posed by the spectacular natural beauty of the area, and the demand for portraits of people and cities during and after the Gold Rush.[14] Michael D. Brown, a San Francisco–based collector of California Asian American art, asserts that early Chinese and Japanese American artists contributed significantly to the development of California art, especially with their modernist realist watercolor scenes from everyday life. Stressing that many early Asian immigrant artists studied at prestigious California art schools, such as the California School of Fine Arts (now the San Francisco Art Institute), Brown contends that early-twentieth-century Japanese immigrant artists influenced California art by "infusing [it] with new ideas and broadening the California aesthetic,"[15] which might be described as modernist, influenced as it is by cubism, machinery, and Diego Rivera's murals, and featuring as it does the bright colors of the California landscape and bold, expressive brush strokes.

Indeed, early Asian American artists eagerly sought to learn about modern art as well as to build bridges to Western society through art organizations. The Shaku-Do Sha was established in Los Angeles's Little Tokyo by Japanese immigrant artists for "the study and furtherance of all forms of modern art."[16] By the 1930s, Chinese American artists were forming schools, galleries, and clubs, such as the Los Angeles Oriental Artists Group and the Chinese Art Association, which was established in 1935 to promote modern art and counted among its members Chee Chin S. Cheung Lee (1896–1966) of the "California school" of regional scene painters, together with Jade Fon Woo (1911–1983), founder of the Asilomar Watercolor Workshops on the northern California coast, and Dong King-

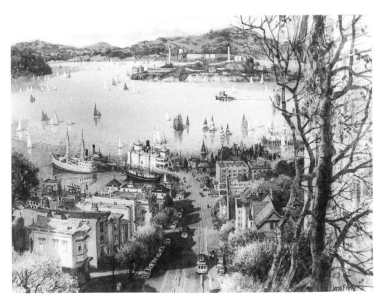

Figure 3.
Jade Fon Woo
Bay Afternoon, 1983, watercolor on canvas, 22 × 29 in. Collection of Pam Della.
(PHOTO BY THE ARTIST)

man (1911–2000), who became widely known as a landscape watercolorist during his long life.

The San Francisco–based Chinese Revolutionary Artists' Club, later called the Chinese Academy of Art, was founded by the modernist painter Yun Gee (Gee Wing Yun, 1906–1963) in 1926 with the support of two Chinese doctors. Gee's goal was to teach modern art theory and painting. Existing materials about his life and work suggest that his efforts to find a place for himself in America as an artist were circumscribed by racial barriers. Gee immigrated to California from a Cantonese village, either as a son or as a "paper son," when he was fifteen years old.[17] Having spent his early years in China during a time of great social upheaval and intellectual activity, when many Chinese youth were engaged in a restless search for the new, Gee was quintessentially "modern." Although he practiced Chinese martial arts, played Chinese musical instruments, and was well versed in Chinese classics, he was also widely read in Western literature and political philosophy. A prolific poet and a futuristic thinker, he reportedly spoke animatedly with friends about how the gap between China and America would narrow in the future, with Americans learning to appreciate Chinese martial arts and herbal medicine, soybeans, fish farming, and food preservation through dehydration.[18] In the 1920s, Gee studied at the California School of Fine Arts with Otis Oldfield, an ardent admirer of Paul Cézanne who had spent fifteen years in France. In California, Gee was exposed to a tradition of romantic landscape painting suffused with impressionism. He also encountered futurism, fauvism, and expressionism. He may have been influenced by Oldfield's method of laying on paint in neat, precise triangles, as well as by Cézanne's warm and cool color contrasts, but he had realist inclinations and tended to use his colors to express dynamic subject matter. Gee was interested in social genre and democratic ideals, the subject matter of Western modernism as well as of the revolutionary Chinese Republic of his youth. He liked the warm, throbbing colors of California landscape painting and the form and rhythm of European color abstraction. Gee developed a theory of modern color and form that he called diamondism, through which he tried to bring color and form with feeling and philosophical or moral purpose into the creative process.[19]

Bright color, energetic lines, and social commentary are found in Gee's modernist masterpiece, *Wheels: Industrial New York* (1932), in which cubic planes, needle-like strokes, and staccato dashes in black, blue, and red express the energetic dynamism of modern life. The vibrant energy of contemporary New York life is expressed in the painting's warm reds and yellows. Tall buildings in the midst of construction, cars, telephone wires, a bridge on pillars spanning a busy street scene form an urban landscape where nothing ever stands still. Movement is further expressed by the arc of polo players and the sun's rays jabbing the earth. The momentum is carried from spoke-like calligraphic lines in the "wheel" of the polo players to the opposite diagonal of the bridge. Social comment is contained in the juxtaposition of tenement houses and polo players. Gee brings nature, industrial artifice, and man together as the plane flies away from the sun and as the odd figure of a man sketched with thin, figurative black lines falls from or tries to fly off the bridge. We cannot know whether the man is committing suicide or trying to soar like the birds in the sky above him.

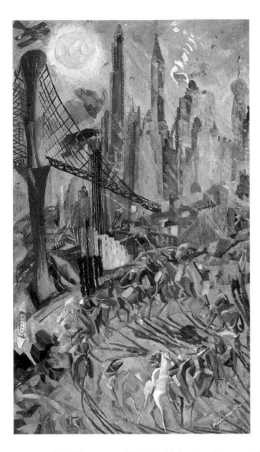

**Figure 4.
Yun Gee**

*Wheels: Industrial
New York,* 1932, oil
on canvas, 84 × 48 in.
Collection of Li-lan.
(PHOTO. TOM KIRKMAN)

In the mid-1920s, Gee attracted the attention of aristocratic European nobility who urged him to go to Paris, where he seems to have been regarded as an exotic novelty. European critics expressed interest in syntheses of Chinese tradition with Western modernism, and Gee tried to harmonize Chinese brush painting with his knowledge of color and to bring Chinese content together with Western forms.[20] His modernist painting of Confucius, which was exhibited at the Paris Salon des Independants in 1929, was praised by critics for its "blending of East and West." Thus, although Gee was apparently taken seriously in Europe as an artist, he could not escape orientalist expectations, no matter how seemingly benevolent. Particularly poignant is his 1929 self-portrait, *How I Saw Myself in a Dream,* in which he pictures himself in Chinese clothing, walking hunched and alone down a deserted Paris street, an exotic and isolated figure. On both sides are rows of buildings, and behind him is a large, vivid cross, perhaps symbolizing the alien environment. The figure, the background, and the muted brown and green colors converge to produce a mood of loneliness and displacement. Nor can we conclude, despite the attention he attracted as an artist, that Gee was completely accepted into French society: in 1930, he married a German-French poet princess whose parents cut her off without a penny until the couple finally divorced. Gee was propelled back to New York, where he found a stark contrast between the attention, however orientalist, he had enjoyed in Europe, and his reception in America. In an undated essay, he writes:

> Still floating from the reception and kindness of Paris, I came to New York. . . . Here the
> scene is changed to indifference. . . . I was no longer an artist. I was an oriental from
> Chinatown . . . and I suppose the interpretation of such a person was that he was only a
> Launderer or a Restaurateur . . . and this was hardly the reception I expected in my own
> country. . . . The name for the Chinese in this city was "Charlie," an unfair interpretation
> of the many distinguished Chinese families who aided in making America grow. . . .
> After dragging through this moral muck for five years, I decided to return to Paris.[21]

Early on, Gee had opposed cultivation of "merely an art of compromise . . . a safe, middle-of-the-road art" that catered and pandered to Western appetites for "orientalia."[22]

Although he sojourned in Europe a second time, ultimately he was unable to successfully accommodate the East-West synthesis that seems to have been expected from him as a "Chinese." The artist returned once again to New York. Joyce Brodsky suggests the negative reception his work received there "provoked a total crisis" for Gee, who she says suffered deep depression that spread through the last two decades of his life, during which he battled financial difficulties and alcoholism. Before he died in 1963, he had painted out and varnished over some of his works. Brodsky writes, "If America did not always provide the milieu to strengthen and nourish the genius of European artists, it offered even more resistance to artists of Asian origin. No creative person tried harder than Yun Gee to soak up the adventure and promise of the New World, and few other artists suffered such complete and tragic disillusionment."[23]

Not many Asian American artists have been formally trained in Asian art traditions and techniques. Dong Kingman, who was born in Oakland, moved to Hong Kong with his family as a small child and returned to live in the United States when he was still a teenager. In Hong Kong, he studied not just traditional Chinese but also Western art, which was taught by a Paris-educated artist who had returned to Hong Kong. Once back in Oakland, Kingman enrolled at the Fox Morgan Art School, where he was encouraged to become a watercolorist.

Of the thirty-five early Japanese American artists featured in the Japanese American National Museum's 1992 *View from Within* exhibit of internment camp art, only three besides Chiura Obata received any training at all in Japan. Of these, one artist studied *sumi-e* painting for a few years and another attended an art high school before immigrating to the United States. Among the 100 pre-1965 works featured in San Francisco State University's 1995 *With New Eyes* exhibit of Asian American art in the West, only Chao-Chen Yang (1910–1969) stands out as having had training in Chinese art in China. Most of the early Asian American artists who received formal art training attended American art schools, mostly the Otis Art Institute in Southern California and the California School of Fine Arts

Figure 5.
Dong Kingman
San Francisco, ca. 1940, Chinese ink on paper, 14 × 13 in. Courtesy M. James Fine Art.
(PHOTO: STEVE VENTO)

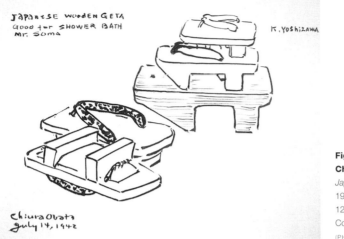

Figure 6.
Chiura Obata
Japanese Wooden Geta,
1942, sumi on paper, 9 ×
12 in. Obata Family
Collection.
(PHOTO: KIMI KODANI HILL)

and the California College of Arts and Crafts in Northern California. A few studied at the Art Students League in New York or the Chicago Art Institute, and an occasional artist enrolled at the New York Photography Institute or the Pennsylvania Academy of Fine Arts or studied art at Columbia or Berkeley.

Yuzuru Henry Sugimoto (1900–1990), who studied at the California College of Arts and Crafts, the California School for Fine Arts, and the Paris Academie Colarassi, painted California and French landscapes in oil and watercolor. He also made wood-block prints that some interpret as expressing his "oriental" heritage, though they are as likely to have come to him via the West, where interest in Japanese *ukiyo-e* was keen during his lifetime. Sugimoto's work was shown in Paris and San Francisco before World War II, when he was incarcerated in the internment camps for Japanese Americans at Jerome and then Rohwer, both in Arkansas. He taught art classes in the camp high schools.

The imprisonment had the paradoxical effect of bringing together established and aspiring visual artists. Internment meant forced leisure, though leisure nonetheless, for the first time in the adult lives of many Japanese Americans. Whether because there was little else to do or because buried desires to make art had been unexpectedly unearthed, demand for camp art classes was high. Strongly believing in art's power to soothe the troubled spirit, Chiura Obata set up a makeshift art school in 1942 at the Tanforan Race Track assembly center in San Bruno, California, that eventually offered 90 classes each week, from morning until night, to 600 students from 6 to over 70 years of age. Obata sought donations from his friends and former art students at Berkeley, who helped him obtain drawing pads, watercolor tubes, crayons, and pastel chalks. According to his notes, the internees in the art classes used materials gathered from around the site to create work of astonishing ingenuity:

> Ninety percent of [the students] had no previous training but the products displayed clearly indicated the natural creativeness of a creative people. 1) beautiful woven sun bonnets

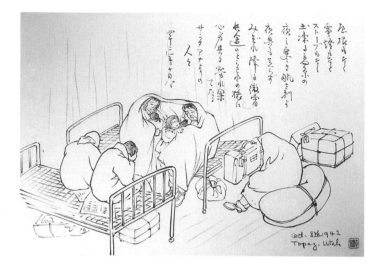

Figure 7.
Chiura Obata

A Sad Plight, October 8, 1942, sumi on paper, 11 × 15³⁄₄ in. Obata Family Collection.

(PHOTO: KIMI KODANI HILL)

made out of tule grass which grows unnoticed in the insignificant corner of the camp; 2) . . . trays, vases, stands, and ornaments [made] out of eucalyptus tree roots which have been discarded in dump yards; 3) ornate wood carvings out of old fence posts of the race tracks; 4) modern lamp and cigarette tray sets made out of junk auto parts which were found in the dump heap; 5) chairs and cabinets made out of fruit boxes; 6) about 400 model boats of all types.²⁴

Before being relocated to the Topaz camp in Utah, Obata arranged to have five sculptures and seventy-five drawings by internees exhibited at Mills College in Oakland and at the International House and the YWCA in Berkeley. Shortly after arriving at Topaz, the "permanent" internment center in Utah, Obata set up the Topaz Art School. Within two months, 3,250 internees were enrolled in art, crafts, and evening academic classes at the school. Obata and his wife, Haruko, who taught flower arrangement, were joined by Frank Taira and Teruo Iyama, who had studied at the California School of Fine Arts, Byron Takashi Tsuzuki, Henry Fujita, who taught fly-tying, and Chiyo Shibaki, who taught leather work.²⁵ While imprisoned, Obata himself produced a series of annotated drawings that constitute an understated visual diary of everyday life in the camp, as well as a group of drawings and paintings of the landscape and sky that evoke a profound sense of isolation, alienation, and determination. U.S.-born Mine Okubo (1912–2001), a nisei with a master of fine arts degree from the University of California, Berkeley, who had worked in the Works Progress Administration's Federal Arts Program before the war, also taught art classes at Tanforan and Topaz, and published a book of drawings of camp life, *Citizen 13660* (1946), after her release. Okubo's drawings do not express the understatement found in Obata's work, and some have read them as being more expressive of the U.S.-born nisei's outrage than the immigrant issei's sense of endurance in the face of adversity.

Most of the artists featured in the Japanese American National Museum exhibition *The View from Within* never achieved Obata's or Okubo's level of visibility. Matsusaburo Hibi

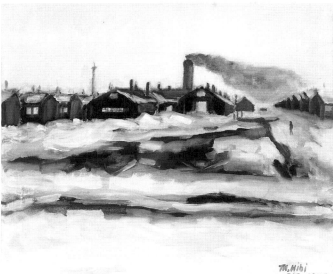

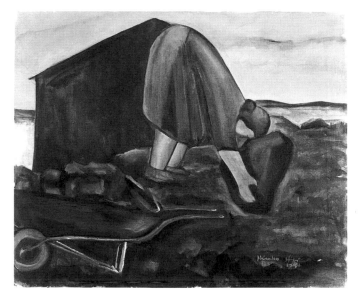
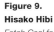

Figure 8.
George Matsusaburo Hibi
Block #9, Topaz, 1945, oil on canvas, 23 × 26 in. Collection of Fine Arts Museums of San Francisco, gift of Ibuki Hibi Lee, 1997.2.1.

Figure 9.
Hisako Hibi
Fetch Coal for the Pot-Belly Stove, 1944, oil on canvas, 20 × 24 in. Collection of Fine Arts Museums of San Francisco, gift of Ibuki Hibi Lee, 1997.2.2.

(1886–1947), who had studied at the California School of Fine Arts and who took over the Topaz Art School when Obata was released in 1943, died of cancer soon after his release. His talented artist wife, Hisako Hibi (1907–1991), widowed and with children to support, worked as a domestic, a dressmaker, and a factory worker until she retired to a senior citizens' facility in San Francisco's Japantown, where she died. Not only had Japanese Americans lost their livelihoods because of internment, but racial barriers locked them out of many occupations for years after their release. Obata was able to return to his teaching post, and Okubo continued to produce artwork in New York, but many other artists made their living in laundries and garment factories or supported themselves as gardeners and

Figure 10.
Chiura Obata
*Hatsuki Wakasa, Shot by
M.P.,* April 11, 1943, sumi
on paper, 11 × 15³/₄ in.
Obata Family Collection.
(PHOTO: KIMI KODANI HILL)

Figure 11.
Mine Okubo
New Pipe, from the *Citizen
13660* series, 1943, ink on
rice paper, 9 × 12 in. Mine
Okubo Collection, Japanese
American National Museum,
94.268.3.
(PHOTO: NORMAN SUGIMOTO)

clerks after the war. Those who continued working in art often became sign painters, fabric designers, or Asian antique art dealers and restorers, or went to work in the Hollywood film studio "art factories." The talented writer and artist Wakako Yamauchi painted shower curtains for a shower curtain factory.

Kristine Kim, curator of a 2001 retrospective of Henry Sugimoto's work, contends that the artist was "completely transformed" by the internment experience: instead of looking to nature, he turned to his "personal experiences, his beliefs" for inspiration. Over the years after he was released, Sugimoto created paintings and wood-block prints depicting life at the Jerome relocation center. According to one critic, although internment "left him melancholy and broken in spirit . . . it also gave his work a depth and poignancy that were absent from his earlier optimistic canvasses." But the fact remains that Sugimoto's career as

Figure 12.
Henry Sugimoto
Arrival at Jerome, ca. 1965,
woodblock print, $13\frac{1}{4} \times 10$ in.
Gift of Madeleine Sugimoto and
Naomi Tagawa, Japanese
American National Museum,
100.2000.46V.

(PHOTO: NORMAN SUGIMOTO)

an artist was cut short by the internment, and he was never able to regain the footing he had enjoyed as a promising young artist before the war. Japanese American National Museum director Irene Hirano points out that besides the "homes and property and personal possessions . . . lost and never recovered," the internment resulted in losses that cannot be measured. "In this case a gifted artist's life was severely altered by the war. . . . Had the war not come along, his career and life would have been so different. How can you measure that loss?"[26]

Although New York and not California has been the center for American art, Asian American art first blossomed on the West Coast. Like Sugimoto, even New York–based artists Yun Gee and Mine Okubo moved to New York from California, where they had first begun to make art. Before immigration quotas were changed in 1965, Asian communities, consisting mostly of Chinese and Japanese but also including Filipino and Korean Americans, were largest and most vibrant on the West Coast, and a U.S.-born second generation came of age by the 1930s. Between 1930 and 1960 and beyond, Asian American artists produced many kinds of modern art, including impressionist and abstract expressionist work by painters such as California-based Bernice Bing (1936–1998), George Chann (1913–1995), George Miyasaki (1935–), who came to California from Hawaii, Arthur Okamura (1932–), and Leo Valledor (1936–1989), and abstract sculpture by Ruth Asawa (1926–) and Seattle's George Tsutagawa (1910–1997). Two Philippine-born painters,

Figure 13.
Bernice Bing
Mayacamas, No. 6, 1963,
oil on canvas, 49 × 48 in.
Collection of M. H. de
Young Memorial Museum,
Fine Arts Museums of
San Francisco.

Figure 14.
Leo Valledor
*Zoot Sutra—Song for My
Father,* 1973, acrylic on
canvas, 8 × 12 ft. Collection
of Mary and Rio Valledor.

Figure 15.
George Miyasaki
Rough Cut, 1999, acrylic
and construction on
canvas, 72 × 90 in.
(PHOTO: BEN BLACKWELL)

Figure 16.
Ruth Asawa
Untitled, 1974, bronze wire,
copper pipe, 1½ × 12 ft.
Gift of the Women's Board
of the Oakland Museum
Association.
(PHOTO: SO-YEON PARK)

Victor Duena (1888–1966) and Roberto Vallangca (1907–1979), painted frescoes and modernist murals with surrealist and primitivist elements.

Few Asian American modernists are as well known and as widely successful as Los Angeles–born sculptor Isamu Noguchi (1904–1988), who was the son of a Japanese poet who abandoned Noguchi's white American mother before Noguchi was born. Raised in Japan until the age of thirteen, when his mother sent him to school in Indiana, Noguchi spent most of his time in the United States, producing over many decades a large body of work of rich variety, including abstract and realist sculptures, monuments, landscape projects, playgrounds, stone sculpture gardens, fountains, furniture, and ceramics. Noguchi is frequently described as an artist who synthesizes Japanese and Western artistic traditions with a "tolerance for polarity"[27] emanating from his biracial identity, but he was influenced by a wide variety of elements: not only his early encounters with Japanese carpentry but also his studies of abstract painting and sculpture in California and the Midwest, his exposure to modern European art in the 1920s and 1930s, and his worldwide travels, during which he came into contact with Chinese palaces and gardens, Italian stonework, Indian and Balinese sculpture, and Peruvian architecture.

Critical reception of Noguchi's work has varied, often according to temporal and geographical variations in political and racial climate. During the 1930s and 1940s, Noguchi was unable to completely escape from anti-Asian prejudice, which posited him as intrinsically foreign and therefore as someone who had no right to engage in social commentary about the United States.[28] At a 1935 one-person exhibition at the Marie Harriman Gallery in New York, Noguchi showed several sculptural pieces that expressed what he called his "wish to belong to America, to its vast horizons of earth."[29] The exhibition included *Monument to the Plough,* which refers to the vast open spaces of the Midwest and to the American pioneer spirit; *Monument to Ben Franklin,* which eulogizes the American spirit of invention; the *Carl Mackley Memorial* to the United Hosiery Workers Union; and *Death (Lynched Figure),* which refers to a photograph of the lynched and mutilated body of a Black man that appeared in a 1930 issue of *International Labor Defense. New York Sun* critic Henry McBride, who had reviewed Noguchi's previous work favorably and

Figure 17.
Isamu Noguchi
*Death (Lynched
Figure),* 1933, Monel
metal, 89 in. Courtesy
of Isamu Noguchi
Foundation, Inc.
(PHOTO: SHIGEO ANZAI)

who was regarded as a "sympathetic and experienced avant-garde critic,"[30] described the work as an attempt to "manipulate American sentiments, the consequence of 'studying our weakness with a view of becoming irresistible to us.'" McBride wrote, "You cannot deny that Isamu Noguchi, the Japanese-American sculptor . . . has grand ideas. I hate to apply the word 'wily' to anyone I so thoroughly like and respect . . . yet what other word can you apply to a semi-oriental sculptor who proposes to build in the United States . . . monuments [like *Monument to the Plough*]." McBride went on to characterize *Death (Lynched Figure)* as "just a little Japanese mistake."[31]

In the same year, an *Art Digest* critic urged Noguchi to eschew political statements and engage instead in what was believed to be "oriental" detachment from the profane world: "It is naturally a great temptation to urge the artist to put behind him the obvious fascinations of contemporary life, with all its dependence upon the intellectual substitutes for living and to seek to renew experience with the finest Eastern traditions, so rich in inner vitality as to make a travesty of the mechanical excitements of our own day."[32] Paradoxically, when Noguchi returned to New York after spending time in Japan learning about ceramics, his 1954 exhibition was received unfavorably. Perhaps the reputation of postwar Japanese goods as flimsy, inconsequential novelties spilled over into critics' view of his ceramic work. According to Sam Hunter, "They were said to reflect a confusion of genres. Their humor, small scale, and the unusual folk-art-inspired animal and plant imagery, textures, and motifs struck some reviewers as frivolous, 'cute,' or simply inaccessible to Western sensibility. . . . Such criticism was far more narrowly exacting than the standards which were being applied at the same time to the ceramics and dishware turned out in such profusion, and with huge commercial success, by Picasso, Miró, and other prestigious European masters of unassailable reputation."[33]

Indeed, it seems that at times Noguchi tried hard to perform Japaneseness. In 1952, he married a Japanese film star and moved into an old Japanese farmhouse, which he restored and where the U.S. press eagerly interviewed him, dressed in a kimono and the kind of straw and wood zoris that he forced his wife to wear, even though they made her unac-

customed feet bleed.[34] While reporters from the *New York Times Magazine, Interiors,* and *Arts and Architecture* might have considered the house and lifestyle typically Japanese, according to Bruce Altshuler, Japanese visitors considered the whole thing "a bizarre exercise in exoticism." Likewise, many progressive Japanese artists found his ceramic sculptures "too 'Japanese' to be Japanese," and indicative of a "distinctly Western fascination with old Japan."[35] Whether they approved or not, the Japanese understood that Noguchi was performing Japaneseness.

When working on his *Jardin Japonais* at UNESCO's headquarters in Paris beginning in 1956, Noguchi brought in stone, water basins, trees, and plants from Japan, but he argued constantly with the master gardener who had come from Kyoto to assist him, as Noguchi broke rule after rule of traditional Japanese garden design. He created forms that seemed Japanese but could not be found anywhere in Japan, appropriating elements of the Zen meditation garden but concerned about very Western worries regarding the tensions between permanence and flux in nature. According to Altshuler, "In addition to general expression of his Western sensibility—needing to fill every empty space, insisting on the prominent display of his sculptural elements—the overall plan of the garden employs the curvaceous forms of the 1940s."[36]

The Japanese knew what Americans could not accept. An English-language Japanese brochure essay for his Japan exhibition, apparently co-written by Noguchi, situates him quite correctly as an American modernist: "From an American viewpoint, he is probably regarded as an artist of Oriental nature, but from our judgement of his works we detect a considerable amount of Western elements foreign to us. . . . Underlying his Japanese works there is the logic, or the illogic of Western construction. . . . The real value of Noguchi's art is explicitly revealed when we stop to consider how it fits into modern American architecture. . . . Always uppermost in his heart is the question: How to meet Modern Civilization."[37] Ironically, though he was marked as a Japanese and though he seems to have attempted all his life to come to terms with expectations about what was assumed to be his Japanese identity, even Noguchi's interest in using a variety of Japanese sources and materials marks him as an American modernist. Bruce Altshuler places him squarely in the tradition of modernism: "Surveying Noguchi's work yields a unique compendium of themes and techniques that have been essential to various manifestations of this tradition: elimination of the inessential through formal reduction; truth to materials and honesty of structure; utopian aspiration; production of art from technology; the use of non-Western sources; and, in his late sculpture, a collaboration with chance and accident."[38]

With Isamu Noguchi, Maya Ying Lin is one of the best-known Asian American artists, and like him she has been forced to confront race discrimination. Lin achieved international recognition for her Vietnam War Memorial design, which she designed as a twenty-one-year-old college student in 1981. Although Lin's design had been chosen from among 1,441 entries by a committee of nationally known architects and artists, she was excoriated by veterans, congressmen, and public officials who were offended by the non-monumental, anti-phallic abstractness of her work, as well as by the fact that she was young, female, and worst of all, not a "real American" but rather someone who might share some affinities with the Vietnamese enemy.[39] They criticized the memorial's concept, shape, and color, asserting that it would be a tomblike monument to guilt and defeat. For some, its V shape

Figure 18.
Maya Lin
Vietnam Veterans Memorial (overview),
1982. Black granite,
each wall 246 × 10^1/$_2$ ft.
(PHOTO: KIM RETKA)

Figure 19.
Maya Lin
Vietnam Veterans Memorial (close-up),
1982.
(PHOTO: KIM RETKA)

connoted antiwar protesters' peace sign. For others, "V" stood for Vietnam, victim, and worst of all, vagina—an open wound that could never be healed, a "gash of shame" that suggested castration and bespoke the connections between women, earth, and death.[40] Though the design's opponents failed to have it replaced, they did succeed in having realistic sculpted figures of military men placed nearby. Lin never wavered from her vision and belief in the integrity of the design's concept. Despite her young age, she remained courageous and steadfast as she faced the hatred and anger of the opponents of her design.[41] Since the memorial was built, millions of visitors have been haunted by its beauty and amazed by how powerfully it enables the experiences of remembering and grieving.

Lin's strength may have been fed by the new thinking about American identities that was made possible by the African American–led Civil Rights Movement, which developed during her childhood. Understanding how racism had blocked other Americans from full and equal participation in American life helped many Asian Americans see how they had been forcibly distanced from the national culture their labor was being recruited and exploited to build. During the past three decades, Asian Americans have formed countless advocacy and service organizations across the country to address civil rights, labor, health, and family issues. New immigration has introduced a new diversity of needs and interests. Cultural activity, particularly in literary arts, but also in performance art, filmmaking, and the visual arts, has been lively.

With continually developing communication and transportation technologies and new immigration from Asia, New York is now the center of Asian American art, attracting Asian American migration from California and other parts of the United States. The threads that connect contemporary Asian American artists to California and other West Coast painters and sculptors of prior decades are fragile. But the lines of affinity are just as tentative between Asian American artists of the millennium and New York–based Japanese immigrant avant-garde artists Yoko Ono and Shigeko Kubota and Korean-born video artist Nam June

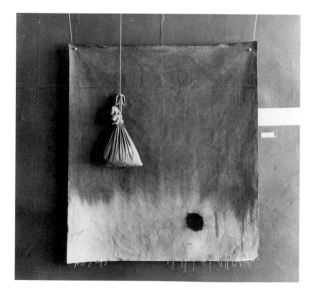

Figure 20.
Yoko Ono

Painting for the Wind, 1961. Canvas, cloth, ink, seeds, varying dimensions. Courtesy of the artist and the Gilbert and Lila Silverman Fluxus Collection, Detroit.

(PHOTO: GEORGE MACIUNAS)

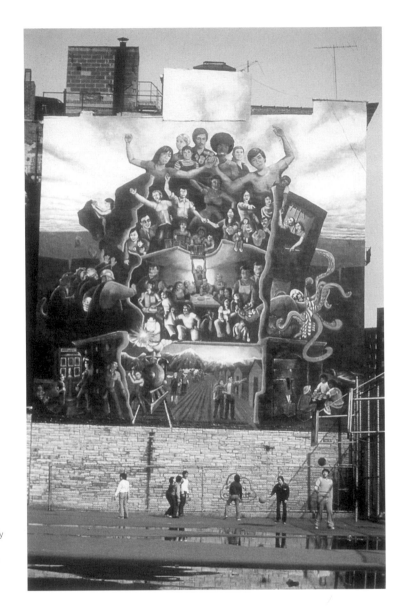

**Figure 21.
Arlan Huang,
Tomie Arai,
Karl Matsuda,
Mary Patten,
Phil Gim,
William Leong**
*Arriba, Chi Lai, Rise
Up,* 1974, Ronan
enamel, approximately
55 × 60 ft. City Arts
Mural, Mural Director
Alan Okada.
(PHOTO: KEN GOLDEN)

Paik, who were participating in the internationalist-oriented, though still decidedly West-
ern, fluxus movement in the 1960s. Nevertheless, some of the issues and concerns facing
today's Asian American artists are similar. We are reminded of how an Asian face was
viewed as incompatible with teaching English and as appropriate for teaching "oriental
history" in the 1930s when Yong Soon Min asks, six decades later, "Why should my work
not reach as broad an audience, in principle as, say, the work of Baldessari? How is it that
my Western contemporary art training, [which is] surely embedded in the work, [can be]
rendered so alien by my subject matter and by . . . perceptions of me [as a racialized Ko-
rean American?]"[42]

In the wake of the civil rights movements of the 1960s, Asian American artists formed collectives, such as the Basement Workshop in New York, the Asian American Resource Workshop in Boston,[43] and the Kearny Street Workshop and Japantown Art and Media in San Francisco.[44] Some of these organizations attracted not only visual artists, but also writers and musicians. The groups produced wall murals and silkscreen posters for rallies and community events, published anthologies of prose and poetry, and sponsored writing workshops, poetry readings, and musical performances. Mural art projects in New York, Chicago, San Francisco, and Los Angeles experimented early with site specificity. Claiming abandoned buildings, party walls, and community gardens in ever-changing neighborhoods, mural artists were less concerned with the monumentalization and conservation of their work than with process and democratization of the arts. The New York City Arts Workshop artists' slogan was "Out of the gallery and into the streets!"[45] Since fresco art was a generally neglected and untaught form, muralists of the 1960s recalled the WPA public art projects of the Great Depression years and referred to both the Mexican muralists of the first decades of the twentieth century and colorful and vibrant Cuban, Chilean, and Chinese poster art of their own day. Whether designed and painted by artists or done in collaboration with members of the local community, mural art emphasized the integral role viewer participation plays in the production of artistic meaning.[46]

The Basement Workshop, which was founded in 1971, published *Bridge Magazine,* an important political and cultural periodical for Asian Americans, and the first anthology of Asian American art and literature, *Yellow Pearl* (1972). Its members conducted oral history interviews of Chinatown's elderly, collected old photographs, offered workshops in silkscreening, photography, music, dance, and creative writing, ran arts and crafts programs for children and youth, and published *American Born and Foreign* (1979), an anthology of poetry and prose edited by Basement writers Fay Chiang, Richard Oyama, and others. Tomie Arai, Jean Chiang, Arlan Huang, William Jung, Colin Lee, and Margo Machida are among the artists who participated in visual art projects. Beleaguered by financial problems, Basement closed its doors by 1987. During its fifteen-year history, the Basement Workshop was a multidisciplinary arts organization that provided an umbrella for arts activities and supported education projects, arts workshops, and cultural performances.

Established in San Francisco in 1972, the Kearny Street Workshop has sponsored poetry readings, art workshops and exhibits, mural art by Jim Dong, graphic art by Nancy Hom, music concerts, and theater for three decades. It has published a number of books of poetry, including *Without Names* (1985), an anthology of Filipino American poetry; Jeff Tagami's *October Light* (1987); Virginia Cerenio's *Trespassing Innocence* (1989); Genny Lim's *Winter Place* (1989); Jaime Jacinto's *Heaven Is Just Another Country* (1996); Al Robles's *Rappin' with Ten Thousand Carabaos in the Dark* (1996); and Truong Tran and Chung Hoang Chuong's *The Book of Perceptions* (1999). Kearny Street Workshop also publishes a resource guide that lists Asian and Asian American artists in the San Francisco Bay Area and has produced several books about photography, including *Texas Long Grain* (1982) and *Pursuing Wild Bamboo* (1992), which features portraits of multimedia artist Chester

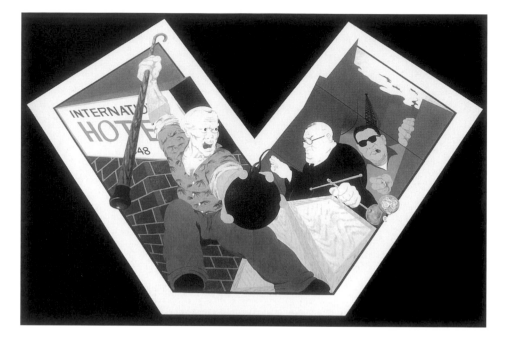

Yoshida, graphic designer Leland Wong, *taiko* drum maker Mark Miyoshi, and performance artist Brenda Wong Aoki by photographers Zand Gee, Bob Hsiang, Crystal K. D. Huie, and Lenny Limjoco. The Workshop has also published a book of cartoons by Ed Badajos, *Ed Badajos: A Retrospective* (1984).

A variety of factors converged in the early 1990s to both increase Asian American arts activity and bring national attention to Asian American art. Changes in U.S. immigration quotas after 1965 produced dramatic growth and diversification of Asian American populations, not only in California and New York but also in the rest of the country, in the 1970s and 1980s. A critical mass of young English-speaking Asian Americans had emerged by the late 1980s. While many of these young Asian Americans were bilingual and able to travel freely between the United States and their parents' homelands, their focus was on Asian American communities.[47] Community organizations that had managed to survive the Republican

Figure 24.
Arlan Huang
Smooth Stones for
Grandfather, 1991,
blown glass, 5 × 7 ×
6 in. each.

years, when funding support all but evaporated, were invested with new vitality when this group came of age. New participation and support strengthened national organizations such as the National Asian American Telecommunications Association, the Asian American Journalists Association, and the Asian Pacific Legal Consortium. On many college campuses, 10 and sometimes 20 percent of the students were now Asian American, and Asian American studies programs expanded and flourished. Publishers clamored for Asian American materials. In terms of ethnicity, language ability, social class, economic status, livelihood, political affiliations, religious and cultural practices, and place of residence, post-1965 Asian communities in the United States had become extraordinarily diverse. Young Asian Americans were now playing professional sports, spinning records, becoming comedians, and making films.

Sa-i-gu, Korean for "April 29," in reference to the first day of the 1992 Los Angeles uprisings, catapulted Asian Americans, especially Korean Americans, into the national spotlight in what were later described as the nation's first multiracial riots. During *sa-i-gu,* the network news media exploited and sensationalized interracial conflicts between Korean and African Americans, precipitating a crisis of representation for many Korean Americans, who felt that as racialized immigrants they had been scapegoated and rendered voiceless, blamed for social problems created centuries before they had arrived in the United States. They wanted a voice, and they wanted to participate in establishing the terms of their visibility.

Sa-i-gu stimulated many young Asian Americans' desire to represent themselves and to participate in shaping the ways in which Asian Americans were seen and understood in U.S. society. They recognized that the attention accorded them, though largely nega-

Figure 25.
Pok Chi Lau
*May and Quincy at
the Asian American
Film Festival, Wichita,
Kansas,* 1993, black-
and-white photograph,
8 × 10 in.

tive, caused others to consider for the first time the possibility that they might in fact be "Americans," as opposed to perpetual foreigners always kept apart from the core representation of American cultural life because "Asian" and "American" were considered mutually exclusive. According to critic and curator Eungie Joo, "For better or worse, the perverse attention of the popular media, academia, and government in the aftermath of *sa-i-gu* took an already broken record and smashed it into shards, so that more facets were unwittingly exposed to view."[48]

Increased visibility for Asian Americans as Americans after *sa-i-gu* coincided with discussions of "multiculturalism" that had already begun in the arts establishment in New York by the late 1980s and resulted in greater receptivity to Asian American art. In 1990, *The Decade Show: Frameworks of Identity* was collaboratively organized by the New Museum of Contemporary American Art, the Studio Museum in Harlem, and the Museum of Contemporary Hispanic Art in New York.[49] This exhibit addressed questions of identity and representation in art and was meant to embrace ethnic diversity and to address issues of gender and sexual orientation. Lacking precedent and perhaps overly ambitious, the show was criticized even by sympathizers as "over-stuffed" and sloppily installed and as offering "only the most cursory glimpse of the work of the 140 or so participating artists . . . represented by only one or two works, so [that] complex careers were often reduced to a single statement."[50] While *The Decade Show* increased the visibility, however briefly, of many artists of color, including Asian American artists such as Tomie Arai, Albert Chong, Ken Chu, Y. David Chung, the Epoxy Art Group, Pok Chi Lau, Yong Soon Min, Tom Nakashima, and Martin Wong, the exhibition catalog "underscore[d] some of the best intentions and achievements of multiculturalism in the arts as well as some of the thorny problematics," including "multicultural segregation." In the words of one

Figure 26.
Bing Lee
Canal Street Subway Station Mural, 2001, ceramic tiles, 10 × 27 ft. A commission of Art for Transit, Metropolitan Transportation Authority of New York City.
(PHOTO: HIRO IHARA)

Figure 27.
Gaye Chan
Fit, 1997, silicone, glass, porcelain pieces, red velvet, carved wood stand, dictionary, $7^{1}/_{2} \times 9^{1}/_{2} \times 6^{1}/_{2}$ in. Courtesy of the artist.

participant, "The overall segregated arrangement of the curatorial essays reinforced the notion that everyone has their own turf, particularly artists of color. Curators of color . . . only [wrote] about their own racially identified group of artists."[51]

Galvanized by the possibilities for Asian American artists suggested by *The Decade Show,* New York artists Ken Chu and Bing Lee began talking about what it would take to start a contemporary Asian American art museum. In July 1990, they were joined by Margo Machida, and Godzilla: Asian American Art Network was founded. The fabled creature of 1960s Japanese monster movies, Godzilla was a giant lizard that mowed down whatever was in its way. The group's goal was creative and subversive arts advocacy and education and the establishment of a network of artists. According to art critic Alice Yang, the name Godzilla "indicates the activist stance of its founders . . . counter to the stereotype of passivity associated with Asian people."[52] About one hundred people participated in the group's regular gatherings. During its four years of operation, Godzilla hosted meetings where artists presented slide talks about their work, established and maintained a slide registry and served as a referral and resource bank for curators and funding agencies, published a newsletter with exhibit listings and articles on relevant issues, organized two exhibitions of Asian American art and contributed to other exhibitions,[53] and sponsored panel discussions on such topics as "Is there an Asian American aesthetic?" On the West Coast, meanwhile, artists Betty Kano and Flo Oy Wong organized a group of Asian American women artists in the late 1980s. They began collecting slides and establishing a network of artists for mutual support and group shows.

By the early 1990s, publicly supported museums were searching for untapped sources of new money, as the previous decade's investor speculation in art that had resulted in so

Figure 29.
Masami Teraoka
*New Waves
Series / Kyoto Woman
and Gaijin,* 1991,
watercolor on paper,
$22^3/_8 \times 30^1/_{16}$ in.
Collection of the
Metropolitan Museum
of Art, New York.
(PHOTO: LYNDA HESS)

Figure 30.
Tseng Kwong Chi
*Disneyland, CA 1979,
with Mickey Mouse,*
1979, black-and-white
photograph, 8 × 10 in.
Copyright Muna Tseng
Dance Projects, Inc.,
New York City.

Figure 31.
Flo Oy Wong
Lew Dung Quock,
from "made in usa:
Angel Island Shhh,"
1938, acrylic and
construction on
canvas. Courtesy
of the artist.

(PHOTO: BOB HSIANG)

much commercial success for some artists was beginning to fizzle. Inspired by stories of Asian wealth and the hypervisibility of Asian, as opposed to European, immigrant economic activity in the United States, museum directors in major U.S. cities began looking to Asian American communities for financial support. Art museums that had paid minimal attention to Asian Americans throughout the century suddenly began inviting them to their gatherings and trying to find wealthy people to invite to join their boards of directors. The Asia Society, which had traditionally sponsored cultural events addressed mostly toward Westerners interested in the high arts of ancient Asia, began to pay attention to Asian Americans in the early 1990s, and the Queens Museum of Art, which is located in one of the largest and most vibrant Asian immigrant communities in the United States, expressed interest in the idea of showcasing Asian and Asian American art.

In 1993 and 1994, two groundbreaking exhibits of Asian American art were launched at the Asia Society and the Queens Museum, *Asia/America: Identities in Contemporary Asian American Art* and *Across the Pacific: Contemporary Korean and Korean American Art,* respectively. *Across the Pacific,* which was curated by Jane Farver and Young Chul Lee, opened first in Queens and then at the Kumho Museum in Seoul in 1993.[54] *Across the Pacific* included the work of Korean American artists Mo Bahc, Sung Ho Choi, Y. David Chung, Michael Joo, Byron Kim, Hyung Su Kim, Jin Soo Kim, Young Kim, Jin S. Lee, and Yong Soon Min and Korean Canadian artist Jinme Yoon, as well as eleven Korean American and Korean Canadian films and videos, curated by Hye Jung Park and Christine Chang and including Christine Chang's *Be Good My Children* (1992), Helen Lee's *My Niagara* (1992), Michael Cho's *Animal Appetites* (1991), and Yun Ah Hong's *Memory/All Echo* (1990). *Asia/America,* curated by Margo Machida, opened in New York in early 1994 and

Figure 32.
Hyung Su Kim
These Americans, 1993,
computer-generated color
photograph, 16 × 20 in.

Figure 33.
May Sun
*Fugitive Landing: A Revolutionary
at Sea,* 1991, multimedia
installation, dimensions variable
(approximately 10,000 sq. ft.).
Capp Street Project, San
Francisco. Courtesy of the artist.
(PHOTO: SIXTH STREET STUDIO)

Figure 34.
Ik-Joong Kang
8490 Days of Memory,
1996, chocolate,
plastic, and mixed
media, 9 × 4 × 4 ft.
(statue), 3 × 3 × 3 in.
each (plastic cubes,
8,490 pieces).
Collection of the artist.
(PHOTO: GEORGE HIROSE)

over the following two years traveled to Tacoma, Minneapolis, Honolulu, San Francisco, Boston, and Houston. The exhibit featured artists Pacita Abad, Tseng Kwong Chi, Sung Ho Choi, Ken Chu, Y. David Chung, Marlon Fuentes, Jin Soo Kim, Hung Liu, Yong Soon Min, Takako Nagai, Long Nguyen, Manuel Ocampo, Sisavath Panyathip, Hanh Thi Pham, May Sun, Masami Teraoka, Toi Ungkavatanapong, Zarina, and Baochi Zhang. Both exhibits emphasized links between Asian American artists and Asia: *Across the Pacific* attempted to suggest lines of affinity between Korean *minjung* art (art "for the people" created during the South Korean social movements of the 1980s) and Korean American art. *Asia/America* featured the work of artists who had been born in Asia and were working in the United States and focused on themes of homeland and displacement. Neither show addressed the question of how Asian and Asian American art is related to American art. Still, both exhibitions generated excitement in Asian American arts communities because they seemed to indicate that art expressing heterogeneous Asian American aesthetic, political, and personal concerns was finally beginning to receive serious attention in discourses on U.S. culture.

Smaller exhibitions of ethnicity-specific art organized by Asian American artists included *Yellow Peril: Reconsidered* (1990–91), an exhibit featuring Asian Canadian photo, film, and video artists, and *The Curio Shop* (1993), an exhibition organized by Godzilla at Artists Space in New York. Some critics complained that these exhibitions featured mostly descriptive work geared toward "correcting" racist stereotyping with "authentic truths" that locked art into a closed circuit of dominant representations. Eungie Joo writes that artists "understood to be dealing with 'the politics of identity'" were receiving much attention by the late 1980s, many of them subject to "ill-fitting interpretive contexts favor-

ing 'positive' identity formations—the transformation of abject representations of race, identity and ethnicity to the heroic" and contexts that "lumped together everything from folk and 'outsider' to conceptual and realist forms of expression." Joo continues, "Tangible, accessible, citable ethno/racial community formations were sought, at times created by artists, critics and institutions. Diversity had become marketable. By the early 1990s, the once radical call for the valuation of lived experience so often ignored [in] formal systems of historical narrative was being degraded by critics and artists alike as self-involved, overly objective, and in many cases, deviant, as 'identity' came to mean women, gays, and blacks/browns/yellows, infantilized."[55] Some artists feared that being classified as Asian American would segregate and confine them to their race or ethnicity. According to Alice Yang, it was becoming clear that the challenge was how to "undo the ethnographic tendency . . . to shift the emphasis away from race as a matter of mere content towards positions of greater complexity and specificity that encompass race as only one of the many components that both shape artistic practice and are addressed by it."[56]

In 1993, Godzilla asked artists, curators, and writers for their opinions about group shows dedicated only to Asian American artists. In the pages of the organization's newsletter, respondents argued about how even though Asian American group shows threatened to rivet the artists into suffocating spaces circumscribed by skin color, the "strategic essentialism" of safety in numbers was sometimes necessary in a race-obsessed culture just to get the work of racialized artists shown. Their responses revealed feelings of ambivalence, as seen in the response of installation artist Mo Bahc: "Asian American artists' exhibitions are the kind of shows that I am usually invited to be in. That is the biggest reason that I am in those exhibitions, not that I try hard to be in those shows. That is not to

Figure 36.
Mo Bahc
Untitled, 1993, wood,
acrylic, net, etc., 36 ×
20 × 12 in. each.

say that there are other kinds of show I want to be in, or that I am sick of another Asian American or Korean American show. I keep making art. And it is better to show than not to show."[57]

Certainly decentering race, as Alice Yang contends, might help bring into view other issues that "make up the complex terrain of identity," such as sexuality, nationality, religion, and class, and perhaps even bring the mutual constitutedness of these elements into view. But many Asian American artists insist that racialized identities cannot be ignored because the questions of who can make art and what can be seen remain as important as ever in an American art world where whiteness remains unmarked and Asian American artists are still seen as *not* American. Fully recognizing that Asian American artists walk the line "between the need for alliance and dialogue and the resistance to cliché and self-ghettoization" as they continue to be misunderstood, stereotyped, or ignored in mainstream society, Yang concedes that

> the wider dissemination of art by Asian Americans in this country is still fraught with contradictions and difficulties. At the same time that Asian American artists try to articulate their own position within this society, they run the risk of reducing it into a formulaic set of generalities. Trying to open up a space for critical discussion within their own community, they run the risk of isolation and segregation. But if they do not do all of this, then they also lose the possibility of articulating the distinctiveness of their experience and culture, and they run the risk of invisibility and incomprehension. Whatever they do, their position in relation to the mainstream remains highly ambivalent.[58]

Liberal multicultural agendas have conflated domestic racialized groups with international cultures, obscuring critical differences among and in racialized minority groups to support the false notion of a democratic and inclusive society where these groups already enjoy equal access and representation. In her critique of the September 1990 Los Angeles

Festival of the Arts, Lisa Lowe describes how "world" artists were brought from Java, Bali, New Zealand, and Ecuador and fetishized according to a "logic of commodification . . . concerned with 'importation,' not 'immigration'" that represented Los Angeles as "a postmodern multicultural cornucopia . . . a global department store" where Angelenos could forget about the impoverished African American, Chicano, and Asian immigrant communities just outside the door.[59]

Asian American art is not synonymous with Asian art. There are striking contrasts between the Korean and Korean American art featured in the 1993 Queens Museum exhibit *Across the Pacific: Contemporary Korean and Korean American Art.* Korean curator Young Chul Lee sees a similarity between Korean American artists who are "rootlessly drifting along the margins of [U.S.] society" and the Korean artists who "are strongly influenced by the West but [who remain] on its periphery."[60] But while the Korean artists contest the Korean establishment, their work expresses a sense of Korean citizenship, of belonging to a Korean nation and its sociocultural life, and of continuity with something understood as "Korean tradition" and the "Korean experience of modernity." According to Lee, "They all focus on trying to understand Korea at the end of the [twentieth] century," many of them by reconstituting a "Korean self" separate from Western culture in an attempt to challenge the center-periphery hierarchy between the United States and Korea.[61] Their work is accomplished in conversation with traditional Korean art forms, such as eighteenth-century portrait art and nineteenth-century folk art that features panoramic two-dimensional scenes of everyday village life. The social commentary directly addresses such issues as the destruction of farming communities and the patriarchal subjugation of women in Korean society. By contrast, the Korean American art expresses tentative, multiple, and sometimes contradictory identities and allegiances not bounded by the sense of direct cultural lineage or links to national selfhood expressed in the Korean art. Jinme Yoon's *Screens,* for example, is an installation composed of text fragments that trace the irregular movements of a daughter away from her immigrant mother as she loses one language and gains another. Byron Kim's monochromatic green paintings titled *Koryo Celadon Ceramics* refer to the *pisaek* or secret glaze color used by twelfth-century Korean potters. The secret of the glaze has long been lost and can never be replicated, thus, there can be no return for the Korean American. Kim's work converses with the work of American abstract artists, including Ad Reinhardt, as well as with that of minimalist Donald Judd. But he extends that conversation by troubling the boundaries between abstraction and realism for, as Thelma Golden has observed, his skin-color portraits can be seen as representational and even figurative.[62] Using melted crayons from the new politically correct Crayola shades, Kim brings traditions of abstract monochrome painting to a discourse on race that has divided the world into black, white, red, yellow, and brown. Subverting the universal meanings conventionally attached to Western abstract painting, Kim throws in the monkey wrench of race, an issue about which Mark Rothko's and Brice Marden's work is not concerned and which artists from Korea often dismiss as a "personal identity problem" that inspires "mere belly button–gazing" rather than a focus on important "political issues" like human rights, global capitalism, and art historical concerns in relation to the history of Korean art.[63]

Figure 37.
Byron Kim
Synecdoche, 1992,
oil and wax on panels
(204 panels), 10 × 8 in.
each. Courtesy of Max
Protetch Gallery.
(PHOTO: DENNIS COWLEY)

Figure 38.
Byron Kim
*Two Egrets with
Bamboo,* 1996, ink
on paper, irregular
$13^{15}/_{16} \times 10^{3}/_{8}$ in.
Whitney Museum of
American Art, New
York; purchase, with
funds from the Draw-
ing Committee 96.170.
(PHOTO: SHELDAN C.
COLLINS)

In an essay about critical misreadings of her first book, Maxine Hong Kingston notes that even though she wore a sweatshirt for the dust jacket photo "to deny the exotic," reviewers mistook her for a Chinese and *The Woman Warrior* for a Chinese book. Kingston wanted her work to be read next to the work of American writers William Carlos Williams, Walt Whitman, and Jack Kerouac, as well as Chinese American writers Frank Chin and Jade Snow Wong.[64] Asian American visual art likewise exists in relation to other American art, including other Asian American art, and to other Asian American expressive forms, including Asian American literature. Asian American art can be read not only in terms of content, message, ethnography, and biography but also in relation to Western as well as Asian art practices, and in accordance with critics' knowledge of conceptualism, minimalism, pop, feminist art, African American art, Chicano and Native American art, and other Asian American art.

The American roots of Asian American art are embedded in the story of race and racialization in U.S. life, including the little-discussed lateral relationships among racialized groups. Asian American art is imbricated in many other discourses, particularly cross-racial ones. It exists within the broader context of struggles for cultural definitions in other racialized American communities, such as the struggles against homogenization, decontextualization, curatorial eclecticism, and exoticization that Guillermo Gómez-Peña describes as occurring in Chicano cultural communities.[65] While African American art has been interpreted as "primitivist" and Asian American art has been subjected to orientalist expectations, Native American and Chicano art have been particularly susceptible to being thought of as ethnographic artifact. And the assumption that diversity and artistic quality are mutually exclusive has affected African American, Chicano, and Native American as well as Asian American art communities, which have at various times rejected purely formalist standards in light of the importance to so many artists of color of elements outside the artwork itself. As Lowery Sims has noted:

> There is no denying that the contributions of Black, Hispanic, Native American or Asian Americans have had an indelible influence on the flavor of American culture as a whole. But, if we continue to consume the products of these cultures while the populations within which they are engendered remain excluded, oppressed and exploited in the arenas of world and art politics, then as professionals and cultural consumers we can no longer maintain our smug self-images as social liberals, and must confront the inherent contradictions that permeate our chosen field of endeavor.[66]

African American cultural critics have pointed out that the preponderance of stereotypical representations of African Americans in American painting and sculpture, combined with the lack of respect afforded forms like quilting, sewing, carving, potting, and craft or folk art practiced by a number of Black Americans from the eighteenth to the twentieth centuries, helps explain the relative paucity of established African American artists.[67] African American art shares vocabulary and concerns with Asian American art in terms of effaced complexities and the imposition of binary oppositions between racialized identity and artistic practice. Richard J. Powell writes that African American art "makes a claim

for black subjectivity" but is not solely dependent on race and ethnicity, however important to an artist's personal identity. "Black cultural subjectivity in art . . . becomes design, word, act, attitude. . . . We can look at the art itself, its multiple worlds of meaning, its place in the social production of black identities."[68] As artist Raymond Saunders has commented, "Color is the means and not the end."[69]

Like African American cultural critics, Chicano art historians have argued for the reinsertion of elements such as narrative, decoration, figuration, and allegory into art. Alicia Gaspar de Alba emphasizes the importance of the vernacular, what she calls the *rasquache,* in Chicano art, which subverts the dichotomy between high and popular culture. Emphasizing the viewer's importance to contemporary Chicano art, she notes that thousands of *raza* across the United States never felt addressed or represented in an art museum until they attended the *Chicano Art: Resistance and Affirmation 1965–1985* exhibit, which ran from 1990 to 1993. For them, *rasquachismo* could become a weapon and a tool, as "a theory and praxis of popular pleasure as a uniquely working-class strategy of resistance to dominant aesthetic codes in the art world, otherwise known as the 'Quality' issue; . . . alter-Nativity, an antinativist approach that contests the ethnocentric academic practice of categorizing marginalized indigenous cultures and 'subcultures' or objects of discovery . . . [and that] underscores the relationship between 'other' and 'native.'"[70]

Instead of viewing Asian American art as either soullessly copying "American" art forms or imperfectly replicating "real Asian art," perhaps we can think of it—and of American art in general—as a mixture or partial fusion of different visual languages, and critical assessments can at last move away from the economy of the copy to the narrative of similarity. Located on the untranslatable, incommensurate in-between, in the interstice between mainstream and Asian American (as opposed to Asian) cultural traditions, perhaps Asian American art can be thought of as a site of creation, contradiction, and conflict emerging from the continual collisions and transformations that comprise Asian American cultural experiences.[71] Perhaps the question to ask is how Asian American art has expressed and continues to express a hybrid or even mutant culture that engages, extends, and transforms American art.

Many Asian American artists express their dismay that both mainstream and Asian American art critics and curators are reading their work as literal expressions of biography or sociology.[72] Noting that autobiography is too frequently used to authenticate their work, as if speaking from personal experience were the only allowable position, they say they want viewers to think about not only *what* they are doing but also *how* they are doing it.[73] Yong Soon Min complains that the Asia Society organizers placed obtrusive, interfering wall labels very close to each work at the *Asia/America* exhibition. This wall text, which included bullet-point lists of biographical details about the artists and the artists' statements, was reminiscent of the informational captions displayed in natural science or ethnography exhibitions. According to Min, some of the participating artists objected to the wall text because they feared that their work would be flattened by "curatorial editorializing" aimed at accommodating mostly white viewers to whom the work was unfamiliar and opaque: "It can be seen as a capitulation to the lowest expectation from this or any other audience. In the hyperbole of one viewer, '[A]t the preview, I watched the Manhattan press corps shuffle from label to label, as though paralyzed by doubt.' Might these la-

bels inadvertently suggest that the works are so alien and so incommensurate with other contemporary art that they need the extra information to bridge the otherwise unfathomable gulf?"[74]

In objecting to "the burdensome overlay of encapsulated information," Min does not argue for a "return to the modernist emphasis on [the] primacy of form" over content but rather for recognition that art locates the personal "within the cultural, social, and historical forces that construct the self [and in] relation to the historicized collectivity."[75] Indeed, many Asian American artists demonstrate how formal innovation and complexity can be integrated with "message" and content and how content leads to or even requires formal innovation. Sometimes this involves inventing new forms by blending various formal approaches. Y. David Chung brings together elements of German expressionism, African and African American folk stories, social realism, Japanese *anime,* and Korean folk art to express the collision of past and present, Korea and America as experienced by the young immigrant. Shahzia Sikander combines Western pop and folk art forms with traditional Indian miniature painting to express themes of contemporary dislocation. Manuel Ocampo mixes his interpretations of baroque, kitsch, and pop art to challenge distinctions between Western and non-Western or high and low art and to critique Catholicism and U.S. imperialism in the Philippines. Using paper, paint, plaster, and hair and pieces from an old rug, Allan deSouza creates "landscapes" that call into question the hypostatized "homeland" yearned for by many immigrants. Graphing together architectural catalog models and industrial designers' ergonomic templates of the female body to demonstrate

Figure 39.
Sowon Kwon
average female (4), 1995,
blueprint on linen, 8 × 8 ft.
Courtesy of the artist.
(PHOTO: SEONG H. KWON)

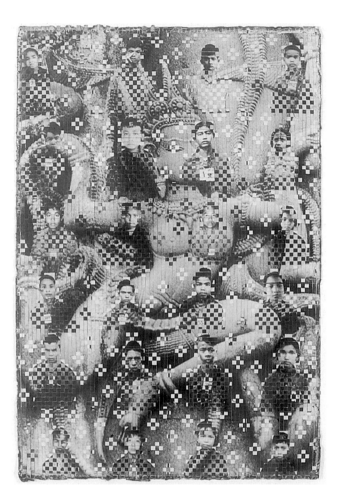

Figure 40.
Dinh Q. Le
Apsara, 1997, C-print and
linen tape, 19$^1/_2$ × 29 in.
Collection of Jeff and
Jennifer Hurlow.
(PHOTO: MICHAEL HONER)

how the woman's body is stuffed into a cramped interior space, Sowon Kwon integrates
medium and message, which the viewer can interpret as being about gendered imprison-
ment or perhaps about how already cast molds delimit freedom and possibility for the
racialized immigrant, who is exhorted to squeeze herself into an "American" mold.

Dinh Le cuts his photographs into long strips, which he weaves into objects that look
like painting, a technique adopted from his aunt's grass-mat weaving, which he watched
as a child in Vietnam. But his photograph weaving is by no means an "ethnic craft tech-
nique," a quaint "Vietnamese" survival. It is a new form he has created to express his in-
terest in what he calls "jarring experience" in both form and content: contradictions, para-
doxes, and border crossings that combine old weaving and contemporary photographic
techniques, Christian and Buddhist iconography. His patterns are based on the images he
wants to create, with certain elements more visible and others more hidden. Dinh's art-
work brings together disparate elements, turning the tables and performing the unex-
pected. In the 1997 series titled *The Headless Buddha,* he fuses contradictory sets of im-
ages of what is best known about Cambodia in the West, using Khmer Rouge photographs

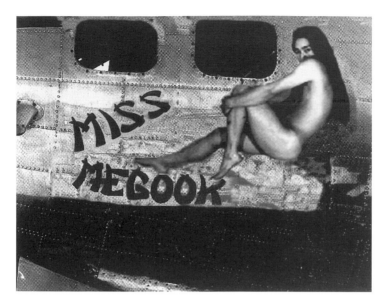

Figure 41.
Michael Joo
Mongoloid-Version B-29,
1993, computer-
manipulated IRIS print
(detail), multimedia
installation, dimensions
variable. Production
collaborators: L. Letinsky
and N. Newman.
Courtesy of Anton Kern
Gallery, New York.

of people condemned to die and of Angkor Wat. The eyes of the prisoners stare out at the voyeuristic viewers who know, as the condemned do not, what will happen to them. In the interview published in the *Headless Buddha* exhibition catalog, Dinh indicates a desire to photograph in the future both headless statues of Buddha in Cambodia and the heads in U.S. museums. Bringing the severed heads and the headless bodies together in an installation might inspire thoughts not only about partition and decapitation but also about how contested cultural, religious, commercial, and aesthetic meanings are created and impinged upon according to differential power relations in different political and geographical sites.

Asian American artists actively engage with other American artists, bringing new meanings to American art with their unique perspectives and issues. For instance, Lynne Yamamoto's work invokes Japanese American women's lives, brushing against the grain of orientalist fantasies about Asian women. In *Wrung,* from one of her installations, Yamamoto combines materials that juxtapose contradictory stereotypes of Asian women as sultry sex objects and drudge laborers by pressing long, straight black hair through a laundry wringer. That the laundry worker referred to in this piece is Yamamoto's grandmother, a laundress who committed suicide, is important but should not prevent the viewer from noting the formal complexity of the work. Yamamoto, like Eva Hesse, uses unconventional "soft" materials, such as latex, fiberglass, and other found materials, to suggest bodily forms and functions, and like Hesse's work, Yamamoto's *Wrung* is profoundly sensuous and imbued with emotional power despite its minimalist sensibility. Michael Joo employs scientific language and materials to call into question the objectivity of science and technology. Citing the influence of Richard Serra, along with Robert Smithson and Joseph Beuys, Joo engages contemporary American art forms to complicate notions of race. In the Miss Megook decal in *Mongoloid-Version B-29,* which was created for the 1993 Venice Bien-

nial, Joo critiques the United States' racist imperialism in Korea. Joo's use of Plexiglas tubes filled with MSG suggests stereotypes of Asian deceptiveness. Placing the image of the Asian male (Joo himself, nude and concealing his genitals) as a pinup to be admired by a heterosexual consumer of otherness interrogates the racist notion that Asian men are asexual or sexually ambiguous. The artist's long black hair exposes colonial fantasies about Asian female sexuality. And the use of nose cones from actual American cargo planes brings into view the Korean War, in which Korean women's sexuality was commodified and Korean people's lives were disposable.

Young Los Angeles–based fourth-generation Japanese American sculptor Glenn Kaino is inspired by Marcel Duchamp's challenge to the primacy of form over function in art, as well as by American modernists' emphasis on distilling complexity into pareddown, efficient simplicity. In his installation *Fishing with Morice* (2001), Kaino extends the quintessentially American impulse to choose democracy and practicality over hierarchy and extravagance and engages with mainstream Western sculptural traditions by making an unlikely comparison between them and West Coast Japanese American cultural practices. The work features twelve oversized reproductions of late-nineteenth-century fishing lures crafted of vacuformed plastic with lacquer and metal on wood. At this magnified scale, the curved lures recall the work of Romanian sculptor Constantin Brancusi, who was noted for his masterful reduction of natural form into essential lines. Like many Japanese Americans, Kaino is from a fishing family. Fishing lures were first developed around the turn of the last century. Contemporaries of Brancusi, the Japanese American fishermen were engaging in reductive sculptural practice, making us ponder why the sculptor is heralded while the maker of fishing lures is not.

**Figure 42.
Glenn Kaino**
*Fishing with Morice #6
Silver Sizzler,* 2001,
vacuformed plastic,
lacquer, and metal on
wood, 58 × 13$^1/_4$ ×
13$^1/_4$ in. Courtesy The
Project, New York and
Los Angeles.

Asian American artists like these should be studied by Asian American studies scholars, who have generated long lists of books on Asian American history and literature but have produced very little serious writing about Asian American visual art. Perhaps contemporary Asian American artists, many of whom are located on the East Coast, have been neglected partly because so much of the foundational scholarship in Asian American studies is rooted in the history of Asian Americans on the Pacific Coast. Or perhaps Susette Min is correct in suggesting that visual art was ignored in Asian American studies scholarship

because visual culture and visuality, such as through the media of photography and film, have traditionally been regarded with suspicion as colonial tools of silencing and deracination.[76] It is certainly true that for almost two centuries Asians have been represented visually in the West, first in books and drawings, then in cartoons, comics, and magazines, and finally in films and on television, as grotesque stereotypes.[77] But Asian American studies' neglect of visual art might have as much to do with its vexed relationship to the U.S. art establishment as with its alleged ignorance and inability to theorize and thereby get beyond realist, transparent surfaces that need equally transparent antidotal "correction."

Unlike visual art, Asian American literature as such was recognized well before debates about essentialism and identity politics raised important questions about racial categorization. Asian American literature began to be widely recognized after the success of Maxine Hong Kingston's *Woman Warrior* in 1976. By the time Amy Tan's *Joy Luck Club* was published in 1989, publishers, calculating the possibilities of niche markets and specialized lists, were actively soliciting Asian American literary work. Many educators, obliged to address more and more Asian American students (whose families immigrated in exponentially increasing numbers after immigration quotas were changed in 1965), had more or less accepted Asian American literature as a viable "field" or "sub-field" in college curricula. Also, since literature is textual, it is more easily absorbed into academic disciplines, while visual art is still not viewed as a "discipline."

Although contemporary Asian American art emerges from and speaks to cultural and social conditions that include the already established existence of something understood as "Asian American culture," Asian American visual artists operate within the specific context of an art establishment that differs in important ways from its literary counterpart. The art world's institutions, which consist of museums, galleries, and magazines, and its individuals, comprised of curators, critics and writers, collectors, and dealers, are comparatively tight and closed. Breaking into the charmed circle is no easy task: an artist's work must be exhibited if it is to be reviewed; it should be reviewed if it is to be sold; it should be salable if it is to be exhibited, especially since art often functions as a speculative commodity. Blockbuster books produce gigantic profits for publishers, but while the majority of books are not bestsellers, schools and libraries provide huge markets for imaginative writing, both "classic" and contemporary. Unlike book prices, the price of artwork can become a prime factor in its critical assessment, which, cultural critic Daryl Chin contends, helps explain why art auctions are reported as part of art news.[78] Moreover, although museums are supposedly public, they are influenced by what private galleries show, and art collectors who buy from galleries often sit on the museum boards and committees at museums, advising them (and being advised by them) on what to collect.[79] According to the Guerrilla Girls, the New York–based activist artists' collective, "Gallery owners, collectors, critics and museums . . . back certain artists. Once enough money has been invested in a certain artist, everyone mobilizes to keep that artist's name out front and consequently in history. The artists who make it in this way begin to define quality."[80] As with film stars and athletes, one visual artist among many might become a celebrity who can determine her or his conditions of work, but most are vulnerable to, indeed at the mercy of, the vi-

cissitudes of a market oriented toward the fickle attentions of profit-driven art establishment elites.

Andrew Ross laments that the art world's "race to privatization," begun during the highly speculative 1980s and continuing until the present, has occurred at the very moment when genuine attempts were finally beginning to be made to democratize public culture and diversify its participants, its content, and its reach to a wider range of communities. Describing the "business structure" of the contemporary art world—the gallery system, the art market, the glorification of authorship, the control of access and participation, the uses of fine art values to police class divisions—Ross notes the state's "final recognition of the art world as a medium for transferring, circulating, and generating capital" through "private investments in the name of public interest."[81]

This context has been particularly detrimental to artists of color historically unable to gain access to the American museum, which art historian Judith Wilson has called "one of the last bastions of white supremacy-by-exclusion."[82] In her study of the 1980–87 exhibition records of the Brooklyn Museum, the Solomon R. Guggenheim Museum, the Metropolitan Museum of Art, the Museum of Modern Art, the Queens Museum, and the Whitney Museum of American Art, artist Howardena Pindell found that with "very few exceptions," artists of color face an industry-wide "restraint of trade" that limits their ability to show and sell their work.[83] PESTS, a group of New York–based African, Asian, Latino, and Native American artists, arrived at similar conclusions, publishing a roster of sixty-two top New York galleries whose "stables" were all or almost all white.[84] Pindell also notes that "boards of art museums, publishers of art magazines and books and owners of galleries rarely hire people of color in policy-making positions . . . [so that] the task of cultural interpretation . . . is usually related to 'people of European descent,' as if their perspective was universal."[85] For Pindell, this situation spells disaster because so many European American critics' background knowledge is inadequate to the task of discussing the work of artists of color.

Maurice Berger agrees that the museum is "one of America's most racially biased cultural institutions." Noting "at least some effort" on the part of white people to share venues with African Americans and other people of color in music, dance, literature, and theater, he posits that "the visual arts remain, for the most part, stubbornly resistant," preserving instead "the narrow interests of their upper-class patrons and clientele." Race discrimination, according to Berger, explains why established African American artists like Faith Ringgold and the late Romare Bearden have been kept from "the super-star status available to white artists of equal (or less than equal) talent," and why accomplished Black artists like Pat Ward Williams have had more trouble finding gallery representation than white artists of equal stature.[86] Daryl Chin asserts that this racial double standard has been applied to Asian American artists as well, explaining how famed video art pioneer Nam June Paik found American universities unwilling to give him salary and benefits comparable to those offered such white artists as Allan Kaprow, Ed Emshwiller, and Robert Morris.[87]

The extent to which popular racial attitudes permeate the rarefied world of art and art criticism can be seen in the kinds of emotional fury expressed in the generally negative

critical response to the 1993 Biennial of the Whitney Museum of American Art, which had been receiving criticism from cultural activists in African American and other communities of color for more than two decades for practicing "racial apartheid." The art establishment's brief flirtation with "multiculturalism" ended in the wake of the Biennial that year, when a curatorial team led by Elizabeth Sussman selected for exhibition many works by female and gay artists and artists of color, apparently mostly on the basis of content. The critical response was both fierce and furious. Many reviewers objected to what they saw as a privileging of "social message over esthetic considerations." They decried the selection of artwork lacking in craftsmanship or formal excellence as well as intellectual rigor and theoretical substance. Eleanor Heartney characterized the artwork as "numbingly didactic."[88] Richard Ryan found it "childish . . . charmless . . . a self-indulgent PC fest" and "merely a bunch of dull, talentless experiments" in what Roger Kimball called "preening ethnic narcissism."[89] Robert Hughes described the exhibition as "one big fiesta of whining agitprop."[90] John Taylor dubbed the exhibition "mope art," an "extended exhibitionistic frenzy of victimization and self-pity."[91] Arthur Danto found the work "strident . . . noisy, disheveled, disordered, menacing and arrogant" and dismissed it "in the aggregate" as "mawkish, frivolous, whining, foolish, feckless, awful and thin . . . [on the] level [of] the bumper sticker."[92] Carol Strickland snickered at the show's apparent inclusiveness; it was supposed to "look more like America, or at least like a waiting room at the Immigration and Naturalization Service."[93]

The exhibition was attacked for being a bad idea and for showcasing bad art. Whatever the arguments about the work selected and presented by Sussman and her team, the intensity of critics' rage as expressed in their reviews can be viewed in part as being about the marginalization of their formalist training and the currency and popularity of political content in contemporary art. It can also be seen as reflective of a common attitude shared by many people in the United States who are not art critics and intellectuals and who are for that matter not even formally educated: outrage and anger against racialized Americans who are taken as threatening the centrality of white racial dominance by undermining "accepted standards of excellence" with their shallow stupidity, their confrontational and sometimes menacing harangues about their "awful" victimization, ostensibly by white people whose heroism is thus called into question, their self-pitying stories about their experiences of victimization, presumably at the hands of white racists, and their arrogant refusal to acknowledge their racial inferiority. California-based artist Daniel Martinez's "I can't imagine ever wanting to be white" exhibition admission tags were read flatly as expressions of racial hatred aimed at humiliating and embarrassing white visitors.[94] The critics do not seem to have considered the unspoken assumption that a white person would not want to be not white as emblematic of racial hatred, or to have viewed the more popular assumption that people of color actually want to be white as a humiliation, since it was only Martinez's words that raised questions about white predominance in the existing racial order.

The fundamental issue that connects art concerns in racialized art communities is the need for democratization of art in America. If, as Thomas McEvilley contends, the primary social function of art is to "define the communal self," the museum is a "historically

layered picture of the self in a culture," and the exhibition is a "ritual attempt to bond a community around self-definition," what is considered "art" in the commercial art world does indeed make assertions about a collectivity, with universal validity implied.[95] Gender, race, and age underlie and shape value judgments. If museums produce ideologies that shape the way we see history and other cultures and reinforce the notion of taste as inborn and universal, transforming cultural rights into social privileges by validating a certain group of people and a certain way of life over others, then it is always dangerous to divorce art practice from its social and political contexts, and class, race, gender, and sexuality should be foregrounded in our study of art without another thought.

Calling for "de-chauvinized" culture, Guillermo Gómez-Peña advocates democratization of art: "To be avant-garde in the late 1980s means to contribute to the decentralization of art. To be avant-garde means to be able to cross the border; to go back and forth between art and politically significant territory, be it inter-racial relations, immigration, ecology, homelessness, AIDS, or violence towards women, disenfranchised communities, and Third World countries. To be avant-garde means to perform and exhibit in both artistic and non-artistic contexts: to operate in the world, not just the art world."[96]

In his discussion of the New York Museum of Modern Art's re-opening in 1984, Douglas Crimp notes that the helicopter leading into the design galleries was manufactured by Bell, the major defense contractor supplying helicopters used in Nicaragua, Guatemala, El Salvador, and Honduras in the 1970s and 1980s. He also notes that the *New York Times* critic writing about the installation failed to mention what so many people in the contemporary world think of when they see helicopters—the U.S. military abroad, in Southeast Asia and Central America, and FBI and police surveillance in poor communities of color across the United States. Instead, separating the "political" from the "aesthetic," the critic rhapsodized about the helicopter as "bright green, bug-eyed, and beautiful," adding, "We know that it is beautiful because MOMA showed us the way to look at the twentieth century."[97] This critic's comments, which adhere to what Maurice Berger has termed the "high modernist canon of apolitical lyrical abstraction,"[98] demonstrate the cost of denying that meaning exists outside of a work by emphasizing only form and help make clear how important "alter-native" American art, such as the work being done by Asian American and other artists of color, is. As a start, this art can challenge the notion that art is by definition neutral, exclusive, aesthetically transcendent, and autonomous.

The increasing integration of art and capitalism is transforming the old oppositions between elite high culture and mass or popular culture into tensions between public and private. These tensions have placed artists of color in the interstice as diversity has become a key funding source for museums as public spaces charged with the task of educating people about "culture." Museums have often responded to funding for diversity by insisting on work that is recognizable as having been produced by artists of color or women or queer artists, thereby encouraging reductive simplification, flat thematics, and autobiography as interpretation. This is a self-fulfilling prophecy in that critics who dismiss Asian American art as work that is autobiographical choose work that is autobiographical for them because it is familiar. The documentation bias seems to be in the mainstream critical reception rather than in the production.

In his essay "New Ethnicities," Stuart Hall discusses the shift away from the "essential black subject" of the Black Arts Movement in Britain in the 1960s and early 1970s. He argues that the abandonment of essential categories does not mean giving up one's "essential commitment to the project of the politics of black representation." This commitment is to address the relations of representation that perpetuate and rationalize inequality and injustice. Hall refers to his late-1980s debate in the *Guardian* with Salman Rushdie about the work of some contemporary Black British filmmakers:

> I certainly didn't want Salman Rushdie to say he thought the films were good because they were black. But I also didn't want him to say that he thought they weren't good because "we creative artists all know what good films are," since I no longer believe we can resolve the questions of aesthetic value by the use of these transcendental, canonical cultural categories. I think there is another position, one which locates itself *inside* a continuous struggle and politics around black representation, but which then is able to open up a continuous critical discourse about themes, about the forms of representation, the subjects of representation, above all, the regimes of representation.[99]

Hall calls for a "political criticism" that takes into important account "the signs of innovation, and the constraints" under which Black artists operate.

Asian American cultural expression and criticism have also moved away from insistence on congealed identities and substitution of the "positive" as the main means of contesting omissions, distortions, and other manifestations of dominant regimes of representation. At the same time, commitment to a cultural politics that challenges, resists, and hopes to transform those regimes has been retained. As artist and activist Richard Fung has stated, "Now is not the time to waver from commitment. More than ever it is important to stick to principles, forge new alliances, develop more sophisticated strategies; press for change, make art and circulate it."[100]

In complex, witty works of great beauty and technical ingenuity, young Asian American artists are exploring how art can examine and push the traditional boundaries of race and identity discourse. Glenn Kaino calls his large multimedia installation *Chasing Perfect: You Are Now About to Witness the Strength of Street Knowledge* (2000), a period piece about the futility of ethnic-specific discourse. The work refers to the potential for significant radical change that is wasted when ethnic groups work against each other, not recognizing the tactical dynamics they could share. This labor-intensive installation features six perfectly crafted remote-controlled wooden tugboats floating in Plexiglass tubs filled with water and placed on wooden stands. The boats, which fan outward and face different directions, are all tied to a large, comical set of gold-capped teeth inscribed with the words "street knowledge" and resting on a tasseled red velvet pillow. The scene is specifically local: sixteen-foot curved reproductions of the Los Angeles horizon, complete with palm trees, surround the boats as a backdrop. When thinking about the small boats moving as vector opposites pulling against each other, Kaino recalls the lack of significant panethnic collaboration in revolutionary civil rights strategies: they pull the gold in opposite directions and consequently go nowhere. The boats simultaneously call to mind both com-

munity leaders and captains of industry, each group vying to subvert the other. When the boats move forward, they pull the teeth apart, fragmenting a potential source of commonality. While humorous, this work is about tension and contradiction. According to Kaino, it is meant to "provoke . . . simultaneous inquiry into the source of struggle and the strength of solidarity, historical goals, and the futility of work."[101]

Kaino is interested in momentum, strategy, engineering, and, ultimately, in the futility of such efforts. His work subverts its own elegant craftsmanship, technical virtuosity, and engineering skill by placing them at the service not of industry or progress but of social criticism, race consciousness, quirky playfulness, and boyish manias. His very specific cultural sources include Hollywood films and production processes, Zen Buddhism, comic books, martial arts, East L.A. youth culture, nisei fishermen, cars, the worlds of both hip-hop and surfing, toy models, digital technology, and Japanese woodblock prints.

Portending what is surely in the future for Asian American arts and culture, Kaino makes a point of collaborating with other artists of color and of working, often simultaneously, in as many genres as possible. As of this writing, he has just finished a five-year gallery project called *Deep River* with Southern California Chicano artist Daniel J. Martinez and designer Tracey Shiffman and is writing and producing a film about Daniel titled *Between Dog and Wolf* and working on a 3–D video re-creation using the choreography of the Bruce Lee–Kareem Abdul Jabar fight in the film *Game of Death*. In the re-creation, Kaino will duke it out with Los Angeles African American painter Mark Bradford in a cross-racial, cross-genre encounter.

Artists who identify themselves as Asian American challenge the notion of a homogenous "American" culture. Exploring subjectivity in all its complexities and contradictions is not necessarily a clichéd descent into identity politics. It could also constitute a critical contestation of the kinds of sameness global capitalism is creating as it transforms people and communities around the globe to suit the needs of transnational corporate interests. People create culture to express their thoughts and feelings in complex, mediated responses to diverse historical circumstances, which in turn are shaped as their consciousness shifts in an ongoing mutual relationship between ideas and material conditions. Writing about fashion and theater, Dorinne Kondo has characterized the world of representation and aesthetics as "a site of struggle, where identities are created, where subjects are interpellated, where hegemonies can be challenged."[102]

Rethinking the importance of Asian American art as process, not exotic artifact or investment item, so that we can appreciate both the political identities it expresses and the aesthetic processes that are inseparable from these identities, inspires the creative expression of Asian Americans who have felt excluded by particular forms of racialization from conversations about American culture. It might also lead to a long overdue reevaluation of the impact of the artistic output of various racialized American groups on "American art." At the same time, it could help us all more clearly recognize our own potential to break the invisible bonds that hold us as unwitting slaves in our individual cells, apart from one another, devoting our work and creative potential to enabling the commodification of and sale to the highest bidder of whatever brilliance, beauty, and community we manage to create.

I conclude with some comments about the boundary-breaking visual work of Theresa Hak Kyung Cha, not only because of the beauty and community it expresses and inspires, but also because her work, though not widely known in the commercial arena, has been fought over by various parties that wish to claim it for themselves. The contenders include both Asian Americanists who believe that Cha's identity as a gendered and racialized Korean American is crucial to the understanding of her work, as well as historians of avant-garde art who, like some of the critics of the 1993 Whitney Biennial, fear that brainless advocates of "identity politics" will flatten and reduce her work with their "disheveled," "mawkish," "bumper sticker"–level readings.

No literary or cultural critic worth her salt would classify Cha's 1982 book *Dictée* as simply another artistic expression of postmodern fragmentation and indeterminacy. Appreciating *Dictée* demands specific knowledge of history and the politics of race, gender, and colonization that this work addresses with both form and content. Moreover, like other Asian American artists, Cha writes into a politics of representation that includes a long history of orientalism as well as the putative "burden of representation" that cultural theorists like Kobena Mercer and Stuart Hall address so cogently. And finally, Asian and Korean American artists write into the specific cultural politics of their communities, such as tensions between cultural nationalist and feminist concerns, questions of nation and postcoloniality in minority discourse, and differential racial formation across decades and locations among internally diverse groups.

Like her writings, Cha's intensely personal, political, and poetic visual artwork draws upon a wide spectrum of materials and sources, including film theory, linguistics, mythology, history, and poetry. Elaborating on the work of film theorists like Jean-Louis Baudry, Christian Metz, and Thierry Kuntzel, she explores the relationship between cinema and dreams, deploys notions of layering, residue, and the unseen or unconscious, and focuses on the relationship between the filmmaker and the spectator by bringing into view the point of splice where a film's individual frames are joined to create the illusion of seamless fluidity. At the same time, her artwork refers repeatedly to Korean history and politics and focuses intently on the displacements brought about by colonization, war, and partition. But instead of trying to forge a congealed Korean or Korean American identity, Cha destabilizes equivalencies that demand binaries and polarities. For instance, in *Passages Paysages,* a three-channel video work produced as her M.F.A. project in 1978, the past seems to be lamented, "as good as gone," with the lit and the extinguished marking the passage of time. But the voice-over repeats various grammatical formations of *light* and *extinguish* by substituting different suffixes to the agglutinative Korean verbs ("Turn off the light," "Have you turned off the light?" "I have turned off the light," "Turn on the light," "Try turning on the light," etc.). The image of the hand on the screen, which opens and closes, does not "match" the words being spoken, nor are the French words spelled in white on a black screen dissolving into each other equivalent to any sound uttered alongside or superimposed on them. Male and female voices overlap, reading letters in French, Korean, and English that are not equivalent. Cha has written that she was "looking at the roots of language before it is born on the tip of the tongue," at what was not said and not seen, and that she was interested in language as someone who had been "forced to learn languages

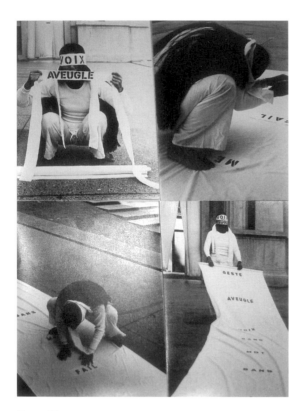

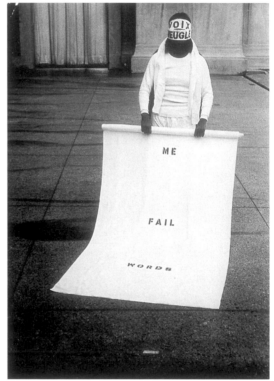

Figure 43.
Theresa Hak Kyung Cha
Aveugle Voix, 1975,
performance still, $9^1/_2 \times 6^3/_4$ in.
Collection of University of
California, Berkeley Art
Museum. Gift of the Theresa
Hak Kyung Cha Memorial
Foundation.

Figure 44.
Theresa Hak Kyung Cha
Aveugle Voix, 1975,
performance still (detail), $9^1/_2 \times$
$6^3/_4$ in. Collection of University
of California, Berkeley Art
Museum. Gift of the Theresa
Hak Kyung Cha Memorial
Foundation.

more 'consciously' at a later age. . . . Certain arenas that continue to hold interest for me are: grammatical structures of a language, syntax. How words and meaning are *constructed* in the language system itself, by function or usage, and how transformation is brought about through manipulation, process as changing the syntax, isolation, removing from context, repetition, and reduction to minimal units."[103]

In *Passages Paysages,* language is manipulated, juxtaposed, reduced, repeated, removed from context, and changed over time. By situating the viewer in the space between the words on the screen and the words on the sound track, Cha raises the question of how words convey meaning, or indeed even whether they are sufficient to do so. The gap between image and sound is analogous to the gap between the unnamed origin and unknown destination of the exile. Cha experiments with video technology to explore the exile's yearning to reenter the unrecoverable past and her attempts to imagine a homecoming that can never take place. With video, we can play and replay memories in our attempt to recover lost time, but ultimately there is no return. Cha deploys lightening and darkening, blurring, dissolving, fading, and repeated stutterings in three overlapping languages—French, English, and Korean—to suggest how the exile's struggles to remember are caught in the suture between the unoccupied houses of sender and receiver. At the same time, community is created between the sender and the receiver and between the artist and her audience.

Ultimately, despite the common view that the "mother tongue" is the fount of identity, language for Cha is not reliable as a cultural signifier, and the past drifts away like a dream. This means not that identity and the past are irrelevant or unimportant but rather that the polarization of past and present, here and there, Korean and not Korean are dissolved to reveal the splice, the autonomous in-between.

A few remnants remain from Cha's *Aveugle Voix* performance in San Francisco in 1975, including ten $9^1/_2$-by-$6^3/_4$-inch black-and-white photographs, fragments of a totality that can never be recovered. In the photographs, Cha's eyes are covered with a strip of white cloth onto which the word *voix* (voice) has been stenciled in black ink. Over her mouth is tied a piece a cloth reading *aveugle* (blind). Cha unrolls a large cloth like a scroll, which,

Figure 45.
Theresa Hak Kyung Cha
Pomegranate Offering, 1975, stenciled ink and typewritten text on cloth with thread, $14^1/_2 \times 14^3/_4$ in. Collection of University of California, Berkeley Art Museum. Gift of the Peter Norton Family Foundation.

like the headband, can be read from both ends. We stare at the official-looking black block letters: *aveugle voix sans mot sans me.* Blind voice? The eye that hears? Blind voice without word? Voice without word? Without word, without me? Me without word? Without word, without voice? Blind without voice? This is no faithful document. The scroll stymies attempts to read it linearly by "progressing" in the usual spatial-temporal mode from "start" to "finish." The words can be read both alone and as part of the composition, which also includes the artist's body, which forces us to consider the affinity between the art and the artist, whose long black hair, so often the metonym for the Asian woman, rolls down her back like a scroll.

Art is inspiring because it can offer us new visions of the world and of ourselves. That this is often said makes it no less true. While work by early Asian American artists might have been tolerated as harmlessly exotic, today's critics have at times tried to stifle and dismiss what they read as social protest or preoccupation with shallow identity issues and concerns in Asian American art by denigrating both medium and message. But the Asian American artists brought together here refuse to separate new aesthetic practices from expressions of alternative cultural and political values that emerge from the particular location of Asian Americans within U.S. and world cultures. Location on the interstices of Asia and America, of black and white, of cultural nationalism and feminism, of aesthetics and politics, makes it possible to view the world from several different vantage points at the same moment. This double and triple vision engenders in Asian American visual art *fresh* and *daring* expressions of great beauty and feeling as well as invaluable critiques of contents, forms, subjects, and regimes of representation.

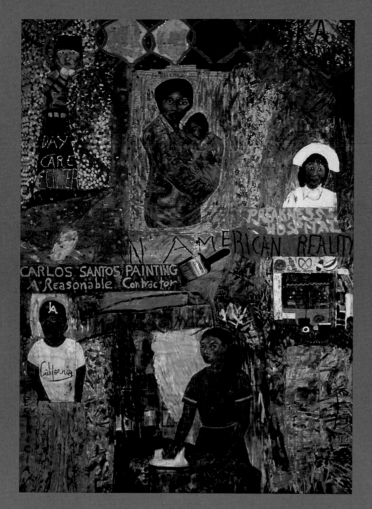

Plate 1. Pacita Abad
I Thought the Streets Were Paved with Gold,
1991. Acrylic, oil, wood, bristle, printed cloth,
collage on stitched and padded canvas,
95 × 69 in. (PHOTO: JASON HOROWITZ)

TRAPUNTO, **ACCORDING TO PACITA**
Abad, is "an Italian word that means to put stuffing into, to fill and then to sew" (interview with Rachel P. Mayo, *Manila Times,* February 14, 1991). The technique is her own invention, a way to make an accessible, frameless (and thus portable) art of the people. In the Philippines, sewing is a traditional part of family education, a technique that anyone can take up and understand. It also provides a more open and flexible context into which to incorporate other indigenous techniques and materials. Unlike traditional European stretched canvases, the trapunto works are easy to roll up and transport. As such, they are designed to both reflect and accommodate the migratory experiences that characterize the lives of

Filipino and other Asian emigrants. Abad uses bright colors, found objects, and materials collected during her travels around the world to communicate her commitment to rejuvenating and transforming indigenous artist traditions from such nations as Indonesia, Thailand, Bangladesh, and the Sudan, as well as the Philippines. These varied influences are a product of her extensive travels and sojourns, giving rise to work that is simultaneously indigenous and international in feel. She combines these seemingly opposite qualities because she is at once firmly rooted in her own native Philippine traditions and in an emerging international consciousness that seeks independence from the conventional Western definitions of art and culture.

In *I Thought the Streets Were Paved with Gold,* Abad uses bright crayon-like colors and a simple style that liken the immigrant's American dream to a child's viewpoint. Enticed by the promise of easy riches, the immigrant finds herself trapped in what Abad calls "an unrelenting cycle of low-paying jobs." Women from the Philippines today are migrating to countries all over the world to labor as domestic workers and send their hard-earned wages home to support large extended families. Once in America, they dream of Ivy League universities and luxurious consumption, but the women in this painting are shown as caregivers—nurses, maids, and child-care workers—while the lone man is a day laborer.

Plate 2. Kristine Yuki Aono
Relics from Camp (detail), 1996. Mixed media installation, dimensions variable.
(PHOTO: STEPHEN A. GUNTHER)

PERHAPS ONE OF THE MOST POIGNANT items displayed is the Tule Lake baseball uniform. It is ironic that Tule Lake, the camp that was designated as a segregation center for "dissidents" and known for its protests and riots would also foster participation in that most American of sports, baseball. (See Bill Hosokawa's description of Tule Lake in *Nisei: The Quiet Americans* [New York: William Morrow, 1969], 377–378.) The other objects—photographs, dolls, zoris (sandals), tools, articles of clothing, and various other items—are also powerful testaments, not only to the reality of the camps, but to the internees' perseverance and determination to maintain and enjoy life's simple pleasures even while surrounded by barbed wire and armed guards. By situating these everyday objects on the ground, Aono presents the historical legacy of the camps as "grounded" in an undeniable physical reality, extending and embodying the internees' humanity beyond the subjective realm of memory.

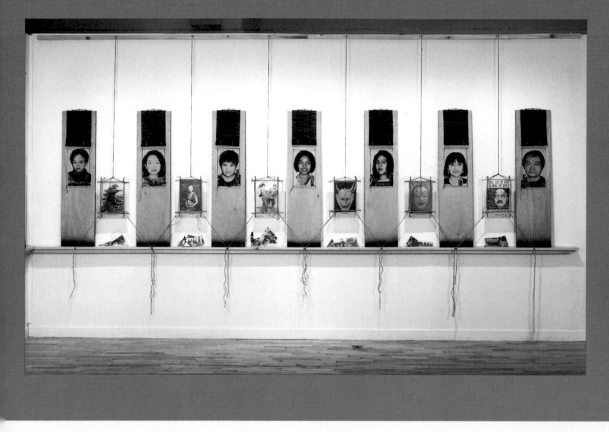

IN *FRAMING AN AMERICAN IDENTITY,* Arai explores the complexity and hybridity of contemporary Japanese American identity. Applied directly to the surface of wooden planks, the photographic portraits of Japanese Americans of mixed heritage (and various ages) possess a natural, tactile quality, as if ingrained in the wood itself. Rolled-up bamboo shades hang above each portrait as if to suggest that a private, interior self has been temporarily revealed. In between the planks and suspended from above, sheets of cracked glass bear other kinds of "portraits"—racist and stereotypical images of Asians from a variety of historical and pop cultural sources. In stark contrast to the solid physicality of the portraits on wood, these images appear translucent and fragile, penetrated by light and held together only by thin strands of tightly wound twine. They are suspended in front of but below and in between the portraits, creating a visual and physical contradiction. The portraits on wood lean back away from the viewer, but register a more solid physical presence, addressing the viewer at eye level; the stereotypical images on glass advance toward the viewer but are ultimately ephemeral and are at a lower level than the wooden portraits. This contradictory arrangement draws the viewer's eye in and out and up and down and around the piece, creating a web of associations that parallels the complex process of identity formation. Even within the definition of a category as specific as Japanese American-ness, ethnic identity is not a fixed, original essence. Rather, Arai reframes it as a delicate balancing act allowing for a multiplicity of influences and backgrounds.

IN *AMERICAN PIE,* CHOI EXTENDS HIS concept of the American flag-target first established in *American Dream* (1988–92) into a multicultural and educational setting. First used as an ambivalent symbol of Korean immigrants' desire to come to America and their subsequent disillusionment, the icon takes on a different meaning in the context of a rotunda at IS-5, a public school in Elmhurst, Queens. Separated from references to a specifically Korean experience and inserted into the context of a racially and ethnically diverse New York public school, the flag-target symbolizes the ideological and economic forces that draw people from all over the world to the United States, hoping for a better life for themselves and especially for their children. As access to a good education is primary among these forces, the piece's location in a school is particularly apt.

At this large scale, radiating out across the ceiling in all directions, the flag-target takes on a unifying, soaring quality and a new monumentality. However, it is far from monolithic. Like its predecessor, it is peppered with individual newspaper clippings. However, this time the clippings come from newspapers in a variety of languages: public, quotidian documents of the diversity of immigrant life in the United States. In their previous incarnation, the clippings interrupted the surface of the target, penetrating and disrupting the overall pattern. This time, the pattern is clearer, and the clippings serve to give it texture and depth, emphasizing that ethnic diversity is "as American as apple pie." Divided into forty-nine individual "slices," the circular mural is simultaneously a target and a pie chart, symbolizing the dream of entitlement, or the "piece of the pie" that attracts immigrants in the first place. With this mural, Choi has successfully transformed his own iconography; the flag-target has evolved from a symbol of immigrant disillusionment to one of affirmation and acceptance.

Plate 4. Sung Ho Choi (left)

American Pie, 1996. Silkscreen on acrylic, plywood, 22 ft. diameter. Mural project at IS-5, Queens, commissioned by New York City Board of Education, New York City School Construction Authority, and New York City Department of Cultural Affairs, Percent for Art.

(PHOTO: D. JAMES DEE)

Plate 5. Albert Chong (right)

Aunt Winnie, 1998. Thermal transfer print on canvas, inscribed copper mat, 30 × 20 in. Collection of William Benton Museum of Art, University of Connecticut, Storrs.

(PHOTO BY THE ARTIST)

IN *AUNT WINNIE,* CHONG DOCUMENTS and celebrates the life story of his maternal aunt. Framed with a large sheet of copper embossed with stories and illustrations of her early life in Jamaica, her photograph becomes far more than a simple portrait. The piece is simultaneously a document of the life and struggles of a Jamaican woman of Chinese and African descent, a subtle look at the complexities of biracial identity, and a comment on the processes of memory and preservation. The large copper frame inverts the traditional relationship between frame and photograph, drawing the viewer's attention away from the central image to the stories inscribed around its periphery. Embossed into the metal itself, the stories and illustrations possess a tactile, three-dimensional quality that extends them physically into the viewers' space. The stories not only extend the piece into three dimensions, but also create a context and history for the photograph, giving the viewer a sense of what it was like to grow up biracial in 1920s Jamaica. They expose the interracial tensions not only between Aunt Winnie's family and the surrounding communities, but also within the family itself. It is these stories, Chong suggests, that are the most precious part of remembering, because as personal recollections, they are often the most ephemeral and difficult to obtain. By rendering them in such a solid, tangible form, he attempts to preserve them, giving them a new, physical life beyond the confines of personal memory.

Plate 6. Ken Chu
Café Cure (detail), 1994. Installation with medical paraphernalia, paper coffee cups, malt glasses, spoons, bleach, laser prints, Ken dolls, acupuncture meridian models, ribbons, dinnerware, dog toys, condoms, house paint. Commissioned by 42nd Street Art Project, New York. (PHOTO: BECKET LOGAN)

IN 1994, CHU TRANSFORMED AN abandoned diner on Forty-second Street in New York City into *Café Cure,* a site-specific installation encouraging people living with HIV/AIDS to consider alternative health care options in addition to their traditional primary health care. The "menu" featured various immunity-boosting "cocktails," factoids and statistics about the virus, and alternative treatment options such as acupuncture. In this detail, a table in the center of the diner supports a legion of Ken dolls. Painted yellow, they are a reference to the Asian American gay male community, a group traditionally under-served in terms of AIDS/HIV–related health services and awareness. Several of the dolls are marked with big red plus signs on their chests, symbolizing HIV-positive status. In this installation, Chu manages to put a racialized face on the epidemic and simultaneously introduces the idea of an openly HIV-positive identity within an Asian American community. This dual intervention reveals how the HIV/AIDS epidemic is situated not only within one isolated community, but also at the intersection of all categories of racial, class, and gender identification.

TAR BABY **IS PART OF CHUNG'S**
Hoodoos series, a suite of six screen-
prints based on a mural he created as
an artist-in-residence at the Mary Lou
Williams Center for Black Culture
at Duke University. The prints that
comprise the *Hoodoos* series depict
scenes and characters from traditional
African American folktales. The Tar
Baby is a popular character, believed to
be a monster composed entirely of tar.
In the folktales, it would cast insults at
people traveling through isolated areas
until they were provoked to physically
attack it, at which point they became
mired in its sticky substance.

Chung employs a graphic drawing
style, influenced by comic books and
other forms of contemporary popular
culture, to visualize and enliven the Tar
Baby story, updating it and asserting its
relevance in the present day. The result
appears to have more in common with
science fiction comic books than with
the anthropological endeavor of record-
ing and representing folklore. By pre-
senting the stories in a form readily
understood by contemporary viewers,
Chung gives them new life and intro-
duces the issues they address into
modern-day culture. Although the
meaning of the Tar Baby story is open
to interpretation, its message about the
dangers of violence as a means to re-

solve conflict is clear. When people
cross the line into physical violence,
they find themselves trapped and sub-
sumed by the relentless Tar Baby. In
light of the history of tension and vio-
lence between African and Korean
American communities (as in the media
coverage of the 1992 Los Angeles riots),
this message is a particularly fitting one,
and reflects Chung's ongoing interest
in the products of cross-cultural ex-
change and collaboration. As a Korean
American focusing on the issues and
history of African Americans, he has
created a compelling starting point
for inter-ethnic communication and
interpretation.

Plate 8. Allan deSouza
Terrain #8, 2000. C-print, 12 × 18 in.
Collection of the artist.

PART OF A SERIES OF PHOTOGRAPHS depicting eerily artificial desert scenes, *Terrain #8* explores the relationship between traditional notions of landscape and the racialized and gendered body. The landscape depicted appears to be a vast, open expanse, referencing the romanticism of early American representations of the Western frontier as a virgin, untainted territory. However, upon closer examination, the landscape takes on an artificial air; dioramic rather than panoramic, it suggests a scene that is miniature rather than vast in scale. In fact, deSouza has constructed this landscape out of the detritus of his own body: hair, eye-lashes, ear wax, and nail clippings. It is literally a projection of the body. By then photographing this "bodyscape," deSouza not only skews our perception of its scale, but also re-contextualizes it in the tradition of early American landscape photography (or painting), whose celebration of the natural beauty of the West was also a celebration of manifest destiny. A trope of grandeur and majesty is here reduced to the quotidian biology of everyday life. By playing with these notions of scale and context, deSouza manages to make connections between the exploration of the American landscape (both for patriotic and industrialist ends) and the control of racialized and gendered bodies in the name of that exploration. The most obvious example is the persecution and marginalization of Native American tribes, but deSouza's landscapes are indeterminate and abstract enough in character to draw more general conclusions as to the overarching nature of imperialist and expansionist ideologies. *Terrain #8* reminds us that the body (here represented by its produce) is territory, and that narratives of expansion and conquest have been used to justify its classification and control in the same way they have been employed in the exploitation of the frontier.

Plate 9. Michael Joo
Visible, 1999. Urethane, nylon, plastic, steel,
glass, wood, lacquer, 60 × 48 × 48 in.
Courtesy of Anton Kern Gallery, New York.
(PHOTO: ADAM REICH)

IN *VISIBLE,* A SEE-THROUGH, HEAD-less Buddha figure rests serenely on a sheet of glass supported by metal saw-horses. Its internal organs and skeletal structure are plainly visible, in the manner of the anatomical models used by doctors and medical students or the educational toys that allow children to examine, remove, and reassemble the various organs. It is the privileging of sight as the primary criteria for knowledge and discovery ("seeing is believing") that has shaped the discourse and development of Western science. In contrast, Buddhism, as a religious practice based on meditation and acceptance, focuses on turning inward or on that which is unseen and unsee-able. But in the Western artistic discourse within which Joo operates, the image of the Buddha represents less a religious figure to be venerated than a popular image co-opted by mainstream Western culture as a symbol of oriental exoticism and mystery. The same culture that produced the invasive techniques of Western medicine fixates on the Buddha as a symbol of the absolute otherness of Asian peoples and cultures. The fact that the Buddha has been beheaded further emphasizes the depersonalization inherent in the Western scientific process. By conflating these two impulses—the will to see and the subsequent desire to establish racial categories based on visible difference—Joo's *Visible* emerges as a cleverly crafted comment on the systems of scientific quantification that allow for the racial classification and control of different bodies.

ENVIRONMENT L IS A PRODUCT OF
Kim's ongoing fascination with reclaim-
ing the cast-off detritus of modern
American consumer society. Kim was
shocked, upon arrival in the United
States, not only by the abundance of
manufactured goods only dreamt of in
Korea, but by the casual attitude with
which they were discarded. Taking it
upon herself to collect and revitalize
these forgotten objects, Kim imbues
these products of mass industrializa-
tion with a deep personal significance.
Creating her installations entirely by
hand, she reenacts the repetitive pat-
terns of handcrafted labor familiar
to her from her upbringing in Korea,
translating them into a new, industrial
context. The copper screens that domi-
nate the installation are constructed
from wire found in the walls of her
studio (formerly a grocery store) and
lovingly wrapped by hand. This treat-
ment gives the industrial material an
uneven, human quality. By reviving
and recycling these materials, Kim
honors her memories of life in Korea,
while building a more human place for
herself within the disposable consumer
society of the United States.

Plate 11. Hung Liu
The Boxer, 1998. Oil on canvas, 60 × 108 in.
Collection of M. H. de Young Memorial
Museum, Fine Arts Museums of San Francisco.
(PHOTO: BEN BLACKWELL)

THE BOXER REBELLION (1898–1900)
was a violent attempt by the Chinese
people to rid China of foreigners and
foreign influence. Aligned with the
Chinese imperial court, the goal of the
Boxers (shorthand in the foreign press
for the militia I-ho Ch'uan, or "right-
eous and harmonious fists") was to kill
all foreigners, as well as Christian and
Westernized Chinese. Ultimately
routed by the invasion of foreign
military forces, the Boxer Rebellion
marked a turning point in China's
relationship with the rest of the world,
resulting in a new era of foreign mili-
tary and economic imperialism (*Grolier
Multimedia Encyclopedia,* 1997, s.v.
"Boxer Uprising").

Liu's *The Boxer* continues her ongo-
ing investigation into the impact of
Western systems of perception and
representation on Chinese history
and identity. The central image in
the triptych is based on an archival
photograph of a Boxer in the moment
before his beheading. Photography,
a Western way of seeing, has been
used to document an act of Western
domination. By re-creating the photo-
graphic image in a lush, painterly style
reminiscent of abstract expressionism,
Liu adds yet another layer of Western
influence—indicative of the fact that
she is viewing and processing these
images across the geographical, tem-
poral, and cultural distance effected
by her emigration to the United
States. This dominant, central image
is flanked on either side by smaller,
delicately rendered images of birds
and foliage. Painted in the pastoral,
decorative, aristocratic style of imperial
Chinese art, these images are re-
minders of the traditional Chinese
culture that the Boxers sought to
preserve from foreign influence.
Together with the central image, they
form a cross, a symbol of Christian
martyrdom. Liu paradoxically presents
the Boxer as a martyr in the Christian
sense, despite the fact that Christianity
was a foreign influence the Boxers
sought to eradicate. This complex
interweaving of the tensions and
contradictions of history, imperial-
ism, and immigration shows how the
history and identity of the Chinese
people are not pure and monolithic,
as stereotypes and national discourse
would suggest, but are rather inextri-
cably intertwined with the con-
structs and conventions of Western
discourse.

Plate 12. Yong Soon Min
Red Shoes, 1999. Installation with
approximately 100 pairs of shoes, 15 × 3 ft.
Courtesy of the artist. (PHOTO BY THE ARTIST)

A SITE-SPECIFIC PIECE LOCATED IN
the botanical gardens of the Philippine city of Baguio, *Red Shoes* is a
pointed commentary on the legacy
of Imelda Marcos, the ostentatious,
shoe-collecting wife of corrupt dictator
Ferdinand Marcos. Over 100 pairs of
red-painted shoes are pressed into a
dirt path, forming a "river of blood,"
a reference to the bloody toll of the
political repression that characterized
the Marcos regime (culminating in
the assassination of political rival
Benigno Aquino, Jr. in 1983). The
use of shoes is a clear reference to
Imelda's signature excess and the
political and financial corruption
that supported them. The fact that
there is "blood" on the shoes sends
an unambiguous message of culpability. However, the piece is more than
just a critique. By placing the shoes
on a well-traveled path, Min encourages viewers to walk on them, giving
the work another, more poignant
meaning. The empty, "bloody" shoes
take on a more human aspect, becoming stand-ins for the footsteps
of people who lost their lives under
martial law. Viewers become participants, actually walking in the "footsteps" of the victims, and the piece
takes on another significance, not only
as political commentary, but also as
a kind of memorial, an urging not to
forget.

Plate 13. Long Nguyen
Emotions Series: #2, #3, #5, #4, #1, 1992.
Mixed media, 32 × 15 × 15 in. each.
Courtesy of the artist. (PHOTO BY THE ARTIST)

THE CONTORTED AND TWISTED FACES of *Emotions* convey a subtle range of expressions within the uniformity of their wrinkled, perforated surfaces. The one on the left could be sad, the one in the center has a slightly calmer, more composed air, while the one on the right looks more angry and conflicted. However, the ascription of these emotional qualities to each head is highly subjective—all of the heads look as if they have been flayed and are covered with small puncture wounds, or pores that have swollen and exploded outward, making it difficult to read an expression with any certainty. Is the figure in the center grimacing in pleasure or in pain? Although the violence implied by the heads' scarred surfaces suggests suffering, Nguyen manages to convey a muted range of emotions within that vocabulary. The facial expressions elicit a subtle emotional recognition from the viewer despite their grotesque appearance. The heads are at once physically repulsive and emotionally appealing, in other words, thoroughly human. In an artist's statement about the work, Nguyen states that they "have been through war," a reference to his wartime experiences as a Vietnamese refugee. Thus they are a testament to the perseverance of the subtlety and complexity of the human spirit even in times of extreme suffering.

Plate 14. Manuel Ocampo
Untitled, 1994. Oil on canvas, 96 × 96 in.
Collection of Museo Extremeño e Ibero-
americano de Arte Contemporaneo, Badajoz,
Spain. Courtesy Galeria OMR, Mexico City.
(PHOTO BY THE ARTIST)

IN *UNTITLED,* BLIND JUSTICE HAS been transformed into a hooded Klansman who sits, literally, "on top of the world," supported from below by two small, struggling, half-naked Black children. The globe is flanked on either side by symmetrical sheaves of wheat, symbols of abundance and prosperity, that, ironically, meet at the base of the globe to form an "x" reiterated in the crossing of a spoon and syringe, a drug user's paraphernalia. This "x" is echoed in the cross positioned at the Klansman's feet that reads "deus ex machina," in which "ex" is given particular prominence, inscribed large, on the crossbar, rather than within the vertical of the cross. Beneath this perversion of traditional Western insignia, Ocampo has inscribed in large Gothic letters, "Para eso habeis nacido!" or "I was born for this" (my translation). This declaration confidently asserts the colonizer's birthright to rule. But this assertion is undermined by Ocampo's sly interventions into the celebratory vocabulary of the neoclassical seal, omnipresent in all forms of official Western culture. The figure of Justice is not only no longer blind, but also a hooded Klansman (of which nothing but the eyes can be seen), reflecting the perversion of justice into a partisan and anonymous judgmental and punitive force. The attendant inequalities of this system are allegorized in the Atlas-like Black figures that struggle to support the globe/throne. The abstract concept of "justice" is in fact part and parcel of a system supported by vast inequalities. Ocampo comments on the irrational construction of this divide in the "deus ex machina" cross, suggesting that it is always by some artificial, arbitrary means (invoking the name of God to justify atrocities, for example) that the corrupt colonial system continues to prevail. Perhaps the most subtle and grim element of this composition is the juxtaposition of the sheaves and the drug paraphernalia, suggesting that the prosperity, indeed, the very sustenance of the colonizer is dependent upon the addiction and debasement of others. Although he skillfully employs the style and language of official emblems and insignia, Ocampo has succeeded in perverting and twisting their conventional meanings to reveal the underlying realities of cultural, racial, and economic colonialism.

HOW SHE LIVES

SHE IS QUITE YELLOW

THE COCKINESS
THE VIRGINAL

BLACK LESBIANS

SHE HAS
IN THE BACK

SHE PRACTICES
EJACULATION

THE
OBSCENITY
TRIAL

SHE
POINTS AT
THE ASSAILANTS

TORQUEMADA
and
JESSE HELMS

UN-AMERICAN
SHORT
DYKES

IS INTERCEPTING

SEX

THE
INTERNATIONAL
LESBIAN
MAMASANS

KGB
OR
CIA?

Plate 15. Hanh Thi Pham
Expatriate Consciousness #9 (Không là nguoi o), 1991–92. Chromogenic development print, composed verses, 10 × 6 ft. Courtesy of the artist. (PHOTO: FUJIMOTO KEMPACHI)

IN THIS STRIKING AUTOBIOGRAPHICAL work, Pham asserts a multilayered sense of identity as a transgendered Vietnamese American woman. Situated at the intersection of anti-patriarchal, anti-racist, anti-homophobic, and anti-imperialist struggles, *Expatriate Consciousness* combines photographic elements from disparate sources with a fragmented personal narrative to convey anger, pain, and an emergent sense of personal power and pride. The piece juxtaposes images of American consumer products and references to American nationalism and military campaigns with archival family photos from Vietnam and sexually charged present-day self-portraits. In this way Pham draws connections between so-called personal, historical, and political issues, reflecting not only on how her individual experiences (as a Vietnamese refugee, transgendered person, and lesbian) have been shaped by external forces beyond her control, but on how an angry, subversive identity has been formed in the process.

The lower-right self-portrait is a key to the piece. Barechested, Pham gestures profanely, her face cast in a fierce snarl. Her flexed arm expresses both anger and strength. The partial text—"Not the person who lives here"—beside her also holds a double meaning. It suggests that the United States is not really Pham's home—she does not belong here. By prefacing the phrase "the person who lives here" (which in Vietnamese often refers to a live-in servant) with "not," Pham signals her refusal to assume the subordinate position assigned to her by the racism and homophobia of U.S. culture and imperialism. To drive this refusal home, Pham includes a drawing of Buffalo Bill Cody, symbol of the American frontier spirit glorified by Hollywood, upside down and crossed out with black tape. By negating this icon, Pham indicts the "manifest destiny" at the heart of U.S. imperialism in the developing world and its insidious offspring, the neo-imperialism of Hollywood and global capitalism. By combining these multilayered photographic images with a textual narrative that negotiates, from a first-person perspective, the complex contradictions of ethnic, sexual, gender, and racial identities, Pham advances a new, contestatory identity forged out of an utter refusal to be defined or delimited by conventional expectations.

Plate 16. Pipo Nguyen-Duy
Dante 1, 1995. Gelatin silver print with wax medium on Gator board, 40 × 30 in. Courtesy of Bucheon Gallery. (PHOTO BY THE ARTIST)

AS PART OF THE *ASSIMILATION* series, *Dante 1* reflects Nguyen-Duy's ongoing exploration of the intersections between Asian and Western cultural icons and mythologies. By photographing himself in a variety of settings derived from Western paintings and mythology, Nguyen-Duy comments on the processes of cultural and artistic assimilation. Like Dante's journey into successively lower levels of hell, Nguyen-Duy pictures himself reaching across a boundary into a mysterious netherworld. However, in place of the metaphysical weight with which

Dante undertakes his excursion, Nguyen-Duy's version is rife with artifice. Shot as a cross-sectional view, the image reveals that the "earth" into which Nguyen-Duy extends his hand is only a sprinkling of dirt on top of a framework of wooden floorboards. A few sad, dead twigs have been "planted," as if to increase the "realism" of the image, but the floorboards resemble those of a stage, reinforcing references to performance. This heightened sense of artifice serves to foreground the process of simulation inherent in Nguyen-Duy's mimicry.

By inserting contradictory references to Asian cultural forms (as well as his racially marked Asian body) into the motifs and themes from canonical works of Western art and literature, he reveals how the process of cultural assimilation is constituted through simulation (rather than adoption) of Western cultural conventions. In exposing the artifice inherent in its construction, Nguyen-Duy reveals how, once embarked upon, the process of assimilation is perpetually and necessarily incomplete, resulting in a range of new, hybrid performative identities.

Plate 17. Roger Shimomura
Suburban Love, 1995. Acrylic on canvas,
84 × 72 in. Courtesy of the artist.
(PHOTO BY TIM FORCADE)

SUBURBAN LOVE IS A TREATISE ON
Shimomura's trademark style of jux-
taposing traditional Japanese *ukiyo-e*
style and subject matter with graphic
1960s pop art conventions. In the fore-
ground, a couple from a traditional
erotic Japanese print make love in front
of a *shoji* screen, behind which stands
a typical American suburban ranch
house. This juxtaposition creates a
jarring discontinuity, further enhanced
by the spatial ambiguity of the compo-
sition. The couple appears to be on
the front lawn of the ranch house, or
perhaps they are indoors in their tra-
ditional Japanese house across the
street. At any rate, Shimomura em-
ploys a contrast of comical extremes

to comment on a Japanese American
experience that is neither wholly
Japanese nor American. The disconti-
nuity between the passionate couple
(probably a courtesan and a nobleman)
and the placid, domestic, nuclear
family life implied by the white clap-
board house echoes in exaggerated
fashion the sense of displacement
experienced by Japanese Americans
growing up in a homogenous Ameri-
can suburban environment. However,
the ingenious combination of pop art
and *ukiyo-e* style belies this apparent
disjuncture. Although his subject
matter is contradictory, Shimomura
has arrived at a representational style
that is a complete fusion of the two.

His hard-edged graphic style owes as
much to pop art as it does to tradi-
tional Japanese woodblock prints,
and it is nearly impossible to separate
out elements of either style. So even
while finding the humor in the dis-
continuity of minority experience in
the United States, Shimomura man-
ages to advance a practice in which
Japanese tradition and American
consumer culture blend seamlessly.
The result is an image that maintains
a strange tension, an idiosyncratic
oddness in which elements from
diverse sources are held in balance
by an overall treatment that favors
neither yet refuses to elide their
differences.

Plate 18. Shahzia Sikander
Ready to Leave, 1997. Vegetable color, water-color, dry pigment, tea wash on wasili paper, 9³/₄ × 7¹/₂ in. Collection of the Whitney Museum of American Art, New York.

IN THIS TINY PAINTING, SIKANDER deftly interweaves various techniques of traditional South Asian miniature painting, references to modern art, and the symbolic languages of South Asian mythology. The complex interplay of these elements can be seen in the icon of the veil, a recurring theme in Sikander's work. In observance of Muslim custom, the face of the woman at the center of the painting is covered, not with a traditional veil, but with a flat, round circle. This abstract shape calls attention to the flatness of the painting surface in typical modernist fashion, contrasting starkly with the illustrated, illusionistic detail with which the woman is rendered. However, rather than being a simplistic postmodern intervention into a traditional painting, the flatness of the circle can also be read as a contemporary interpretation of the common shifts in perspective and scale found in traditional miniature painting. It is thus simultaneously a postmodern veil and a quietly subversive act, inviting the viewer to read modernism through the lens of South Asian miniature painting rather than vice versa. By playing with the line between visibility and invisibility, surface and depth, Sikander manages to create a personal, visual language somewhere in between the conventions of modernist discourse and the strictures of South Asian tradition.

IN *SEOUL HOME / L.A. HOME,* SUH HAS
created a fragile, translucent fabric
replica of his family home in Korea.
Constructed of diaphanous jade-green
silk, the replica is made from a scale
paper pattern with which Suh meticu-
lously recorded the structural details
of his family home. Even minute details
are included, down to the light switches
on the walls. This extreme attention to
detail bespeaks a great desire to trans-
late and re-create a sense of home from
one country to another. However, this
house, stitched together out of thin,
translucent fabric, suggests transience
and mutability rather than reassuring

permanence. It is a kind of ghost house,
displaying traces of the original but
failing to completely re-create it. In this
sense, although it is not a product of
memory alone, it evokes a melancholy
attachment to an intimate space of the
past. At the same time, because it is
literally patterned after the original
home, it also represents a fluid conti-
nuity with that space. More akin to
a tent than an actual structure, it ad-
vances a nomadic notion of home.
Similarly, because it is constructed
out of fabric, it also resembles cloth-
ing, another kind of portable home.

Suh challenges the traditional

immigrant nostalgia for home by trans-
lating the physicality of home into an
infinitely portable space. While the new
home remembers the minute details
of the physical space of the original,
it also extends them into new contexts,
constructing a permeable space that
adapts to many different locations.
Suh's installation proposes a new kind
of relationship between the "home-
land" and a new home country. Sim-
ultaneously melancholy and adaptive,
it advances a concept of a personal
and migratory space that is based in
but not limited to a specific geographi-
cal place.

Plate 20. Mitsuo Toshida
Nation Double, 1993. Ink and gouache
on paper, 48 × 72 in. Courtesy of the artist.
(PHOTO: KOUICHI HAYAKAWA)

IN *NATION DOUBLE,* TOSHIDA continues his investigation into the "doubling" of perspectives occasioned by an existence between and within two different cultures, nations, and languages. Two overlapping circles float against a black background littered with white Japanese characters that have been distorted to the verge of illegibility. Each circle acts as a focusing device, representing a different view of the jumbled field of characters. The circle on the right reverses the characters' relationship to the background: within the circle they appear as black characters on a white ground (the

conventional relationship for optimal legibility). By contrast, in the solid white circle on the left, the differentiation between black and white necessary to perceive and understand the meaning of the characters is totally obliterated. The legibility within the right-hand circle represents the transparency of the Japanese relationship to the characters; the opaque white circle on the left represents a total lack of comprehension from an American perspective. These two points of view overlap in the center, emphasizing their interdependency and coexistence in a transnational "double" consciousness.

(Comparisons to W. E. B. DuBois's concept of "double consciousness" are unavoidable, but the significant contextual differences are too detailed to discuss here.) The red intersection where the circles overlap and the horizontal format of the painting are both clever references to the Japanese flag. The red circle, or rising sun, symbol of Japanese national and hereditary unity, is here eclipsed by being doubled into two equal yet disparate orbs. This split perspective necessarily constitutes a deconstruction of the notion of a homogenous national identity, suggesting a new, more complex formulation.

Plate 21. Carlos Villa
Future Plans, 1996. Box-frame around
black painted unfinished door, vinyl tape,
hat, 25¾ × 20 in. Private collection.
(PHOTO: LARS SPEYER)

IN VILLA'S FORTY-PLUS YEARS AS AN
artist and cultural activist, *Future
Plans* represents a departure of sorts,
a remixing of past work and personal
history. In its use of simple, rectilinear
forms, it hearkens back to Villa's mini-
malist work from the 1960s. However,
the centrality of the image is also remi-
niscent of the anthropomorphic cruci-
form shapes of Villa's feather cloaks,
referencing a personal spirituality and
mysticism. Joining the languages of
pure form and personal ritual, twin
rectangles tilt inward to suggest an
abstract passage or doorway. Sus-

pended in the middle of this "door-
way" is a man's fedora, both a reference
to the *manongs* (early Filipino immi-
grants who labored in the West Coast
agricultural industries of the 1940s)
and, perhaps, a stand-in for the artist
himself.

This crossroads of minimalism, per-
sonal spirituality, and history evokes a
sense of existential openness, suggest-
ing, in conjunction with the piece's
title, that the future is curiously blank.
This openness refers to the sense of
possibility that the *manongs* must have
experienced upon arriving in a new

country—the blank slate upon which
they would write their stories of suc-
cess or failure. But it also marks a new
beginning of sorts for the artist, as he
looks back on his own history and
assesses prospects for his future. By
collapsing the past and the present,
Villa identifies with the *manongs,* not
only positioning himself within the
flow of Filipino American history,
but also extending historical prece-
dents into his own future. History and
personal memory are united in a single
expression of possibility.

Plate 22. Martin Wong
Chinese New Year's Parade, 1992–94. Acrylic
on linen, 84 × 120½ in. Courtesy of P.P.O.W.
Fine Arts, New York. (PHOTO: ADAM REICH)

IN *CHINESE NEW YEAR'S PARADE,*
Wong depicts a larger-than-life China-
town in the throes of exuberant cele-
bration. A swirling, brightly colored
tapestry of line and pattern, the paint-
ing is a departure from the quiet com-
positions and muted palettes of his por-
traits of New York urban and prison
life. It is, as Wong states, a fantasy: "This
is an American Chinatown. It has a
touristy, kitschy feel. A pop feel, and
it's not like anything in real China. The
fantasy of the neon pagoda is a specific
time and place, and I grew up with that
kind of glamour" (as cited by Eliza Lee
in *Asian Week* 15, no. 10 [1993]). An
immense dragon's head is flanked by
lanterns, streamers, and dancers in elab-
orate headdresses, as well as more myth-
ical creatures: blue demons and a smil-
ing Buddha's head. At the center of all

this activity stands a little Asian boy.
With his back to the viewer, he faces the
parade calmly, despite being dwarfed
by its color and energy. By including
this small bystander, Wong not only
evokes his own childhood memories,
but invites viewers to insert themselves
into those memories, sharing a child's
sense of wonder and fantasy. The over-
whelming scale and abstract space of
the painting reinforce this effect, pro-
jecting a dreamlike grandeur. The
characters in the painting do not
occupy a realistic space—they are
layered one atop the other to create a
flat, collage-like effect. This is height-
ened by Wong's obsessively detailed
patterning—objects and clothing
dissolve into an overall pattern of lines,
dots and swirls, giving the painting
an undulating, rhythmic quality.

Wong blends the story-telling tech-
niques of WPA-era mural painting
with the abstract, lyrical patterning and
energy of graffiti art to create a hybrid
style. He combines an attention to
detail with an overall pattern of curves
and swirls that suggest the process of
memory itself—a process that situates
the viewer simultaneously in the past
and the present. Memory, in its unre-
liability, zeroes in on some details,
elides others, and leaves the person
who remembers with an overall
impression rather than a concrete
account. By resurrecting these
fantastical impressions of his child-
hood Chinatown, Wong suggests that
Chinatown is more than a geographi-
cal, economic, and cultural space—
it is an energetic, fantastical, imagined
community.

Plate 23. Lynne Yamamoto
Removal, 1998. Video still. Courtesy of the
artist and P.P.O.W. Fine Arts, New York.

IN *REMOVAL,* YAMAMOTO SUBTLY
narrates a self-inflicted loss of cultural
and ethnic community. A close-up
of tweezers methodically plucking the
black hairs from a motionless big toe
alternates with grainy black-and-white
footage of kimono-clad young girls
performing *obon odori,* a traditional
Japanese dance. The black-and-white
footage, as well as the youth of the girls
depicted, situates the *obon* sequence

firmly in the past, while the mature
fingers and toe in the close-up, shot
in color, indicate a more recent date,
after the onset of maturity and its
ensuing self-consciousness. The act
of removing hair from the body is an
attempt to eradicate the evidence
of both racial difference and sexual
maturity. The fact that this activity is
directed at the subject's big toe attests
to the thoroughness and unrelenting

detail with which this erasure is
accomplished. By contrasting this
contemporary image of self-focused
isolation with archival footage of
an ethnic community celebration,
Yamamoto creates a tension between
the present and the past, individual
isolation and community, reflect-
ing a self-inflicted "removal" from
the sources of cultural and ethnic
continuity.

Plate 24. Zarina
Books for the Road, 1998. Bronze, etching,
4 × 4 × 4 in. each unit. Courtesy of the artist.
(PHOTO: D. JAMES DEE)

IN *BOOKS FOR THE ROAD,* ZARINA transforms the wheel, symbol of perpetual motion, by doubling it to form the covers of a book. Sandwiched between the wheels are the "pages," a series of wooden discs that mimic the shape of the wheels. As in the archetypal book, the pages suggest a narrative, in this case perhaps a travel diary or an attempt to capture and record the passage of all-too-fleeting moments. Together with the wheels they empha-size an understanding of movement not only as a process of spatial dislocation, but one of temporal displacement. *Books for the Road* is therefore a crystallization of a perceptual process that is always in motion. However, cast of heavy bronze, and joined so as to make movement impractical, the "books" are actually rather immobile. Strongly influenced by early minimalist sculpture, Zarina employs its vocabulary of simple, static shapes, industrial-strength materials, and a muted color palette to give a definite form to the concept of travel. By emphasizing the physical presence of the books, this minimalist approach shifts the focus of the piece from the destination(s) to the travel itself. *Books for the Road* gives concrete form to the act of traveling, suggesting that it is not just a time and space between destinations, but a location in its own right.

Faith Ringgold

PACITA ABAD
A Woman of Color

PACITA ABAD IS ALL ABOUT COLOR—IN HER PERSONALITY, IN HER APPEARANCE, AND in her enthusiasms. Color is something no one can miss seeing, both in her work and her person. She has stated, "Color plays an important role in my life. It is not only on my palette, but also in my clothes, my jewelry, my home, and even in the food that I eat."[1]

I first saw Abad's colorful paintings in *Art to Art,* a video about Asian American women artists.[2] I came away from that video smiling, with two immediate impressions: what a shame that I had not seen before more of this exciting Asian American women's art, and how delightful to be able to meet Pacita Abad through her art. Yet I continue as always to be disturbed by the fact that it is so difficult for women to get the exposure they need to have their work become known and appreciated.

Widely traveled, Abad creates her work from the point of view of an international woman of color. Those of us who have also traveled extensively know that creative women of color are working all over the world and are not merely "minority" figures within the narrow confines of the Western art world. Who knows how contemporary art will be seen in years to come, once women and artists of color gain equal opportunity to address their cultural concerns through art? That day, thank heavens, is definitely coming, so let's all of us get ready.

In the meantime, artists like Abad have found a way to work around the problem, and we viewers are lucky to have an opportunity to experience her very "user-friendly" art. One likes both to have it around and to be around it—not just because of its contents, materials, and messages, but because it is an amalgam of multicultural issues and expressions, all done in rich and vivid colors.

I am moved by Abad's "trapunto" paintings of masked faces. The stuffed canvases are sewn with beads and buttons and glass and all kinds of things. They are deliciously multi-layered and adorned, sometimes taking up an entire wall. Abad's home, which is furnished and decorated wall to wall with her lavishly colorful art, is a feast for the eyes of all who visit her.

The huge 1990 trapuntoed canvas titled *The Filipina: A Racial Identity Crisis—Liwayway Etnica and Isabel Lopez* deeply captures my fancy. It speaks of the strength, poise, and beauty of two women of different colors who could be seen as a single woman, or as a representation of women across or within cultural boundaries, all within the complicated fabric of womanhood. Abad herself has said in relation to this painting, "Racism has a lot to do with women . . . in the Philippines. . . . Social status [has to do with] being fair [and wearing] embroidered cloth that is very European-influenced. . . . The irony is . . . after four hundred years of independence, we still don't know who we are. . . . I'm dark, I come from the province, from the island, from the village. . . . 'Liwayway' means a flower; the root meaning is like freedom. . . . It is deeply Tagalog. It means you are from the village."[3]

Over the years, I too have thought about how to create portraits of two women, and so I find it fascinating to encounter another woman who has the same interests and to see how she goes about dealing with this important subject. Abad's work is full of life and joy. At the same time, it reveals the haunting presence of her own individual self. The more one sees of Pacita Abad's art, the more one wants to see.

∎ ∎ ∎

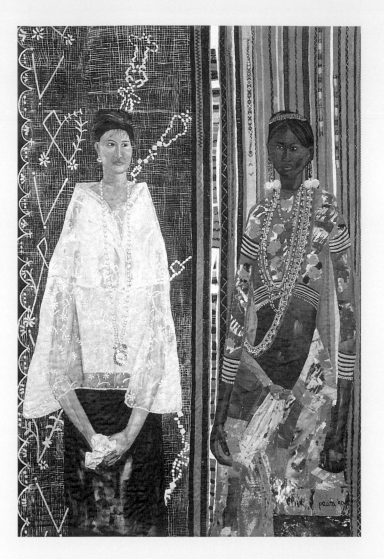

Figure 46.
Pacita Abad

The Filipina: A Racial Identity Crisis—Liwayway Etnica and Isabel Lopez, 1990. Acrylic, hand-woven cloth, dyed yarn, beads, gold thread, stitched in padded canvas, 100 × 64 in.

(PHOTO: RICK REINDHARTH)

In *The Filipina: A Racial Identity Crisis,* Abad depicts a schism in Filipina identity created by colonialism. Divided starkly in half, the canvas compares two women representative of two different Filipina identities, the colonial and the indigenous. By placing these positions side by side, Abad reveals a tension inherent in Filipina identity that points to the very heart of the identificatory process itself. In a colonial society, where does one look for role models? And to which tradition does one belong? The values of the colonizer are most often enforced and emulated over those of the native population, but Abad effectively neutralizes this imbalance by giving Isabel and Liwayway equal space on the canvas. Abad also signals her affinity for the values of Liwayway throughout the piece by employing materials, colors, and patterns that derive more from indigenous artistic traditions than from European art history. It is also interesting to note that while Liwayway Etnica gazes confidently out at the viewer, Isabel Lopez is looking anxiously at Liwayway.

Deborah Willis

KRISTINE YUKI AONO
Installing Memories

There is power in seeing an object from the past. These relics gave concrete weight to the stories of the camps, events that I could only imagine from photos and books. In my mind, the camps had existed as the black and white images taken fifty years ago. These artifacts were physical evidence and give the camps a new reality.

Kristine Yuki Aono, *Relics from Camp*

WHEN LOOKING AT THE WORK OF KRISTINE YUKI AONO, I AM REMINDED OF THE QUESTIONS raised in Alice Walker's essay "In Search of Our Mothers' Gardens." Walker asks, "What did it mean for a black woman to be an artist in our grandmothers' time? In our great-grandmothers' day? . . . How was the creativity of the black woman kept alive, year after year and century after century?"[1] I find that I can apply questions about black women's experiences to those of Japanese American women. In her sculptures and installations, Aono imagines the social, political, and cultural realities of her grandmothers, her mother, and other women of Japanese ancestry. By using dolls her grandmother made while living in an internment camp, Aono discovered her grandmother's creativity under hostile and humiliating conditions. From the well-crafted faces and dress of a Japanese man and woman, we get a sense of the grandmother's ability to keep alive the mem-

ory of her own ancestors, without shame or humiliation, but instead with a great sense of pride.

In addressing family and representation of cultural identities, Aono directs her viewer to a visual narrative of disturbing memories of racism and sexism. She also brings to light family memories that are often poignantly humorous. She incorporates historical references, reconstructed memories from family and family friends, found objects, and photographs to create an imagined authentic voice. In her *Relics from Camp: An Artist's Installation,* she collaborates with her own family members and others who live in Japanese American communities across the country. Constructing a story about "relics" and memories of different concentration camps, she situates her own family and other families.

Aono states, "When you are doing art, everything you do is somehow a self-portrait. . . . I decided to really push it [by doing installations] and let it be about my family, [making] it a narrative and very straightforward. . . . My family never talked about the camps; they are very quiet people. My work, on the other hand, is bold and forceful."[2] By telling the story of the internment camps, her message "straight in your face," Aono is breaking away from the silence. She incorporates in her work objects found by friends who assisted in archaeological digs in the deserts around abandoned internment camps, artifacts loaned by Japanese American families, and objects she found during her own pilgrimages to ten internment camps. What makes it possible for her audience to imagine the shared experience of many Japanese Americans is her ability to re-narrate the stories by making a large grid, a frame of sorts, using soil from each locality and etching the name of the site on glass with selected objects from each camp.

Relics from Camp reflects the isolation and displacement, as well as the love and strength of will, of the families who endured loss of property, privacy, and trust. As one internee stated, "The most difficult problem for me to overcome as a result of the evacuation was the anger and bitterness which has gradually surfaced over the past 39 years. . . . I could never tell my four children my true feelings about that event in 1942. I did not want [them] to feel the burden of shame and [the] feeling of rejection by their fellow Americans."[3]

Aono has stated, "My American-born parents and their Japan-born forebears grew up with the proverb: *'Deru Kugi Wa Utaeru'* or the nail that sticks up the farthest takes the most pounding.' My generation grew up in the U.S. during the civil rights movement with the proverb, 'The squeaky wheel is the one that gets the grease.' At times I find myself caught between these conflicting concepts."[4] At times, Aono directly explores repression, racism, fear, and survival. At other times, her work is encoded with unspoken messages such as this one.

■ ■ ■

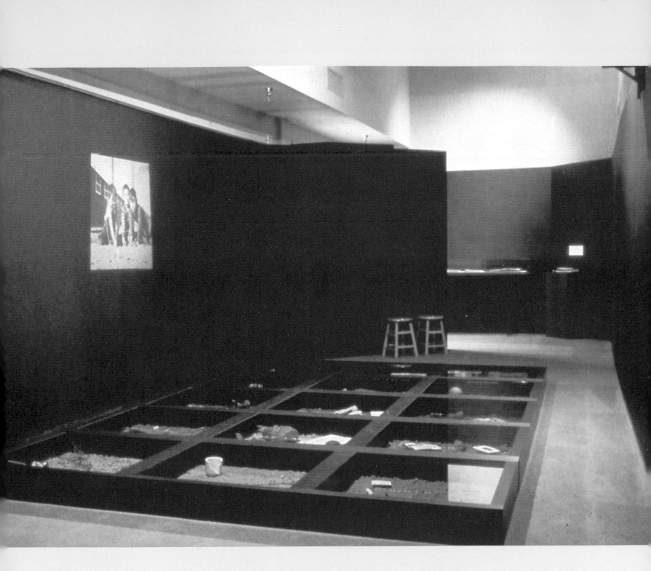

Figure 47.
Kristine Yuki Aono
Relics from Camp (overview),
1996. Multimedia installation,
dimensions variable.
(PHOTO: NORMAN SUGIMOTO)

For commentary, see plate 2.

Jolene Rickard

TOMIE ARAI
Ties That Wrap around the World

THERE ARE A NUMBER OF CONCEPTS IN ARAI'S WORK THAT RESONATE WITH NATIVE American worldviews. As an indigenous person, I think it is time that the lens of cultural, artistic, and literary criticism be articulated from an indigenous perspective. Arai's work in part is a migration narrative. The land that peoples from around the globe have come to, "America," is my homeland. It is dense with ideas and perspectives that predate European constructs of seeing America. Indigenous people in the Americas have made a conscious effort to resist the hegemony of the West and affirm an alternate worldview. In other words, Native people have made a conscious choice *not* to be "Americans." Rather, in the United States, we think of ourselves as members of our own Nations. It is not a huge leap for me to accept and recognize that peoples from around the world come here and want to define their own identities. Since I have fought for political, cultural, and spiritual sovereignty all my life, I respect that impulse in other people. In fact, somehow I trust this impulse more than that of people who want to cut all ties with the past. Acts of continuously maintaining family and community memory are familiar practices to Native peoples.

Because my own people, the Tuscarora, were forcibly removed from our ancestral homeland, as many Native nations were and continue to be, I appreciate Arai's focus on location. The sites that she brings forth are both public and private. Arai often uses win-

dows, doors, and the photograph as portals to interior, more intimate spaces. It is this inner territory that is often overlooked in analyses of her work that favor the more overt political references. I would suggest that this other, interior area is just as politically charged.

Contemporary art criticism unwittingly censures the conflation of materials, photographic images, and cultural knowledge exemplified by Tomie Arai's work. I believe her use of materials such as wood and string is equal in significance to her use of photographic and cultural symbols. Her use of wood as a textural space to which to apply appropriated photographs is a key example. The wood is not simply background material. In *The Laundryman* (1991), three separate photographic reproductions are applied on a spacious wooden board. The delicate growth-line patterns of the wooden plank frame a man plucking a *san gen* instrument. A tree's life pattern is a record of its existence and duration of life and of the environment in which it grew. The background of the wood's life pattern becomes a profound clue to the life pattern of the unknown people in the photos. Similarly, First Nations carvers from the Northwest coast take the grain or flow of the wood into consideration when making new totems. The totem is the ultimate identity marker of a family heritage. This heritage is not just human lineage but a visual analysis of the connection to the natural and spirit world. The pattern of the tree is a profound pattern of life. Arai instinctively grounds her art on finely crafted planks of wood with sensitivity to the patterns of growth inherent to this material. By consistently grounding appropriated strangers' photographic memories and culturally relevant symbols on nature's patterns, Arai relocates a people.

Arai's use of string is rarely mentioned except as a mere aesthetic choice. *Framing an American Identity* (1992) suggests an impulse to tie the past to the present, looping portraits to one another, symbolically creating community. The Lakota connect themselves with strings of sinew to a central pole during the Sun Dance ceremony. This signifies their connection to the universe, because for them the center of the universe is within the ceremonial Sun Dance circle. The Iroquois bury the umbilical cord of a newborn in the ground close to our communities to symbolically tie the baby to this land. These are ancient acts that were practiced globally by many cultures. Tomie Arai reminds us of the ongoing usefulness of ritual ties.

The juxtaposition of portraits and masks in *Framing an American Identity* also pushes the piece beyond an easy "identity" construct. The masks, tucked in between smiling faces, set up a duality between the public and private face. The Japanese Noh mask with an unknowable expression is positioned beside a demon mask. However, the sight of a mask for a Native American is not taken within the context of a masquerade. The act of wearing a mask is connected to seeking power from or through the experience. Therefore, it is significant that the horned, demon mask is on the bottom, or "under" the public or "upper" faces. The contrast between the two masks sets up an interesting duality that is not solely about stereotyping. It parallels the philosophical view of the Iroquois that within the consciousness of every human being exists the potential to be good or bad: it is our choice to accentuate one over the other, and it is considered a lifelong struggle to keep these dualities in check.

Tomie Arai is philosophically like a spider woman, weaving a story in a new land. The

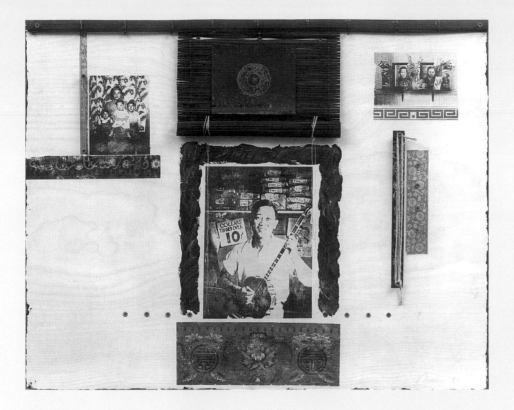

Figure 48.
Tomie Arai
The Laundryman, 1991.
Silkscreen and mixed media
on plywood, 22 × 30 in.
(PHOTO: D. JAMES DEE)

In this elegant collage, Arai cele-
brates the everyday life of a
Chinatown laundryman. At the
intersection of racism and labor
relations, the Chinese American
laundryman is often seen only in
terms of the services he provides,
and rarely as a complete human
being. In an effort to counteract
this prevalent stereotype, Arai
chooses to picture him in a
moment of relaxation, smiling,
meeting the gaze of the viewer.
As in *Framing an American
Identity,* a rolled-up bamboo
shade hangs above the portrait,
implying that this view is a privi-
leged one, a glance into a private
life. Arai also includes images
of the laundryman's family and
ancestors, filling in the human
details of an existence that might
otherwise be defined solely in
terms of labor. Swatches of Chi-
nese patterns and symbols are
interspersed with these photo-
graphic images, asserting a link
with a Chinese cultural past even
among the harsh realities of
American life. By presenting this
humanizing portrait, Arai creates
an empowering, honorific image
through which the particularities
of an unsung, everyday life are
visualized and commemorated.

symbolism of circling and connecting these objects sends ripples of cohesion into the world for those who are open to being part of the web. Her work acknowledges the physical shift from Asian lands to the Americas, but the philosophical subtext of the work demonstrates ties that wrap around the world. Like the Lakota, whose tie to the knowledge of the universe is ancient, Arai reveals through her art how deep systems of knowledge are tied to the seemingly insignificant details of our lives. Careful study of Arai's work recognizes these natural patterns as strategic maps for survival. Rather than romanticize the natural world, she appropriately layers these spaces with the modern structures of steel, colonialism, and cultural formations. It is this combination that opens a new space for contemplating what's next for transnationals in a "native" land.

. . .

Suk-Man Kim

SUNG HO CHOI
Suitcase of Memories

IN A SENSE, IMMIGRATION LEADS TO VOLUNTARY OR SEMI-COERCED DENIAL OF THE
past. An American flag and an *imin kabang* (the huge canvas suitcase on wheels that
Korean immigrants of the 1970s and 1980s usually brought when they came to settle in
this country "forever"). Could it be that immigration itself is the sacrificing of memo-
ries in exchange for the promise of a new life? To immigrate is to place one's memories
into a crate like a time capsule and bury it along the asphalt runaway or deep beneath a
harbor.

In 1988, seven years after coming to the United States from Korea, Sung Ho Choi be-
gan to create a large installation titled *American Dream,* which he finished in 1992. It was
made of newspapers, kimchi (spicy Korean pickled cabbage) jars, and a large *imin kabang.*
The suitcase lies open under a red, white, and blue target plaited with Korean-language
newspapers, all filled with stories of Korean immigrants' struggles in America.

I live in Korea. From here, I have my own particular thoughts and feelings about Ko-
rean immigrant life in the United States. My aging widowed mother, who immigrated to
Los Angeles with her three children in 1974, is beginning to lose her memories one by one.
In the Buddhist cycle of life, being able to forget everything and return to a childlike state
before death, they say, is to be truly blessed. But as I watch my mother lose her memory,

I belatedly realize that she is the only one who can relate stories of the past, and I do not have her memories. I hurriedly try to record her remembrances.

From my mother's stories, I can discern only the contours, not the details, of the past. Her most gripping stories are about living, pregnant with me, under communist rule for three months and then crossing secretly by boat from North to South Korea before the Korean War. Once she had decided to flee south, she had already buried the memories of her life in the North along the bed of the Daedong River in Pyongyang.

I do not know much about my mother's childhood, partly because she is losing her memory, but mostly because she does not want to talk about her long-buried past. When I press her repeatedly, she shows me a pair of palm-length knitting needles. She has kept them since she was ten years old. She still keeps them oiled. Although I saw them before when I was young, I did not know that these are her oldest possessions. She says that she got them by begging her father for them. He paid a sum equal to half a *gamani* of rice. When my mother passes away, all that will be left of her will be my tape recordings of her voice, a bundle of pictures, some old letters, and these knitting needles. They are the things I will have to remember her by. The rest is buried along the banks of the Daedong River or under the runway at Kimpo airport, never to be transferred to anyone.

Carrying their *imin kabang,* Korean immigrants arrive at this rich and orderly culture, having left their memories of the past at the door. They do not receive any credit for having buried their memories. The *imin kabang* should be what transports and holds their memories of the past. Living in America, different racial groups know little of each other's memories. The only real way for the different racial groups to live together in peace is to coexist within each other's memories.

A Korean proverb states, "In death, tigers leave their skins, and people leave their names." All people, not just Koreans, leave their names behind when they die. Buildings and monuments bear the names of the renowned and beloved, so that others can remember them in perpetuity. Indeed, the names of villains who have committed terrible deeds are repeated in history and literature. Some like to carve their names on boulders high on a mountaintop. Even those who have lived the most ordinary lives might at least leave their names on gravestones. But a name dissociated from memories of that person has no meaning. To leave a name *means* to leave a memory. Victims of natural catastrophe, when asked what they would salvage in a moment of crisis, often say they would take their photo albums. When the material base of a life is destroyed, new life can be built on memories of the past. A life forcibly deprived of memories is a life of pain.

An immigrant needs at least a *kiyok kabang,* a suitcase of memories.

■ ■ ■

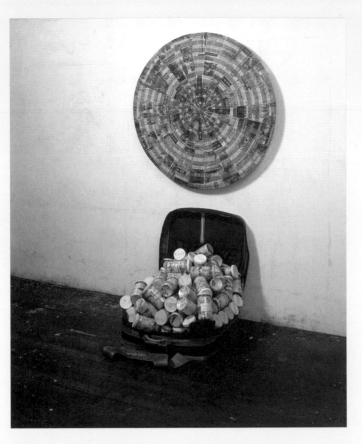

Figure 49.
Sung Ho Choi
American Dream, 1988–92. Acrylic,
newspaper, wood, glass jars, suitcase,
86 × 48 × 27 in. Courtesy of the artist.
(PHOTO: D. JAMES DEE)

Choi's installation is a bittersweet
deconstruction of the "American
Dream," or the promise of a bet-
ter life in America seen from the
point of view of a Korean immi-
grant. Hanging on the wall, the
American flag has been reshaped
into a target, symbolizing America
as a desired goal or destination.
That it is a flag rather than a map,
for example, points to the idea
that it is the ideological promise
of America rather than the reality
that is "targeted" by the immi-

grant. Korean-language news-
paper stories of immigrant
struggles in the United States
"interrupt" the surface of the flag-
target, implying that all is not
as promised in the country of
destination.

On the floor below this ambiva-
lent flag-target lies a large open
suitcase. This is the suitcase that
Choi arrived with when he first
came to the United States, but
rather than being filled with mem-
ories or artifacts from his home-
land, it is filled to overflowing with
kimchi jars that have been stuffed
with clippings from the *New York
Times.* Choi consumed the kim-
chi (spicy pickled cabbage) over
the four-year period he was con-
structing this piece and then

replaced it with the newspaper
clippings. The kimchi, a sustain-
ing and visceral reminder of his
Korean homeland, is exchanged
for the public and disposable
accounts of American life docu-
mented in the newspapers. Al-
though they are placed inside
the suitcase, the bottles do not
represent baggage brought to
the United States from Korea,
but rather an accumulation of
time spent in America, in which
private memories of Korea have
been exchanged for American
realities. Filled to overflowing,
the suitcase can now no longer
be closed, preventing the immi-
grant from ever regaining the con-
nection to his homeland eroded
by years spent in America.

Arturo Lindsay

ALBERT CHONG
"It's Complex"

"WHAT DOES IT MEAN TO YOU TO BE OF CHINESE ANCESTRY?" I ASKED ALBERT CHONG in a recent telephone interview. "Not much different from being of African ancestry," he responded. Until recently, Chong's art only embraced his African or Caribbean ancestry. Having seen his recent work that openly embraced his Chinese heritage, I was curious to know what had brought about this change. After several attempts to get Chong to discuss his mixed-race Chinese ancestry, he finally confided, "It's complex." He went on to inform me that it is a question he is frequently asked, but one that he has not been able to answer very easily.

Albert Chong was born in Kingston, Jamaica, in 1959, the son of parents of mixed Chinese and African ancestry. Both of his grandfathers were Chinese, and his grandmothers were black Jamaicans. Like many other young Chinese men in search of work in the mid-nineteenth century, Chong's grandfathers migrated to Jamaica. This Chinese migration was not specific to Jamaica or the Caribbean. Often working in slave-like conditions, hundreds of thousands of Chinese immigrant workers provided cheap labor to other parts of the Americas.

While some returned to China after "making their fortunes," others sent for their wives and families or imported young brides from China to create new families and start new

businesses in the Americas. Still others married, took common-law wives, or lived with non-Chinese women, often over the objections or threats of ostracism from their families and communities.

In the nineteenth century, Panama, like Jamaica, experienced a great migration of Chinese laborers who, along with the Caribbeans, worked in appalling conditions. Many lost their lives and limbs during the construction of the Panama Canal and the transisthmian railroad. After the canal and the railroad were completed, a number of Chinese went on to California, while others remained in Panama to open small grocery stores. As a child growing up in Panama during the 1950s, I heard the word *chino,* literally "Chinese man," popularly used to refer to Chinese-owned mom-and-pop grocery stores. The term *chino* still has that double meaning.

In Panama today, there are many educated and successful Chinese families that own and operate import and export businesses, while others engage in farming, real estate, and politics.

According to Chong, his father was a living success story. He began as a poor man who moved from the country to the city. By the time Albert was born, the family operated a grocery store in Kingston. His father went on to become a very successful businessman and a beloved justice of the peace. He was often referred to as "The Justice."

As a child, Albert Chong was interested in identifying with his Chinese ancestry, but he did not find the Chinese community very accessible to or accepting of him. He could not speak the language, and he knew very little about the culture and traditions. According to Chong, not even his father, who spoke Cantonese, was accepted by the Chinese community. As a child, Chong's father also suffered abuses from his own father for being visually more black than Chinese.

Life among black Jamaican kids proved to be equally difficult for Albert. He was often taunted with such names as "Chiney Royal" or jeered with "Chiney man, nyam daug" ("Chinese man voraciously eats dog"), to which he would reply, "Niggah man nyam de shit out they battie" ("Nigger man voraciously eats the shit out of their asses"). Chong's mixed-race ancestry made it difficult for him to identify completely with either community.

It was the music and lifestyle of black Jamaicans, and especially the Rastafarian movement of the 1960s and 1970s, that would eventually determine Chong's identity. A 1979 Bob Marley concert at the Apollo Theater in Harlem was a seminal moment that forged the direction of Chong's life and art. "It was like watching a prophet of your people," he recalls. That moment led him to deeply and profoundly embrace Jamaican culture and Rastafarianism in particular.

Although Chong soon discovered that he could not be an orthodox adherent of Rastafarianism, he continued to find solace in the spiritual aspects of the movement. The Afrocentric tone of the movement also provided him with an avenue through which to investigate his African heritage. In his self-portrait series *I-Traits* (1980–85), he used Rastafarianism as a mirror through which to view himself.

The sudden death of his father in 1989 stunned Chong and left him filled with regrets. In an unpublished statement, he writes, "My inability to verbally express my feelings prevented me from telling him of the love and respect I felt for him. In dealing with his

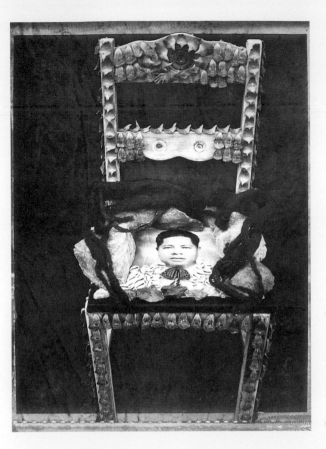

Figure 50.
Albert Chong

The Throne for the Justice: Variant with Monarch Butterfly for a Tie, 1990. Silver gelatin print, 40 × 30 in. Courtesy of the artist.

(PHOTO BY THE ARTIST)

Created in memory of his father, a Jamaican justice of the peace, Chong's *The Throne for the Justice* combines the spiritual traditions of his African and Chinese ancestry in a syncretistic New World mysticism. In drawing a parallel between the two traditions, Chong reveals a common, not always recognized bond between the displaced populations of China and Africa: the need and desire to translate the spiritual practices and beliefs of the homeland into a new, overseas context (Jamaica and the United States). In doing so, Chong creates a hybrid spirituality, a mystical practice that, while it seeks to recognize and maintain ancient beliefs, has been adapted to reflect contemporary, real-life circumstances.

Bringing the plane of the spiritual into everyday life is an important part of Chong's work. He seeks to imbue everyday objects (found materials, photographs, and items with bodily connotations such as hair) with spiritual and mystical significance. In combining his father's image with the dreadlocks, for example, he gives the memory of his father (whose visage is now only accessible through photographs) a more palpable, bodily association, inviting his spirit to "sit" on the throne and assume a place in everyday life once again. However, the transitory, ephemeral nature of this spiritual connection is evident in the fact that *The Throne for the Justice* is itself a photograph (as well as a three-dimensional object). It is as if Chong had attempted not only to invoke but also to capture the presence of his father's spirit on film. *The Throne for the Justice* is a poignant attempt to recover and honor the memory of a lost loved one in the context of the hybrid spiritual heritages of contemporary Jamaican culture.

estate, I learned more about him." The loss of his father forced Chong to realize he had lost an important link to his past and prompted in him the need to rediscover his father and his Chinese heritage.

Chong has been working on the idea of ancestral thrones from a New World African perspective for almost eight years. These works were conceived as places to seat the spirits of his ancestors or as shrines or altars on which to make offerings to them. His father's passing led him to create *The Throne for the Justice,* a multimedia installation that honors and venerates his father as an ancestor. The work has now opened a new door for Chong, inspiring him to create a series of ancestor-venerating works that investigate his Chinese ancestry in a deeply personalized manner. In a very sincere way, Chong confided to me, "I really don't want to give up part of my cultural heritage."

Like Africans, Chinese do not want to give up their cultural heritage, especially reverence for and veneration of ancestors. Chong is right: being of Chinese ancestry is not much different from being of African, or Native American, or Arab, or European ancestry. Maybe it's just being human.

■ ■ ■

GOOK
FAG
CHINK
FAIRY

Robert Vazquez-Pacheco

KEN CHU
You Don't See Yourself

IMAGINE SEEING YOURSELF IN A MIRROR BUT NOT YOURSELF NOT THE GUY/GIRL FILLED with your personal demons your own particular teenage madness—not the person that you can love or hate depending on the moon's location or the time of day or what you just said or how you're feeling now—you know the person who is too fat or too skinny whose skin is fucked up whose nose is weird whose hair is jacked up whose features are way too ethnic who's too stupid who's too girly/butch whose outside doesn't match the inside who just doesn't fit in—that's not the person you see not the one who you think you know best of all the fucked up one who feels like he/she is the only one in the world carrying all this shit inside them—you don't see yourself

nah you see other people's fantasies of you like a slide show where the image keeps changing—the kid who has hopes and dreams encrusting her/him until she/he suffocates under them—one minute you see that nice boy/girl who your parents hope will get married to a nice girl/boy and make them grandparents next minute, you see the high school graduate the hardworking college student who will become a successful and responsible american a pillar of the community—you see what your parents your ancestors your teachers the cops and the clergy expect you to be or you see the problem kid the fucked up ingrate—

maybe you see the evil one that forced your uncle or your cousin to do that to you—you don't see yourself

then you see the other fantasies people have about you the negative shit that drops on you like pigeon shit—you see the creature created by racism, by hatred because of the color of your skin and the shape of your eyes and your other language which is different from the main one—you see the model minority the yellow peril the one who gets beat up cause he/she ain't white you see the fear that makes them hate you because you don't want the wife and kids you want your best friend who is a boy/girl, just like you and that makes you weird so you see that poor sick twisted creature who will end up tied to a fence in wyoming or in a hospital bed or maybe stabbed on some empty street in the gay section of town— you don't see yourself

look at your reflection you see words like chink fag fairy gook that's what they think you are that's what they make you—what can you do you're only a fucking kid you got no power—nobody listens to you and after all maybe they're right after all you're asian and you're a fag/dyke/boy/girl—all you want to do is be yourself with no agenda you know just be happy so maybe then as you look at your reflection you see a way to make all those words all that pain that people put on you

you see a way to make it all go away a way to stop it—cause maybe you don't deserve love maybe they're right—so you make all those dreams and fantasies go away by picking up that razor or the pills and making sure that you won't see yourself again

■　■　■

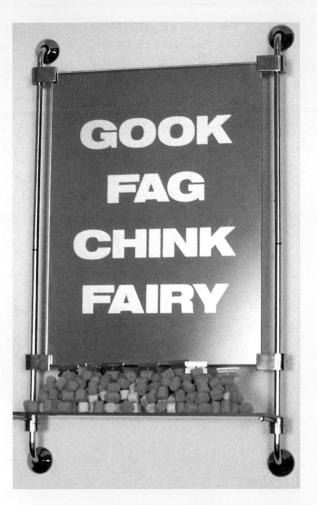

Figure 51.
Ken Chu
Boys Will Be Girls, 1997. Mixed media,
24 × 18 × 5 in. Aronson Galleries,
Parsons School of Design, New York.
Courtesy of the artist.
(PHOTO: DAVID TAFFETT)

In *Boys Will Be Girls,* Chu constructs a small altar to the complex process of self-perception in light of internalized racism and homophobia. Inscribed on the wall-mounted vanity mirror are the alternating racist and homophobic appellations *gook, fag, chink,* and *fairy.* The words inter-

fere with and distort what would otherwise be a clear reflection. Upon looking into the mirror, the viewer's image is literally labeled with personal slurs. This intermingling of words and reflection is a metaphor for the internalization of such slurs, and their incorporation into the self-image of the victim. That this internalization happens at the most private and intimate levels is reflected in the personal scale of the vanity mirror.

On a shelf in front of the mirror, like offerings at an altar to the self, sit pieces of bright pink chewing gum studded with razor blades.

This double-edged offering—at once seductively sweet and cruelly dangerous—extends the concept of internalized self-hatred into the viewer's physical space, translating it from the realm of vision into that of action. The objects themselves, sharp razors embedded in soft, flesh-like bubble gum, imply a disquieting, self-inflicted violence. However, as sweet treats that are meant to be ingested, they form a literal equivalent to the psychic process of internalization, reflecting in bodily terms its dangerous and life-threatening potential.

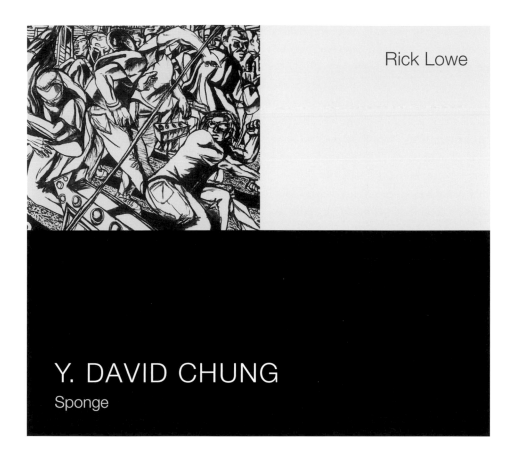

Rick Lowe

Y. DAVID CHUNG
Sponge

I HAVE ALWAYS BEEN INTERESTED IN HOW ART RELATES TO THE BROADER PUBLIC. MY own work centers around the idea of how the arts integrate into the flow of society at large. As I continue to explore, I find the connection between art and the public, between the audience and the creative process of the artist, between art-making and giving the audience the opportunity to participate in the process.

While at first glance Y. David Chung's *Third Ward Jungle* at Project Row Houses in Houston's Third Ward neighborhood may have seemed the result of an independent, non-participatory process, watching Chung work, I could see that his process exemplifies all the important aspects of integrating art and society. Even though the execution of this piece was mainly performed by Chung himself (there were some students who worked on the drawing), it was evident that the audience played an important part in the process.

Third Ward Jungle is a product of Chung's four-week residence in June 1996 at Project Row Houses. It is a charcoal drawing, approximately eight feet high and thirty feet long. The piece wraps around half of one of our small row houses. The thirty running feet are filled with beautifully stylized drawings of the row houses' courtyard and depict the chaos and energy that can be observed at the Project on almost any day: children running around exploring their creativity, young hip-hop artists acting out scenes from the latest Jackie

Chan film. The piece also captures many of the special moments that a watchful eye may encounter on any day: a poet stopping by to share the rhythms of his poetry, a neighborhood folk artist quietly working on a piece, a baby sleeping by the window.

Chung's piece itself is a wonderful work of art, but what really brought it to life for me and for most of the neighborhood residents was Chung's very open creative process. One of the reasons that I think he was able to grasp the essence of Project Row Houses and its surrounding neighborhood so quickly was his very fluid and open process. He allowed himself to become a sponge in this liquid environment. Of course, the first thing he did was to set up his work space, but almost simultaneously I could see him opening himself up to what was to become his content. While we walked from one house to another, I could see him absorbing the meaning of the landscape. He was always eager to talk to anyone who happened to pass by, whether they were artists, visitors, neighborhood children, or parents. It was almost as if he was about to put on a performance and he was scouting for a location and cast members.

Chung did not attempt to escape his audience and keep them away until the time of the "unveiling." He engaged them, soliciting input from neighbors and other artists alike. As he got to know many of the people around him and as they got to know him, they would discuss the neighborhood and the piece, and new images would appear, often depicting someone Chung had been conversing with. I felt as though there was a collaboration going on. The neighborhood would inform him and then he would execute the drawing. Maybe Chung's knack for involving his audience stems from his experience as a multimedia artist.

The last image in this panoramic-style drawing is of a wonderful ice storm on a sunny ninety-four-degree day around the end of June 1996. I guess that was about as appropriate a time as any for him to stop, but the Project Row Houses and our neighbors can't wait to have Chung back to reveal more of the elements of our lives to us.

■ ■ ■

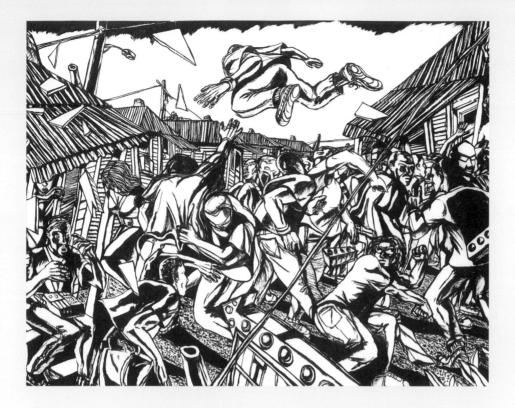

Figure 52.
Y. David Chung

Third Ward Jungle (detail of *The Flying Man*), 1998. Oil stick on paper, 8 × 60 ft. Made at Project Row Houses, Houston. Courtesy of the artist.

(PHOTO BY THE ARTIST)

This detail is an example of Chung's long-running interest in the products of cross-cultural interaction. As a young man, Chung worked in his family's grocery stores, which were located in predominantly African American neighborhoods. Powerfully influenced by this experience, he has dedicated much of his work (such as the collaborative rap opera *Seoul House*) to exploring the urban interface between immigrant and American cultures. Houston's largely African American Third Ward neighborhood was the perfect setting for the continuing development of this theme.

Rendered in Chung's signature energetic drawing style, this section of the mural references a common theme in African American folklore. A lone man flies effortlessly above the chaos of a street riot, out of reach of the tumult below him. As a representation of freedom, the Flying Man is a fantastical figure, capable of literally rising above the chaos and oppression of a racialized existence. The folktale's reliance on a superhuman ability to escape oppression is a poignant reminder of the powerlessness and frustration of the African American experiences from which the folktale arose, but it is also an expression of profound hope that resonates across ethnic and racial boundaries.

Chung created the mural within the setting of the old row houses, which had been converted into an art center (as well as a home for unwed teenage mothers). Learning about and interacting with the neighbors and combining and distilling these experiences through his own vision, Chung created a work that reflects his deep interest in the formation of new, hybrid cultures, intermingling the identities of people that previously had little or no contact.

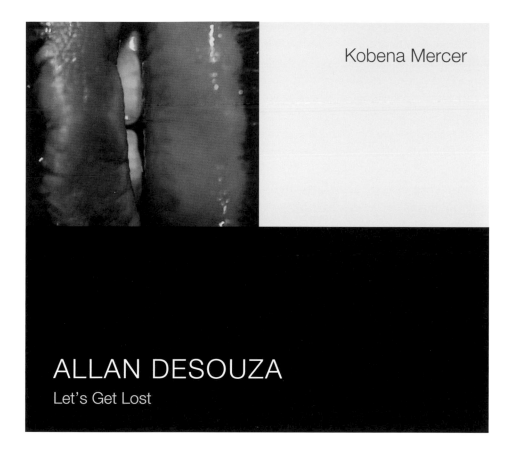

Kobena Mercer

ALLAN DESOUZA
Let's Get Lost

TRAVEL BROADENS THE MIND, OR SO THE CLICHÉ TELLS US, BUT WHAT HAPPENS TO your body during the journey? Unlike tourism, where the pleasure of taking a trip outside yourself depends on the guarantee of return, travel entertains the risk that unforeseen and uncontrollable events may turn you away from your goal. By deferring the desire to return, travel opens consciousness to uncertainty and hence to opportunities that may lie in loss—the loss of illusions, the loss of attachments, the loss of identity. Earlier this century, anthropologists who felt threatened and/or tempted by this prospect called it "going native." At century's end, ironically enough, postcolonial artists who wish to evade capture as "native informants" often find themselves passing through the subjective spaces of migration, diaspora, and multiple belongings in ways that re-route the displacement of the self. Where colonialism demands a fixed identity that must always know its place, the postcolonial replies: get lost.

Allan deSouza's art has traveled through a range of media to "create fictional narratives which, masquerading as autobiography, cast doubt upon the process of truth-making."[1] Born in Kenya in the 1950s and emigrating to Britain while young, deSouza was a key presence in the 1980s Black British arts scene. Since relocating to the United States in the 1990s, he has collaborated with his Korean-born partner, Yong Soon Min, in performance and

photo-based projects such as *AlterNatives* (1997). Exploring ambiguity and authenticity in codings of cultural difference, deSouza draws insights from his passage between territories of ethnic classification—Asian means South Asian in the British context, while in the United States, it refers primarily to Asian Pacific—and his work often takes such "discrepant cosmopolitanism" as a starting point for projects that reveal various knots and slippages in socially received maps of cultural differentiation.[2]

Dick and Jane (1997), evoking the mythically innocent names of the characters found in storybooks that teach children how to read, challenges deSouza's viewers as to the reading of his stance on sexual difference. The *Dick* series is comprised of close-up photographs of a man's mouth agape, fleshy lips parted to reveal glistening white teeth surrounded by shadows of dark bristles of facial hair. *Jane* consists of a series of written utterances pictorially arranged into the shape of vases, the lettering raised up like welts on the skin by the way the computer-generated print abrades upon the flesh-toned canvas. Conceived and named separately but exhibited as complementary, there is something slightly awry in *Dick and Jane's* re-presentation of the supposed symmetry of sexuation. Rotated onto a vertical axis, the photograph of the man's mouth can be visualized as a woman's vulva, which suggests that the underlying masquerade reveals fetishism as the archetypal male response to the fear of genital difference. As deSouza himself comments, "The man's mouth, in mimicking the object of male heterosexual desire and anxiety, becomes its own fetish: the *missing* dick, as it were, [represents] the fear of the vagina dentata, of castration."[3] Knowing that the man's mouth is deSouza's may encourage an autobiographical interpretation of the work as a self-representation of deSouza's personal journey from gay to straight identity. But the notion of such a unidirectional movement from A to B—as if the dynamics of sexuality were the same as traveling from one country to another—is undermined by the manner in which *Dick and Jane* shows that sexual difference does not quite work in such a simplistic A : non-A way.

In the *Jane* series, the image of the vase connotes the crudely masculinist belief that the vagina is merely a receptacle or vessel (for penis or fetus), yet the possibility of an autonomous female presence is erased by the third-person pronoun that marks the subject of each utterance as male, although what kind of male he is we cannot be too sure of, after all—*He was the Lady Macbeth of the family; He practiced diligently at being a woman; He groped for her penis and woke as his hand came up empty.* Because the *I* of enunciation is male in both series, visually masquerading in the former, textually fictionalized in the latter, *Dick and Jane* de-stabilizes the subject/object boundary of the me-Tarzan / you-Jane dichotomy. Not only does it parody the self-referential solipsism that accompanies classical Oedipal anxieties (where, for masculinity to be founded as a "true" identity, it requires a false and fictive Other, which makes the feminine the domain of masquerade and dissimulation), but it outwits an identitarian reading by implying that the boundary between homosexual and heterosexual masculinities may not be that clear-cut either. In my view, the intense lighting effects that arouse the curiosity of the scopic drive in the *Dick* photographs heightens the visual equivalence of mouth and vagina, which thus erodes the subject/object differentiation on which *desire* ordinarily depends: what we see instead is an act of *identification* in which "I am the object"—an altogether more complex insight

In naming these works (from the
Dick and Jane series) after the
characters from the classic chil-
dren's reading primers, deSouza
affirms that gender and sexual
differentiation are functions of
language, and are thus suscep-
tible to deconstruction and manip-
ulation. *Dick* confuses biologistic
ascriptions of gender identity by
turning a lushly photographed
image of a male mouth, replete
with mustache and beard, on its
end so that it suggests a female
vulva. By transforming a mascu-
line body part into a stand-in for
the marker of feminine difference
and lack (the absent "dick"),
deSouza invokes not only refer-
ences to castration anxiety (a
vagina dentata) but to gay male
oral sex. The boundaries between
male and female, gay and straight
become confused by concen-
trating all of these associations
in one iconic yet liminal image.
Similarly, in *Jane,* opposing gen-
der associations occupy the same
space, blurring the boundaries
between them. In each print,
sentences narrating various
(and humorous) instances of
male gender and sexual ambiguity
are arranged to form a stereo-
typically feminine vessel or vase-
like shape. The stories at once
construct and "fill" the vessel,
constituting a space that is
neither clearly male nor entirely
female. In creating these am-
biguous images, deSouza
questions and confuses the
conventional definitions of gen-
der and sexual identity, reveal-
ing that they are inadequate
to describe the multiplicity and
fluidity of individual experience.
In exposing the inadequacy
of such binaristic definitions,
Dick and Jane effectively pro-
vides a starting point for a
new understanding of human
sexuality.

into the vagaries of gender and sexuality as symbolic positions we are obliged to occupy, but which mostly engender nothing but unsatisfaction.

Representations of the (male) body have been a consistent feature in deSouza's work, from the Xerox body-prints exhibited in *Ecstatic Antibodies* (1990) to the painterly triptych *Something Stirring in a Rose Garden* (1990), depicting a young man about to get fucked by an older man in a graveyard setting, witnessed by a pair of hovering angels. Such works highlight deSouza's interest in elements that art history often assigns to the feminine, such as the decorative and the detail. With its multi-positional identifications, *Dick and Jane* can be seen as an unanticipated turn along the same journey, broadening deSouza's artistic trajectory as he continues to operate within the interstices of the individual contingencies of biographical happenstance and the governing fictions of the symbolic materials of which social identities are composed.

Loosening the ties that bind the body, and the voluptuous peculiarities of human flesh, to the grim weight of the sedimented codes that demand that we must stay in place beneath the signs that make our bodies socially readable, deSouza's strategies de-couple the conventions of sexual boundary-marking by working with the ambiguities and uncertainties that arise in the permanent gaps between body and language. Without such gaps, movement is impossible. By drawing our attention to their presence, with humor and subtle gestures, Allan deSouza's art embraces the happy accidents of uncontrollable events that may move us into the kind of queer little places we might never have otherwise known.

■ ■ ■

Gina Dent

MICHAEL JOO
A Rock and a Hard Place

AT THE PLACE WHERE TWO PATHS OF HISTORY CROSS, THE NATURAL AND THE SOCIAL
meet. The ancient tortoise confronts its modern competitor—the image and its afterlife.
A video projected into a three-dimensional space is shot through with the precision of a
laser that fails at the same time to deflate it. The structure is in the way we perceive this
play of light and fog, watching the story unfold in three equal parts—the wish-fulfillment
of an ethnic dream made in advance and made over as kitsch (the Asian American self as
martial artist); the illusion of the nonviolent capture of living things (an image of the an-
cient mammal marking its way through time and space); perhaps the most human of ges-
tures represented in quantified form (a flash of information containing the exact caloric
expenditure required for suicide).

These stories are already ours, so familiar to us, but from where? Watching this, it is
difficult not to feel weightier, as if the fog seeps inside us, making not only the image but
our bodies denser. Humanity may consist of the work of self-representation in an envi-
ronment of confounding historical claims, extracted from us without permission.

Too much information. Science invades flesh; this is what kills us, not the natural or-
der of death and birthing, the romance of time. Living in the image, we understand our-
selves already as the products of a self-estranging science that forces us through the glass,

looking. We meet on the other side, but some fail to arrive, either because they have not been sent or because they have never unthought themselves and the machine we are inside of. Of such an otherside, racialized self someone once wrote, "We the machines inside the machine." Colored bodies are science in space, the science of space; like the image trying to extend in fog beyond its two dimensions, we strive for a fourth. And yet we see ourselves in multiplex polychrome, already digested. How many calories were burned?

Burnings in photographs, overexposed. The divided histories of science, of the image, and of the flesh threaten to converge here. The promise of new vision is seductive, pulling at the heart. So I do what I must and begin counting the beats. It helps when you know where to concentrate. Then again, there is a possibility; maybe something will shift against the failed narratives of science.

Something to learn: where knowledge ends. Something to feel: where knowledge begins. Some things to do (excerpted from a long and personal list): ask someone; see without looking; find out if there is a number greater than three—since nothing consumes more energy than belief (over ten thousand calories, according to Michael Joo).

■　■　■

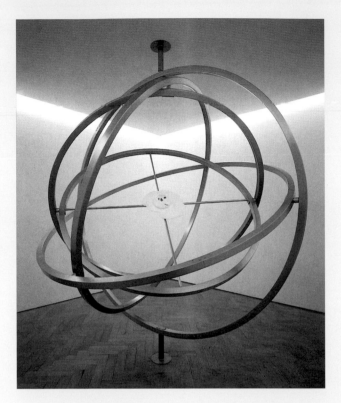

Figure 54.
Michael Joo
Conserving Momentum
(Egg / Gyro / Laundry Room), 1998.
Stainless steel, bronze, glass, and
mixed media, 106³/₄ × 96 × 2 in.
Courtesy of White Cube
and Jay Jopling.
(PHOTO: STEPHEN WHITE)

The formal reference for *Conserving Momentum* is that of the
gyroscope, a mechanical device
whose own perpetual motion
keeps it in the same place. This
physical contradiction provides
the logic for the piece.

Although not a working gyroscope, the piece's rings can be
repositioned by the viewer, allowing for a customized—either
closer or more distanced—view
of the center of the piece. Suspended in the center is a cast of
a fried ostrich egg. Chosen for its

scale, the egg gives the piece a
biological connotation (suggesting an atomic or cell nucleus) in
addition to the mechanical one.
As the raw material for life, it provides a biological counterpart to
the potential energy inherent in
the gyroscope. However, the fact
that it is a fried egg implies the
intervention of culture—it is a
processed, rather than natural
nucleus, cooked, and thus deprived of its potential. Adding to
these contradictions, the yolk of
the egg has been replaced with
a crystal snow globe, filled with
water, fake snow, and a miniature
diorama of a laundry room, complete with washing machines and
two pairs of pants, one adult-size
and one child-size. This hermetically sealed scene suggests a
kind of manufactured purity. In it,
the (possibly sexual) impropriety
implied by the "dirty" pants of the

adult/child couple is subjected
to a mechanical cleansing. By
compressing all of these contradictions into a single structure,
Joo demonstrates how our experience of physical reality is
inextricably intertwined with and
contained by a scientific structure
of understanding. The psychosexual drama of the domestic
sphere is laundered clean, neutralized; the egg, symbol of
organic potential, is cooked,
rendered impotent; the gyroscope is in constant motion, yet
makes no progress. This continuous process of cleansing
and negation defines the scientific rationale. Joo exposes the
myth of scientific progress by
demonstrating how this process
is essentially conservative: it
remains in constant motion in
order to remain in the same
place.

Lowery Stokes Sims

JIN SOO KIM
Primal Energy

JIN SOO KIM IS KNOWN FOR HER ROBUST ENVIRONMENTAL INSTALLATIONS AND SCULP-
tures that recycle found materials and objects. *Body and Shadow II* (1992) consists of a
mattress that has been stripped of its batting and cover. Its coils have been re-wrapped.
The result is both graphic and psychological. The spiral and circles of the coiled springs
appear as ideographic elements within the grid of the support elements, while the linear-
ity of the skeins of the wrapping conveys the experience of confinement and the desire to
break free.

Kim's artistic strategy of wrapping and weaving indicts the wastefulness of America's
consumer society and, at the same time, recalls pre-industrial Korean society in an era when
everything was done by hand.

The intensely primal energy that emanates from Kim's work finds affinities with ten-
dencies as diverse as Italian arte provera and aspects of expressionist sculpture in the 1950s
and the minimalist sculpture of Carl Andre, Christo, and Robert Smithson in the 1960s.
But materials are not mere fodder for art from Kim's point of view. There is an affinity
with the surrealists in her response to the "poesie" of the found object. She is also acutely
attuned to the former condition of these elements, as well as the resonances of their for-
mer owners. Kim has noted her interest in forms such as mattresses for what they convey

about the body and human experience. Her reworking transcends their humble, even re-pugnant character, so that they, in the words of Regina Coppola, serve "as a kind of ac-cumulative tribute to intermingling memories from different sources, and to the time borne by human labor."[1]

In contrast to *Body and Shadow II,* the works from the *imprints* series (1994) are more subdued in physical presentation, although no less intense in content. Kim sets the nar-rative against a background of monochromatic washes of pigment that maintain their own abstract character. The twelve panels deal with the Los Angeles riots sparked by the ac-quittal of the police who beat Rodney King in 1992. In one panel, we read the words of a Korean American mother and her son, who was killed during the riots. In another, a young black man reflects on his relationship with Koreans.

That these panels are meant as a statement of healing is symbolized again in the way they are constructed from steel panels wrapped in plaster bandages. As the wet bandages dried, the rust that was formed came through and stained the surface. Kim then imprinted the lettering onto the surface through carbon paper, hand-etched under velum on which the text was printed. For Kim the process was intended to humanize the content, "allow-ing the events to be repeatedly revisited and memorialized while [she was] working on the piece. . . . The materiality of the steel and bandage caused its own staining look which . . . seems to refer to a staining or draining, as when someone cries and stains their face or when bandages are soaked with discharges or exudate after a wound is dressed."[2]

Kim is extraordinarily sensitive and sympathetic to different points of view and expe-riences, despite their divergences. Her chameleon-like "performance" recalls Anna Dea-vere Smith's one-person theatrical revues that present the diversity of American voices in conflict, in pain, in anger and resolution. Kim's panels create "portraits" of unseen indi-viduals in much the same way as her manipulated objects.

Although they seem disparate in approach, *Body and Shadow II* and the *imprints* se-ries deal with similar themes, chronicling the tensions of contemporary society—the first metaphorically, the second literally—where human beings as well as objects can be used and cast off. Kim also conveys the tensions of existing between two cultures, both as an expatriate and as a member of American society. Through her direct engagement of the materials of this culture, Kim is creating her own private model of the United States.

■ ■ ■

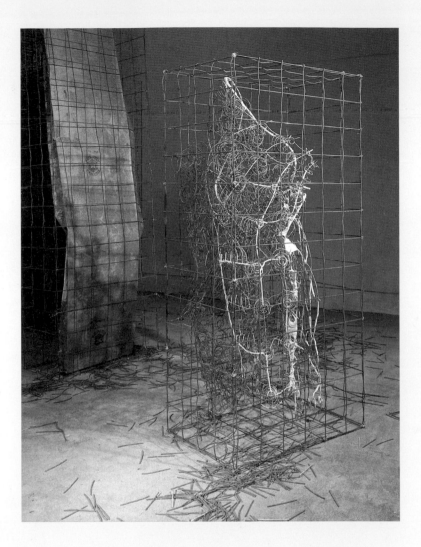

Figure 55.
Jin Soo Kim
Body and Shadow II, 1992.
Bedspring, steel, plaster bandage,
78 × 37 × 25 in. Courtesy of the artist.
(PHOTO: MICHEAL TROPEA)

A torso constructed out of the cast-off bedsprings from a mattress is encased within a grid of metal wire. The bedsprings are bent and twisted into the unnatural (for them) shape of the torso, creating a palpable tension between the energy contained in the springs and the lines of the torso. The springs appear about to explode outward, threatening to dissolve the torso altogether. The piece thus strikes a tense balance between the original shape of the machine-produced bedsprings and their new, human form. Old mattresses bear the marks and indentations of the bodies that have slept on them. The bed, as a site of repose, is perhaps the most personal of mass-produced objects. Kim emphasizes this intimate relationship by literally constructing a body out of bedsprings. Her desire to preserve rather than discard the bedsprings is further reinforced by her use of the wire cage. The cage protects the bedspring-torso and bespeaks an impulse to contain and memorialize it. As part of a series of caged objects, *Body and Shadow II* is part of a larger effort on Kim's part to preserve and recycle discarded and forgotten objects that bear poignant traces of human life.

Griselda Pollock

HUNG LIU
Odalisque

PAINTING IS A RETURNED GAZE UPON AN ABSENCE, A LOSS THAT IS SUMMONED BACK to meet us at the surface where the painter has worked and history has been invoked.

But whose history?

The artist herself emerges from the interviews and documentaries that narrate the "artistic biography" as a historically charged figure. Even snapshots from "the family album" flip us from the present-day United States to the still almost inconceivable social turmoil and personal dislocation of Maoist China's Cultural Revolution. On the cusp of further education and study as an artist, Hung Liu was sent to be "reeducated" by working in the countryside with the peasants. She tells us that, amidst her toils, she made sketches and drawings and took snapshots of the villagers every day, a ritual that marked the bridge between the desiring subject and the reprocessing of the social subject that was the ambition of the Cultural Revolution. Since the late 1980s and early 1990s, the artist has been working with a cache of photographs from the turn of the century that capture in Western modernity's mechanical gaze the last days of the imperial era—its royal icons, highborn concubines, and child prostitutes. Bodies as signs traverse the unbridgeable gap Roland Barthes defines as the specific spectatorship created by photography's temporal and spatial dissonance: here- and then-ness.

What could be more removed form the vivid experiences of one of the most cataclysmic experiments of China's political modernity than the almost lost relics of the Imperial Age, preserved in the frozen moment of the camera's opened shutter?

Hung Liu finds herself a ghostly wanderer in the uncanny spaces of a China that is now almost unimaginable, though itself less than a hundred-year turn away. Painting from these photographs, she touches a moment that registers the encounter between a past China and another facet of modernity—the trope of the prostitute: sexuality as commodity advertised through the relation of displayed body to the gaze of that Western technology, the camera. Fully dressed, yet reclining in the erotic pose derived from Western paintings of the nude, a young Chinese woman looks toward the viewer from that complex historical time. The painted encounter with the photograph re-creates a space now continuous with the spectator through the framing of the large canvas upon a shelf supporting real vases and gilded flowers. Here, in our space, then in her time, we encounter death and the attempted defeat of that loss by painterly invocation.

Painting is a medium of fluidity. In the painting, the hard fixity of photography's light-written image is infused with color and begins to swim before our eyes. The stiff edges of the young woman's white tunic are set off against the modulated reds of the couch, and her full trousers accentuating painfully tiny touches of white that are the child's bound feet, the feminine sacrifice to the patriarchal logic of woman's lacking otherness. Below the couch, the linseed-rich paint flows and drips in evocation of both traditional Chinese literati painting and the gestural trace of American high modernism. Beyond this hybridization lies the refusal of the dominant ideology of socialist realism in which the painter was trained, while the bold translation of the tiny photograph of an unknown sex worker into a monumental figure painting retains that ideology's attempt to offer the stage of representation to the proletariat. The running paint signifies both the "unfreezing" of the image and the intervention of another woman, the painter, and another time, a permanent now.

How can such an image escape the orientalist gaze, rooted as that is in the colonial moment when the camera lens reproduced the gaze of the West to record and create the exotic otherness it had desired to find and display? This painting layers four gazes. First, there is the gaze of the Chinese photographer seeing his object through the orientalizing codes of the photography he harnessed for the local sex trade, an internalization of the colonialized as (Western) self-consolidating other. Then there is the return gaze of the young woman, directed at an imagined client and framing a potential sexual encounter. This is for me the punctum of the painting—the thin line of unknowns where the familiar turns strange and the past returns to place us amid all that subsumes a vulnerable girl-child into a commodity for men's sexual use. Around that punctum plays the third gaze, that of the painter, that fluid, present gaze that circumvents the specular politics of both the photograph and its cross-cultural freights. Finally, the painting, the product of that missed encounter, falls under the gaze of the viewer, within the gallery space of the United States in 1992 or now in this book.

How does the play of these gazes interrupt or realign them through the collapsed time of painting's return journey? How does time collapse while the markers of another time

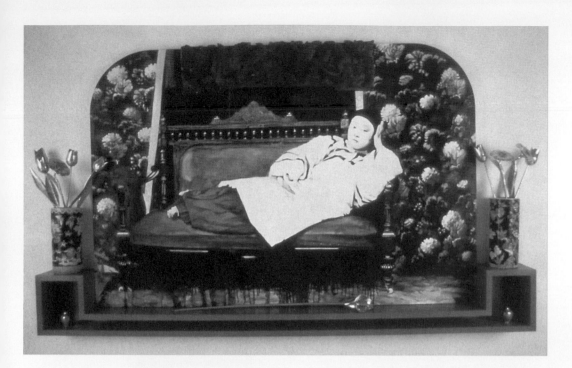

Figure 56.
Hung Liu

Odalisque, 1992. Oil on canvas,
wood, ceramic, antique wall panel,
$52^1/_2 \times 95 \times 8$ in. Collection
of Barbara and Eric Dobkin.

(PHOTO: BEN BLACKWELL)

In *Odalisque,* Liu creates a
monumental altar to an anony-
mous woman, a turn-of-the-
century Chinese prostitute. In the
process she opens up a window
into the complex processes of
perception and representation
in the history of the relationship
between China and the West. By
transforming the small, intimate
photograph into a large-scale
painting, Liu not only reclaims a
place in history for the prostitute
(so often left out of accounts
of China's glorious past), but
documents and foregrounds
the relationships that made the

photograph possible in the first
place. Western technology,
namely photography, enabled
the commodification and con-
sumption of sequestered Chinese
female bodies by thrill-seeking
Western voyeurs. The traditional
Chinese clothing of the woman
in *Odalisque* contrasts with the
ornate, Western design of the
sofa upon which she reclines
and the flowered, Victorian-style
backdrop. These trimmings ren-
der the woman's image at once
more familiar to a Western eye
and resolutely foreign, registering
a tension in the imperialist desire
to simultaneously control and
exoticize. By recasting this ten-
sion in a Western, painterly style,
Liu turns the relationship between
the commodified woman and the
Western consumer gaze inside
out. As a Chinese woman using a
traditional Western medium, Liu is

now the one controlling and redi-
recting the viewer's gaze. Adorned
with Chinese vases that contrast
with the Western furnishings in
the painting, the three-dimen-
sional shelf on which the painting
rests extends the direct gaze of
the woman into the viewer's own
space. The scale and style of the
painting, in combination with the
shelf, recontextualize the image
to present it as a kind of updated
altar to an ancestor. The invo-
cation of the altar simultaneously
situates the painting in a Chinese
cultural context and, by offering
an image of a prostitute for wor-
ship, subverts the notion of a
noble, pure Chinese past. Oddly
enough, it is only through the
historical intervention of Wes-
tern technology that Liu is today
able to reclaim and commemo-
rate a neglected part of Chinese
history.

and space are so overwhelming in their otherness as to leave us both fascinated with that difference and bereft before it?

This image, made by a Chinese artist now living in the United States as part of a series of paintings made from photographs of imperial China's last days, may function as a kind of *Trauerarbeit,* a work of mourning. In it, we witness a working-through of generational, geographical, and personal dislocation created in the unassimilable discontinuities between old China and the modernity Hung Liu experienced as a young woman, as well as between China and the West. Through this painting practice, the trace of that then-ness has the immediacy of here-ness before me, meeting my gaze. Multiple losses are registered and encountered, and the central thematic of the postmodern era, trauma, seems to enter in to endow Hung Liu's paintings with a tenderness of tragedy and the sternness of a determined refusal to forget the forgotten.

■ ■ ■

Luis Camnitzer

YONG SOON MIN
Defining Moments

TO STUDY ONE'S OWN NAVEL, OR THE ACTIVITY OF LINT GATHERING, HAS ALWAYS BEEN a metaphor and euphemism for waste of time, self-indulgence, and narcissism. Even the mystical interpretations of tunneling into the deeper self to get in touch with the essence of the universe share some of these traits of self-centeredness and self-indulgence.

Yong Soon Min's use of various individuals' bellies and navels in *Belly Talk* reverses these assumptions. The navel becomes, after self-understanding, an organ of outward expression of communication with others. The belly becomes a landscape—*the* landscape— possibly the only territorial property of which one can claim ownership unencumbered by artificiality. Here, body and landscape become an individualized unity. This unity reflects the owner by establishing a relationship with the property of that landscape, as much as the face does, by individualizing the landscape. However, a face is loaded with psychological projections and interpretations, while the belly is bare and nevertheless particular. It is the perfect valley to have resonate with precision the echoes of that equally particular statement emitted (or birthed) from the elements that shape that landscape.

Min's act of landscaping is even more pointed for those of us who have lost our traditional terrains and who, because of uprooting, end up associating any perception of a landscape with foreignness. The original landscape is located in memory and is incompletely

accessible. The "real" original landscape from where we came continues to evolve on its own, unaided by our witnessing. The new landscape that now envelops us remains forever a borrowed one. The murmur of the trees, the color of the air, the smell of the rain, are gone and usurped by strange noises, shades, and odors difficult to order.

In her earlier *Defining Moments* series (1992), a six-part photo ensemble, Min used her face and body to register the traumas that disrupted and reshaped her original landscape and that displaced old myths. She then recorded and mixed the disorders supplied by the new landscape. In her biography, continuity and sanity are provided by her face and body. External events puncture her image but are unable to destroy it. They are "defining moments" because they reaffirm the survival and integrity of Min's image.

In *Belly Talk*, four years later, these moments have become orderly not only through a compression into a spiral of text, but through the veil and administration provided by memory. They become Nazca drawings where the message, unable to blind, is blended with the awareness of a detached perspective. They grow from what started as a scream to a methodology to be shared, one that teaches mature survival.

■　■　■

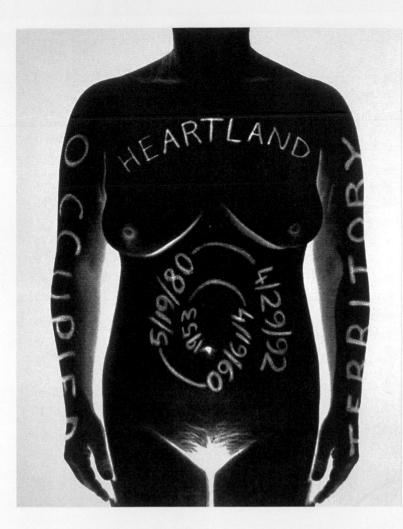

Figure 57.
Yong Soon Min
Defining Moments, 1992.
Six-part black-and-white photo-
graph ensemble, 20 × 16 in.
Courtesy of the artist.

In *Defining Moments,* Min has
photographed her own body,
inscribed with a series of signifi-
cant dates that form a spiral
across her belly emanating from
her navel. Each date holds per-
sonal and historical significance,
attesting to the intertwining of
public and private experiences in
the formulation of identity. The
year 1953 marks the year of
Min's birth and the end of the
Korean War; April 19, 1960, is
the date of the student uprising
that overthrew Syngman Rhee's
government, and 1960 is the
year Min emigrated to the United
States; May 18, 1980, is the date
of the Kwangju uprising and mas-
sacre, in which 240 students were
killed while protesting martial law;
and April 29, 1992, is the date
of the Los Angeles riots, which
had a profound impact on the
Korean American community in
the United States. Collectively,
these dates create a chain of
"defining moments" that have
shaped Min's life as a Korean
American, an artist, and an ac-
tivist. Emanating from her navel,
they form a lifeline of sorts, a link
back through time, a way of re-
membering and commemorating
the past. Min positions her body
as landscape or homeland, label-
ing her chest "Heartland" and
her arms as "Occupied Territory."
Home has become a construct
that she embodies rather than
occupies.

Laura Elisa Perez

LONG NGUYEN
Flesh of the Inscrutable

This body is an enigmatic sign, a hybrid whose impassivity is at odds with the itinerary of pain recorded on its skin.

One hand further opening the gaping hole in the trunk of the body, the being reaches within as if searching a bag or drawer, lips pursed in concentration.

What does it seek to discover? What does it uncover?

There is another visible hole, an anus, like an Oh or a zero, that is perhaps also the mark of missing genitalia and limb.

If it is a he, he is femaled in a map of opened and torn tissues.

This form of being, this s/he, is remnant, scar, hole.

Yet, a hole that if wound is also aperture; a flesh that if scarred is also luminous; a remnant that remits as much to what is missing as to what is not.

A skin meticulously stripped away by self or other, or both.

A flaying, a mutilation, a vivisection that is perhaps none of these.

Inside and out, the being is made of the same evanescent sea of light into which an unfinished limb fades.

Framed by shells in each of the corners, the painting pictures a fluidity where external and internal, surface and interior, limit and limitlessness, manifestation and nothingness, merge in a sea of precipitating and dissolving forms.

The painted canvas is also a s/he: the body as parchment, bearing the inscriptions, excrescences, uneven colorations made in embodiment, through stories of being as s/he.

A codex-like parchment, recording the simultaneity and imbrications of the sublime and the historical, in the strange hieroglyphic of a serene, bloodied figure, afloat yellow waters.

Yellow waters, yellow canvas, yellow parchment, yellow histories, yellow skins.

Yellow: the color of the occident's cultural unknowns, colored through both attraction and repulsion, like all that seems enigmatic.

The inscrutable, once presumably illustrated in bodies colored yellow; indeed, painfully inscribed as such.

Moments and ways of being, some so raw, some so luminous that they are only partially told in tales of yellow skin.

■　■　■

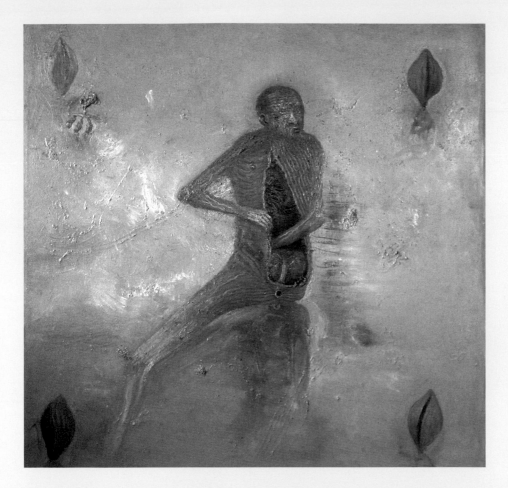

In *Tales of Yellow Skin #2,* Nguyen depicts a flayed, castrated, one-legged man with a gaping wound in his torso, suspended in a viscerally textured sea of saturated golden yellow. Despite his damaged condition, the man's expression is calm, resolute as he reaches one hand inside the wound. For Nguyen, this probing represents a kind of visceral soul-searching, a mark of self-examination and hope rather than an invasive, self-destructive gesture. In fact, the static, balanced composition of the painting and the man's matter-of-fact facial expression combine with the image of the flayed and damaged body to create a surreal effect: at once serene and gruesome.

This contradiction is informed by Nguyen's experience as a Vietnamese refugee and his studies in Asian religion and philosophy. Fleeing South Vietnam by boat, Nguyen was separated from his parents, lost at sea for several days, and transported to a refugee camp. He eventually emigrated to the United States. This transitory existence, combined with his study of Asian philosophy, Buddhism in particular, has impressed upon him the need to accept the vicissitudes of a fate not entirely of his own making. His use of the gaping wound or orifice is indicative of the balance between the violence of upheaval and a Zen-like receptivity. The hole in the torso is a wound, evidence of a violent invasion of the body. However, the fact that Nguyen's figure holds the wound open and actively reaches inside contradicts this notion of invasion. Orifices such as mouths, eyes, ears, and noses are the ways in which the outside world is taken in and understood. Nguyen transforms a wound into an orifice—a symbol of pain becomes a symbol of understanding.

Enrique Chagoya

MANUEL OCAMPO
Apocalypse Now

PERHAPS MANUEL OCAMPO'S FIRST IMPORTANT ARTWORK WAS A TRACING HE MADE AS a child of a religious image from a calendar his mother had hung on the wall in their home. The child Manuel took a pen and made bold to paint mustaches on the Madonna and the Baby Jesus. The artist tells us that his mother punished him very harshly for committing this audacious act. Some years later, perhaps by way of revenge, Ocampo returned to the religious format. With several artist friends, he painted Catholic icons in a Filipino colonial style, making them appear old and then selling them to European and American collectors of antiquities. Ocampo still takes delight in this experience as a triumph of his plastic capabilities, and above all as a spiritual reaffirmation, as if he had had the vision of a heaven awaiting his flight to it.

Ocampo feels a great attraction for Mexican altar pieces and votive offerings, admitting that they are a constant source of inspiration for his art. This affinity is no accident. The colonial art of Mexico and that of the Philippines are very similar in the blending of the Spanish baroque with the dramatic touch of native artists in the two countries. It is a fusion that emerges from a violent cultural clash. It is full of wounds resulting from opposite genes combating each other in a war to the death, but from this struggle a new hybrid culture emerges.

The Philippines and Mexico were conquered by the same Spanish empire and later became parts of the viceroyalty of New Spain (Mexico), establishing a very important commercial bridge with Asia. The so-called Ship of China, or the China-Philippines-New Spain-Spain maritime route, was in its day an intercultural bridge of overwhelming importance to all of the countries involved, despite the unequal trade between the dominated and appropriated/expropriated colonies and the dominant, appropriating/expropriating and colonial European mother country.

In Ocampo's view, the connection is neither geographic nor linear. His paintings come from a country that does not exist on our maps, from a place not yet "discovered," from a culture that has not been colonized but nonetheless knows of the existence of colonialism, and in a bold libertarian exercise conquers the conqueror, appropriates the appropriator, as in Ferdinand Magellan's death by execution at the hands of the islanders during his desperate attempt to colonize the Philippines.

Manuel Ocampo appropriates the baroque colonial style and transforms it, taking possession of the saints, virgins, Christs, angels, and demons and bringing them to us in the present as if bidding farewell to the century and the millennium and depriving them of their functions of granting indulgence, washing away sins. He converts them into their opposite; heaven is taken by storm; paradise is invaded by hell; the body of light is subdued by the dark body. They killed God long ago, force triumphs over reason, and justice is massacred by ever-present and omnipotent governments, which in the end are rewarded with amnesty.

Ocampo takes us to a country that has no borders, a world in which physical torture is in truth a mutilation of the spirit. This is a dimension of reality that we very often do not wish to see, even though we are living it daily. We prefer instead to replace it with a virtual reality. Fortunately, we sometimes come upon artists like Manuel Ocampo who show us the dark essence of a very harsh reality and give us a jolt, perhaps in the hope that we will change it, perhaps dreaming that there could be more than 144,000 survivors of a final holocaust we have caused ourselves. Or better yet, that this holocaust need never come.

Fundamentally, the most important element in the artistic work of Manuel Ocampo is not a kind of religious irreverence, nor any war of an ethnic or anti-colonial nature. Rather, it is the struggle of the spirit to survive the limitations of matter. It is the spirit (not the illusion) of freedom attempting to escape from the forms of fundamentalism that imprison it. It has run out of patience and can wait no longer, and it wants to take furious flight from its cage without asking permission, without polite or courteous observances. It is a spirit ready to do anything to be free.[1]

. . .

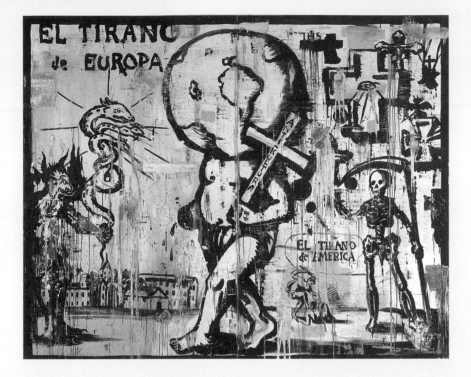

Figure 59.
Manuel Ocampo
*El Tirano de Europa, El Tirano
de America,* 1991. Oil and collage
on canvas, 96 × 120 in. Collection
of Evan Tawil, New York.

A familiar character in Ocampo's twisted universe, the "world baby"—a diapered figure with a globe for a head—marches resolutely through an abstract field of various symbols of cultural and colonial tyranny. Infantilized and maimed by forces of domination enacted on a global scale, the baby is a stand-in for the colonized subject (Jenifer P. Borum, "Apocalypse Now: The Ambivalent Allegories of Manuel Ocampo," in Manuel Ocampo, *Virgin Destroyer* [Honolulu: Hardy Marks Publications, 1996]). The cross he bears is at once a sym-bol of his martyrdom and a sign of protest. Labeled "Anti-kultura," it represents a contestatory space formed out of the struggles of colonized peoples to resist and critique the dominant colonial culture in which they are simul-taneously participants. The para-dox inherent in this situation is reinforced by the assortment of crucifixes floating behind and around the world baby. Unlike the ambivalent cross he bears, these symbols are consummate emblems of the dominant cul-ture. Combined with other, sin-ister symbols from Christian mythology—a skeleton wielding a scythe (Death) and a horned devil brandishing a multi-headed snake—they compose a visual lexicon of the colonizer. Sur-rounded and dominated by such a visual language, the colonized have no choice but to adopt it and transform it to their own ends.

Ocampo's interest in disem-boweling the vocabulary of Wes-tern civilization is evident not only in his choice of subject matter, but in his use of materials and painting styles. Ocampo mines not only the emblems and sym-bols of Western civilization, but its history of painting techniques and conventions as well. Combining Spanish baroque style, abstract expressionist gestures, and faux weathering and aging techniques, he arrives at a result that is thor-oughly Western, yet completely unorthodox. His wholesale adop-tion of the vocabulary and his-tory of Western painting tradi-tions mirrors his use of Western iconography, and extends his critique of colonialism into the present-day context of the art world.

Hulleah J. Tsinhnahjinnie

HANH THI PHAM
Contemplating *Expatriate Consciousness #9*

"In essence we are very similar and at the same time we are moon and sun."

I remember watching the evening news on one of the two channels available on Dinetah (Navajo land). The video clip showed the evacuation of Saigon, South Vietnam. I was moved by the intense struggle for survival. Until that year, 1975, Hanh Thi Pham and I were the same age.

Creating methods of survival is a common denominator for Hanh Thi Pham and me. Survival skills inherited and created from our own artistry. Hanh has said that she had two birth dates: "When I left Vietnam, the people from the . . . American Embassy said that children that are twenty-one . . . or older cannot leave Vietnam. . . . In 1975, when I left Vietnam, I was twenty-one years of age [and so] I had to take on the name and age of my sister. . . . Hanh Thi Pham does not exist. And when I came to the United States and got married, I used the name Vivienne, which is the French name [I got] when I went to French school. . . . [The] Hanh Thi Pham who was born in 1954 never existed."[1]

"Hanh and I, we are moon and sun in the same universe."

As time passed, the complexities of witnessing such an event, even though it was heavily edited and on U.S. government television, deepened my political understanding of colo-

nial hunger. Western greed would be the unwitting catalyst fortifying the future of indigenous intellects. Despite its elaborate theatrics of inventing wars and "official" papers to justify ownership of stolen lands, manifest destiny could not machete the umbilical connection of indigenous minds and spirits to the land.

"The colonial experience connects Hanh and me, just as it separates us."

I am a two-spirited being living upon indigenous homelands, one who remembers the past and who practices "Wiping of the Tears." I live within an aboriginal existence, with a future full of indigenous presence.

Hanh Thi Pham affirms her existence as a displaced Vietnamese lesbian who lives in Amerikkka, ever conscious of white presence and dominance. She affirms her anger and her need to manipulate the white man into killing himself.

"When the moon and sun greet, there is ceremony."

When Hanh and her family arrived at Turtle Island (america), there was no indigenous welcome, no acknowledgment of aboriginal protocol. Perhaps it is not too late. To Hanh Thi Pham, her family, refugees displaced, brought to this land mislabeled America:

> It is only proper to acknowledge aboriginal territories. It is only proper to acknowledge your journey, your culture, and your protective ancestors who have safely guided you to this moment. For what land I can speak for, I invite you to consider the soil on which you walk, to consider our ancestors and the spirits who exist. I invite you to respect the land. There is an expectation, the expectation that the gifts you have brought within your soul will embellish the borrowed land on which you will live. With these acknowledgments, a foundation of understanding has been put into motion.

> Welcome.

"In essence we are very similar and at the same time we are moon and sun."

■ ■ ■

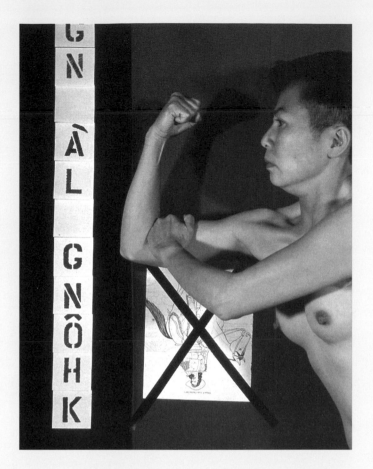

Figure 60.
Hanh Thi Pham
Expatriate Consciousness #9
(*Không là nguoi o*) (detail), 1991–92.
Chromogenic development print,
40 × 30 in. Courtesy of the artist.
(PHOTO: FUJIMOTO KEMPACHI)

For commentary, see plate 15.

Odili Donald Odita

PIPO NGUYEN-DUY
The Thin Line between Tragedy and Beauty

TO BE A SURVIVOR OF WAR IS TO UNDERSTAND LIFE IN A WAY THAT MANY WILL NEVER comprehend. For these survivors, the emotional and psychological scars of war can, at times, be too much to bear. The understanding of this devastation is clear to me since I am myself a living by-product of war—specifically, the Biafran conflict in Nigeria. One resulting tragedy I suffer due to the Biafran war is the guilt of having been able to live free from the immediate horror of death and mutilation my relatives endured during this unforgettable time in which millions lost their lives. My family and I were fortunate enough to be able to flee the country to the United States before the Nigerian airports were closed down at the start of the war. Still, I experience the pain of loss as I ponder what life could have been had I lived my youth safely in Nigeria. My family has since been granted American citizenship, our reward for enduring the many years of racism and nationalism experienced here while in search for that distant dream of prosperity and freedom.

The artist Pipo Nguyen-Duy was born in and has lived through similar difficult situations. As a child during the Vietnam War, the artist experienced his first taste of death. In 1968, his uncle's entire family was crushed in a bomb blast that caused their house to collapse inward. Now, long after the Vietnam War has ended, Pipo Nguyen-Duy calls America his home. Again, it is here where at times he is made aware of his situation as an out-

sider and reminded of the sad history that exists between America and Vietnam. This awareness, in turn, drives him to continually search for ways to incorporate his Vietnamese/Asian heritage into his art without recrimination.

Pipo begins his work by sifting through Western mythologies in an attempt to comprehend and better relate to his current surroundings. By merging Western iconography with various elements from his cultural background, he is able to communicate an understanding of the diverse generalities of daily life that exist between the two poles of East and West.

In *Dante* (1995), a subtle yet starkly explosive photograph, Pipo is metaphorically calling upon the spirits in the land of the dead to answer questions about life in the land of the living. Combining aesthetic devices such as traditional Asian theatrical performance forms with his experience as a fashion model in New York City, Pipo unveils a complex and rich understanding in his mixing of divergent Eastern and Western visual forms. (In the 1980s, Pipo earned a living as a model working for both the Elite and Ford modeling agencies in New York City. He also worked as a mâitre d' and eventually became manager at MK's, a socially and culturally important Manhattan nightclub.) Through the blending of metaphysical, spiritual, and cultural symbols, the artist is able to articulate, in a charged yet elegantly minimal voice, the mysteries of life and death.

In the photograph, the weight of silence becomes immense, if not overwhelming, as the protagonist searches for deceased loved ones. Through a great display of artifice, Pipo seeks the unanswerable. His hand penetrates the fabricated membrane flooring to reach into the dark invisibility of death. The artist becomes a conduit, a kind of animate antenna between the dead and the living. As he extends himself into the unknown, what becomes apparent is that only the memories of lost loved ones can exist, memories he can feel just beyond the outstretched ends of his fingertips. Pipo has said, "I'm approaching my work from the standpoint of being a generic Asian man instead of being a Vietnamese man."[1] Sections of *Dante* exemplify this open and general use of Asian cultural forms within his art. In the picture, strains of Butoh (a Japanese dance form known as "the dance of darkness" and created by Tatsumi Hijikata in postwar Japan in reaction to the nuclear holocaust of 1945) are evident in the physical display of Pipo's body. And with the use of stark black-and-white photography, the artist takes studied and measured steps to evoke his own personal staging of reality within the hegemony of a culture.

According to the artist, "All my work is really dealing with relics, not just the image, but the whole Western relic . . . objects that define a culture and at the same time, define the power of a culture." Through the handling and manipulation of various Western relics, Pipo in turn transforms himself into a mythological icon. In doing this, his goal is to subvert the existent dominant reality of the great Western myth for the sake of another one more conducive to his being—one in which he and others like him can take part. Empowerment for Pipo, then, comes through changing this prevailing mythological landscape to allow values and an awareness of life systems from his past to exist in harmony with those in his present.

Despite the difficulties of living as an Asian in America, Pipo has found in the West the freedom to express himself without being bound by traditional Vietnamese (Asian)

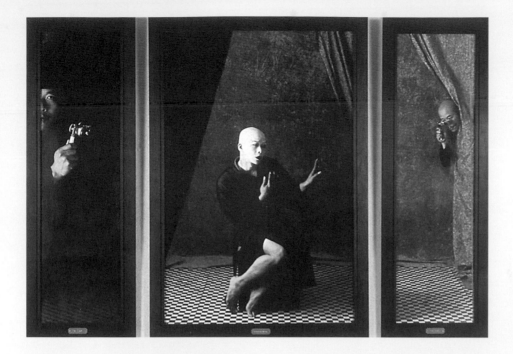

Figure 61.
Pipo Nguyen-Duy
Susannah and the Elders, 1995.
Gelatin silver print with wax medium,
40 × 60 in. Courtesy of José
and Cynthia Rodriguez.
(PHOTO BY THE ARTIST)

Based on the oft-portrayed
biblical story of voyeurism and
blackmail, in which the bathing
Susannah is spied upon by two
elders who subsequently demand
that she sleep with them or be
publicly accused of adultery
(which was punishable by death),
Nguyen-Duy's *Susannah and
the Elders* takes the tale's
themes into new gender and
racial territory. As in the rest of
the *Assimulation* series (of which
Susannah and the Elders is a
part), Nguyen-Duy employs a
heightened sense of artifice and
performance to deconstruct the
tropes of traditional Western cul-
ture. The curtains that create the
stage-like space of the photo-
graph, the opera glasses held by

the elders, and the emphasis on
voyeurism all reinforce this the-
atricality. By establishing and
subverting an intricate system
of gazes, Nguyen-Duy investi-
gates the complex process of
looking as it pertains to gender
and racial categories in the con-
text of Western culture. In the
center panel, in place of the
traditional depiction of a female
Susannah, Nguyen-Duy has
inserted himself, posed and
made up as a Butoh dancer. The
object of the elders' gaze (and
the viewer's) is a male performing
a female role. In transforming
the gender of the object of the
elders' gaze from female to male,
Nguyen-Duy transforms that
gaze into a homosexual, or at
the very least, a sexually indeter-
minate one. Simultaneously, by
marking the male performer with
the trappings of an Asian cultural
form (Butoh), the artist references
both the emasculation of Asian
men in Western culture and the
general exotic-erotic fascination

with things (and people) Asian.
He also literally upends the tra-
ditional gendered relationship
between viewer and object, in
which the viewer is always "male"
(active) and the object "female"
(passive). But perhaps the most
striking detail in the image is the
elder in the left-hand panel, who
has removed his opera glasses
and gazes not at "Susannah"
but confidently out at the viewer,
accomplishing yet another inver-
sion of gazes—that between the
viewer and the photograph. The
photograph itself is no longer a
passive object to be viewed and
consumed, but actively looks
back at the viewer, defiantly re-
fusing to be objectified, and impli-
cating the viewer's own position
in an economy of voyeurism.
By twisting and inverting the
traditional power dynamics
between gender, sexual, and
racial categories, Nguyen-Duy
has created a complex statement
about looking and the power
relations inherent in it.

customs and attitudes. He has made note of the significant number of contemporary Asian American artists who use their own bodies as the main subjects of their work and attributes this to the "newfound freedom . . . of trying to be in this culture."

In Pipo's art, myths serve as a formal and conceptual launching pad for the artist's own unique visions of life. His refined use of visual motifs reveals a deep understanding of culture and the languages of power. Through his inversion of the cultural roles and circumstances of Eastern- and Western-based myths, he is able to communicate in the most subtle and evocative terms his desire for new options and more favorable realities.

<p style="text-align:center">▪ ▪ ▪</p>

Jaune Quick-to-See Smith

ROGER SHIMOMURA
Sansei Samurai

IN 1990, WHEN ROGER SHIMOMURA WAS TAKEN ILL AND UNDERWENT IN-DEPTH MEDI-
cal testing, I happened to be making prints in Lawrence, Kansas. Alarmed to hear how ill
he was, I went to visit him in the hospital. There I found him to be fairly matter-of-fact,
considering that he was suffering from serious heart problems. I went away thinking that
Shimomura was being his usual "tough guy" self and that he was never going to show any
weakness. I felt that his reticence to express emotion was an example of how *bushido,* the
code of behavior passed down by his samurai ancestors, made him pretend to be calm even
in the most difficult of situations.

When he was hospitalized, he had been working on *Return of the Yellow Peril,* a series
of fourteen paintings that addressed the widespread problem of contemporary "Japan
bashing" and other anti-Asian activities. After he was released from the hospital, Shimo-
mura went to Carleton College in Minnesota as the Dayton Hudson Distinguished Visit-
ing Artist/Professor. While there, not only did he involve himself in teaching and writing
a new performance piece but also, on his doctor's orders, he was required to monitor his
blood pressure every hour. The experience prompted him to create *Self-Portrait: Fall 1990,*
the final painting of his *Yellow Peril* series.

In this portrait of himself in a Carleton College T-shirt and kimono, Shimomura takes

his blood pressure and faces his own personal "peril." The painting moved me deeply. I felt that he was allowing me to see for the first time not just a crack in his facade, but a full-blown expression of fear. He did not intellectualize his pain, dismiss his feelings or discredit his experience, but rather he engaged his viewers at the deepest level by confronting universal themes of illness and mortality.

His choice of imagery and expression in *Self-Portrait: Fall 1990* evokes the notion of *ukiyo-e* on two levels. The term was used in the twelfth century by Buddhists to refer to the ephemeral nature of life, and certainly the artist/teacher in this self-portrait, forced to take his blood pressure over and over again in public spaces, faces just that. Yet because of the way he constructed the image, Shimomura was also evoking the Edo period concept of *ukiyo-e,* the "floating world" of courtesans and theater people who employed ritual and illusion to create an ephemeral, dramatic world into which people could escape, for short periods of time, from the everyday world they occupied.

Because the imagery in the *ukiyo-e* prints has come to represent the essence of what is purely "Japanese" to people of the West, Shimomura's canvas also confronts American constructions of Asian American identity as "other." Shimomura portrays himself as an actor playing a samurai, but he gives the viewer ironic visual cues that he is neither actor nor samurai. Indeed, like the Meiji-period immigrants from whom he is descended, he has been stripped of his sword. In the painting, he makes direct reference to the camera, the videotape, and the script for *The Last Sansei Story,* a performance piece he was working on at the time, and paints himself with a stethoscope, blood pressure cuff, and even his glasses—all part of his contemporary American reality. As a Japanese American, he may be descended from samurai ancestors, but clearly he operates with complex understandings of what it means to be an American with an Asian face in a culture that casts him as an exotic foreigner in period dress. If one looks past the costume and the pose, one cannot help but empathize with a man attempting to escape the disguises that might make his personal human struggle to survive seem foreign and far away. Although even the gesture he makes with his eyes is based on Kabuki acting conventions, it is the tenseness of the expression on his face that cuts through all the layers of artifice. This painting reminds us that we, like the artist, suffer the human condition of inevitable mortality.

■ ■ ■

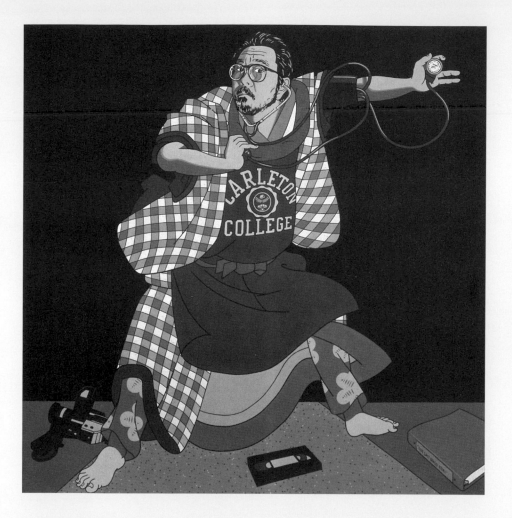

Figure 62.
Roger Shimomura
Self-Portrait: Fall 1990, 1991.
Acrylic on canvas, 60 × 60 in.
Courtesy of the artist.
(PHOTO BY THE ARTIST)

Shimomura created this self-portrait as part of a series of tongue-in-cheek "Japan-ized" portraits of his friends and neighbors in Lawrence, Kansas. Entitled *Return of the Yellow Peril*, the series pokes fun at the American fear of Japanese economic and cultural domination by depicting each of its subjects in traditional Japanese dress. In his self-portrait, Shimomura wears a T-shirt from Carleton College (where he was teaching performance art at the time) that morphs seamlessly into the folds of a traditional Japanese kimono. The incongruity of this humorous juxtaposition renders the racist fear of a Japanese "takeover" ridiculous and unveils the simplistic and reductive thinking from which this fear arises. The exaggerated "clash of cultures" displayed in the self-portrait reveals how the fear of Japanese domination is an overreaction founded in racism and stereotypical perceptions of Japanese culture.

Created during a period when Shimomura was required to monitor his blood pressure every hour, this self-portrait is not only a record of that experience and the emotional turmoil associated with it, but a comment on the act of self-examination and self-evaluation. Faced with the reality of his own mortality, Shimomura created this image as if it were another form of monitoring, a means of checking in on and weighing the prospects for his own survival, both from a medical standpoint and in the face of a growing American racism.

Homi K. Bhabha

SHAHZIA SIKANDER
A Happy Dislocation

I AM STRUCK BY THE FACT THAT SHAHZIA SIKANDER'S WORK TREADS A FINE BALANCE between the traditional and the avant-garde, confusing the distinction between them in a radical way. I was reminded of a moment in David Sylvester's interviews with Francis Bacon where Bacon says that unlike his contemporaries he never wanted to create a new technique; that those who try to do so often limit themselves terribly; that perhaps the most exciting and innovative thing is to, paradoxically, reinvent a technique that has been handed down.

Somehow, it strikes me that modernity for us in the Third World is largely a colonial intervention. It did not grow organically out of historical circumstance and therefore had to coexist with a number of non-modern traditions. The field of visual representation was much more heterogeneous, contradictory, open, and juxtapositional. I am very carefully not saying "pre-modern" because I believe that it was the function of colonialist modernity to introduce the modern/pre-modern distinctions into countries that had their own modes of transformation that were simply different from what was recognized as Western modernity.

When critics deal with post-colonial artists or artists whose work represents cultural difference, they often do so by looking at the content or style of the work—its figurative references, its mimetic demeanor, its style.

Miniatures have very specific framing techniques—various spatial traditions—architecture, the court, the garden, battle, portraiture are deployed to frame the subject of the picture. Sikander does something very original within the surface of the work. She sets up two planes, two surfaces that somehow exist side by side, overlapping, but in different time frames. This is often represented by over-painting, dots, or by providing ghostly or spectral figures that shadow each other, like the fierce Durga figure, a Kali figure from the Hindu pantheon, overlaid with the enigmatic, veiled woman.

Through this kind of layering, it seems to me that Sikander doesn't bring the East and the West together. More interestingly, she brings out the difference between the East and the East, the nearness of difference, the intimacy of difference—not the homogeneity—that can exist within any culture.

Sikander talks about drawing coming out when she's thinking about the work. She talks about its floating character. Her use of colors brings out this floating feeling, this feeling of two planes. Her work is about displacement, a happy displacement, and about re-rooting, free from prescription either by her teacher or by the references in her work. By allowing everything to float up and set up its own tensions, Sikander's work subverts modernity while also subverting certain miniature traditions and certain notions of scale.

At the same time, work like this does require some contextual knowledge in order to understand it. What are the various threads of experience that inform Sikander's practice? She speaks of the problems that arise when Western audiences have specific expectations of the work, because they see it as being "from India," thereby immediately exoticizing it. As she has stated, she finds it problematic to be a cultural spokesperson or an informant. For me, this raises an interesting question. Supposing we don't want an exoticism, we don't want an orientalism, and we don't want all these referential questions that the artist has gotten. If we don't want that, what kind of intercultural knowledge is necessary? Where must I stand to be able to actually pick up the great premeditated subtleties of the work that are manifest? What must I know? Must I be a cosmopolitan? Must I be a nationalist? What must I be as a citizen spectator?

I'm sure that Sikander will continue to enthrall and delight us because she takes up this difficult and I think very productive, very contemporary challenge to live, as she puts it, in between a range of experiences, not necessarily trying to collapse one into the other nor to hierarchize them, but to work between them.[1]

. . .

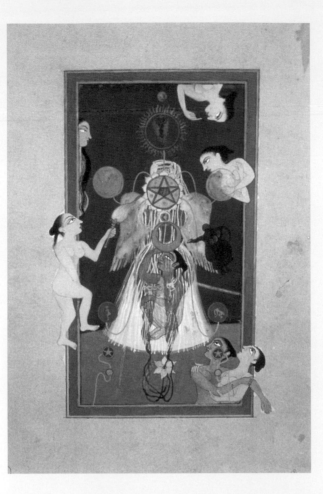

Figure 63.
Shahzia Sikander
Apparatus of Power, 1995.
Vegetable color, watercolors, dry
pigment, tea wash on wasili paper,
16^1/$_4$ × 13^1/$_4$ in. Collection of Carol
and George Craford, California.
(PHOTO BY THE ARTIST)

In *Apparatus of Power,* Sikander
layers iconography from a mixture
of cultural and personal sources
to create a complex and contra-
dictory examination of Muslim
female identity. Recurring in much
of Sikander's work, the central
female figure is both faceless and
footless. In place of her feet, an
intertwining root system suggests

plant-like immobility and a firm
grounding in a place or tradition.
However, in direct contrast to this
stability, wings extend from her
shoulders, suggesting the power
of flight and movement. The fig-
ure is at once grounded and mo-
bile, a state perfectly reflective
of Sikander's own practice of
remixing and combining tradi-
tional techniques and iconogra-
phies to create a fluid, floating,
independent visual language.

Another recurring motif is the
image of the shredded Muslim
veil. The veil, stereotypically seen
as a means of concealing and
thus controlling Muslim women,
is here rendered see-through, yet

still formidable. It retains its power
as a symbol of cultural and reli-
gious identification, but no longer
serves to conceal the female
body. This transparency is rein-
forced by the inclusion of the
naked, crouching figure seen
through the skirt of the central
female form. A reference to
female reproductive power and
sexuality, the image asserts a
clear, shamelessly female identity
from within the trappings of the
veil. It represents a refusal to be
defined by stereotypical notions
of Muslim and female identity,
preferring instead to recast those
notions as sources of personal
power.

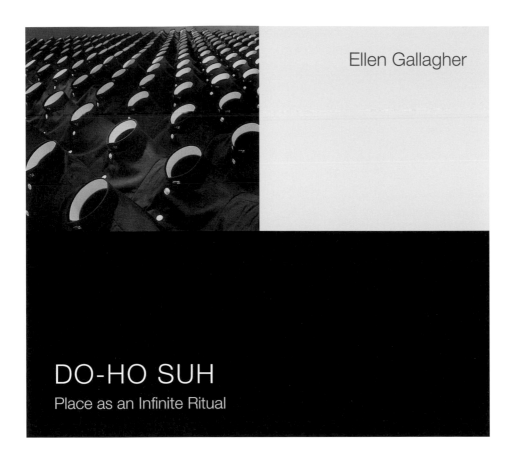

Ellen Gallagher

DO-HO SUH
Place as an Infinite Ritual

*One of the problems with locating being in the body is that we limit our expressive possibilities. To varying extents, our bodies are captive within a large body. As centers and margins dissolve, there is a terror. A real terror of displacement. Not just of being replaced, but the **not knowing whilst conscious**—is too awful.*

A metaphor for conscience: does it have a center, or is it a series of fractured cells? Can we imagine beyond a yes/no relationship to history, to stories? Can we imagine beyond the family? Not a more inclusive family, but individual cells moving through a shared landscape? Does family begin territory, isolation?

1

Row upon row of thumb-scale figures make up a brightly colored rubber welcome mat. The figures are actually tiny replicas of an enormous Korean public sculpture: larger-than-life workers squat under a shared and righteous load. Do-Ho Suh reduces the figures to more dubious and personal work. However mundane, wiping your feet before entering the house is an individual act.

2

In 1995, a public hallway was divided lengthwise down the middle with sheer red fabric. The only way to get across the barrier was to enter the elevator at the end of the corridor. Once the elevator platform was level with the floor, it became not only a vertical lift, but also a horizontal crossing. The occupants of the floor accepted this division for some months.

Possibilities for a Colored Architecture

Reducing and subdividing, Do-Ho Suh creates infinite iterations within a finite (non)space. The welcome mat and the divided hallway manifest an architecture of transitory spaces. These are more surgeries than shantytown. The house is only ever present as absence.

These works contain their own loss. The welcome mat in isolation pushes the house even further away. The architecture becomes the thing you do before entering the house. The distance between the elevator and your individual space is no longer an unconscious event. Place is not a fixed site, but rather an infinite ritual. Liberating the welcome mat from the house and the corridor from the hallway, Do-Ho Suh has tapped into a virtual architecture. Within a ritual world that colored people activate through so many waiting spaces and entry points, this is a real architecture and already exists.

These works do not isolate transitory space only to reinforce some binary route between margin and center. They are not mobile homes. By complicating these non-event non-spaces, time is implied. And time equals positions. Time is site. Given the proliferation of dream escape mobile homes being built by non-colored artists/architects, these meditations of Do-Ho Suh take on increasing resonance as alternatives to a territorial practice. Not a mere mobile site, but a liberation from site, a virtual border town of corridors and welcome mats.

■ ■ ■

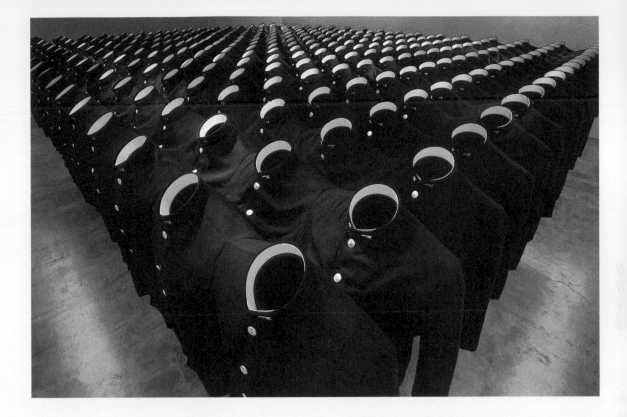

Figure 64.
Do-Ho Suh

High School Uni-Form, 1997.
Fabric, plastic, stainless steel
pipes, casters, 69 × 197 × 176 in.
Courtesy of the artist and Lehmann
Maupin Gallery, New York.

(PHOTO BY THE ARTIST)

In *High School Uni-Form*, Suh
fuses 300 Korean high school
uniforms into one unified mass.
Military in style, the uniforms
evoke visions of an enforced and
strictly regulated conformity. Row
upon row of headless, legless
figures stand eerily at attention,
displaying no signs of human
individuality. The supporting steel
frame and casters reinforce this

uniformity, enabling the entire
mass to move as one entity.
Stitched together at the shoul-
ders, the uniforms flow together
effortlessly, their starched white
collars forming an immense
honeycomb pattern.

The piece clearly plays into
the Western stereotype of the
cultural homogeneity and man-
dated conformity of Asian cul-
tures and could be read solely
as a critique: an overstatement
intended to horrify and repulse.
However, *High School Uni-Form*
also suggests a certain intimacy
that, if not exactly counter to the
expression of overall conformity,
provides an alternate take on it.
Each uniform is stitched so tightly

together with its neighbor(s) that
they share a shoulder, eliminat-
ing individual arms altogether
and presenting a unified front.
The physical structure of the
piece is visibly strengthened
by this intimate interdepen-
dence, forming one object out
of many. At the same time that
the uniform erases individual
identity and integrity, it creates
a new, seamless, and stronger
entity that is perhaps able to
accomplish that which the indi-
vidual could not. By gently refo-
cusing the cultural lens, Suh
exposes an alternate aspect of
uniformity that is often neglected
in favor of an uncritical celebra-
tion of individuality.

Bert Winther-Tamaki

MITSUO TOSHIDA
Transmigration and the Double Nation

SOCIOLOGISTS DESCRIBE TODAY'S MOVING POPULATIONS AS "TRANSMIGRANTS," NOT "immigrants." The pattern is not severance from the homeland, a one-way journey, and gradual assimilation into the new land. Rather, the "transmigrant" is one who travels and forges economic, political, and cultural ties with the new country while sustaining a whole array of active affiliations with the home country. The transmigratory artist is one of many threats in our world to the contemporary vestiges of an eighteenth-century romantic ideal of national identity according to which nationality was a natural genetic property of all human beings. But in the experience of Mitsuo Toshida, a Japanese artist who has been working in the United States for nearly twenty years, national identity has often been stamped not from within but from without—ascribed by European American society as alien identity. Language, for example, has been more the sign of foreignness for Toshida in America than the paramount index of "native genius."

In a series of ink drawings including *Nation Double,* Toshida distributes characters from the writing of his "mother tongue" in such a way as to theatricalize its illegible foreignness and create what he called a "linguistic wall against the United States." The bony script here does not suggest the art of calligraphy. There are no subtle tones of ink absorbed into paper, and no sparks fly from the brush of a masterful hand. It seems more like rough writ-

ing photocopied several generations and then carefully detailed by a graphic designer to create a neon sign. But these characters are dislodged from the regular grid of (con)text and camouflaged into an overall pattern behind and within a configuration of orbs.

The transmigratory experience seems to have refracted the hot red ball of the Japanese flag into two separate spheres, displacing the heart from the old national center to a new midpoint in the overlap. The dislocation of the heart of the old country from its established spatial parameters exposes words in the circle on the right. The three large characters in the middle of this circle say "Anti-West," and around them the circle is crowded with stray illegible tangles and the characters for "dream," "East," "mountain," and "border." Transmigration exposes the negative oneiric diacritica supporting the national fixation in the old country. But if the circle on the left is the space of the new nation embraced in transmigration, one would have to conclude that it is a negative field, a sterile void unable to produce any identifying diacritica at all. It is only the liminal threshold, where the two spaces are riveted together by personal bicultural experience, that takes on the red warmth of life.

But these two national orbs are pictured in a field aggressively figured with bleached skeleton-like characters and fragments that relate to the history of a third nation. These are no doubt words Toshida inscribed with the thought that they would look like "magic words" to those who cannot read them. But when "deciphered," it turns out that each term relates to Chinese history: "Eastern Forest Party," "Kingdom of Heavenly Peace," "White Lotus Society," and "Sango Association." Each was an organization representing some ideological or military strife of intranational difference in China; they were decentering initiatives in a country historically represented as the "middle kingdom." Today's artists as well as airline pilots, Gastarbeiter, criminals, and refugees live in transmigratory societies of an unprecedented scale and character, and this phenomenon is transforming art and society in remarkable ways. But the translation of the "magic words" in the background of Toshida's *Nation Double* suggests the need to recall that the friction of border violence today has a much longer human history.

The resistance produced by the "middle kingdom" long before the advent of transmigration, such as that which Mitsuo Toshida experiences between Japan and the United States today, demonstrated that the authoritarian politics of centralized power was grounded in repression of opposition by those who experienced that centralization as marginalization. Perhaps today's expanding condition of transmigration, though enabled by contemporary transnational technologies and finance, is just a new pattern of resistance against centralized authority.

. . .

Figure 65.
Mitsuo Toshida
Secret Language, 1996.
Gouache on paper, 52 × 66¹/₂ in.
Courtesy of the artist.

In *Secret Language,* Toshida explores the implications of a transnational existence for the linguistic relationship between form and meaning. Unlike many works by European and European American artists that employ abstract versions of Chinese or Japanese calligraphy (Brice Marden's *Cold Mountain* paintings, for example), *Secret Language* is appropriated in its entirety from a work of Buddhist calligraphy. Toshida has not altered the character forms at all, but has merely given them a title. Already striking in their abstraction, under their new title the forms hold implications extending beyond the realm of aesthetics into that of transnational consciousness. As a Japanese immigrant living and working in the United States, Toshida is afforded a certain distance (both geographical and cultural) from the language of his homeland, allowing him to view it from a dual perspective. From a Japanese point of view, it is language pure and simple, a transparent carrier of meaning; from an American perspective, it is a collection of mysterious, perhaps aesthetically pleasing, but ultimately indecipherable glyphs. *Secret Language* reveals the semantic schism inherent in this split perspective. Walking the line between meaning and abstraction, legibility and illegibility, it points to a transnational space in which acknowledged structures of communication break down, exposing the fragility of the linkage between symbol and meaning. However, this space is not altogether devoid of signification. Rather, the title of the piece, *Secret Language,* suggests the hopeful creation of a new system of understanding, if only as a "secret," personal or imagined means of communication in the interstices between cultures.

Amalia Mesa-Bains

CARLOS VILLA
The Common Cape

FOR SOME YEARS I HAVE BEEN WORKING ON MY OWN VISUAL AUTOBIOGRAPHY, OR, AS scholar Jennifer Gonzalez would call it, my autotopography. This series is entitled *Venus Envy* and is divided into chapters. Chapter three, *Cihuatlampa: The Place of the Giant Women,* is the latest piece in the series. It deals with the ancient Aztec view of the afterlife as a metaphor of issues in my own life. Cihuatlampa was the place women who died in childbirth went, a place where they were honored for their courage. I merged this concept with the stories of the ancient Amazons to create the vision of a land of women who simply were too large and too strong to "fit in." This piece required me to develop the elements for the Amazon, including a giant dress of wire that suggested the terrain of the forest and an enormous hand mirror covered with shells as a sign of the sea. I also created a twenty-foot cape made of feathers which, suspended from the ceiling, resembled a giant Central American quetzal bird.

While making the cape, I realized that I was recalling the work of my friend and colleague, Carlos Villa. His early performance work, which involved a feather cape, seems connected somehow to this moment in my own life. I know that the differences in gender and culture have somehow been connected in this shared symbolic form that invokes the phenomenon of natural power. The spiritual and ritual history of feather work has affected

both of us. The word *aves* means both birds and ancestral spirits. The use of the feather garments implies birds and flight. Being transformed into a bird in a visionary or trance-like state symbolizes death and rebirth in many cultures. Shamans and prophets in the South Pacific, Indonesia, Central Asia, and Siberia claim to transform themselves into birds. Buddhist yogis have said that ecstatic flight was the first magical power to be developed through the practice of yoga. Becoming a bird or being accompanied by birds signifies the capacity to undertake the ecstatic journey to the sky and beyond. Among Mayans and Aztecs in the priesthood, feather garments were connected to soul flights for the dead. In the Aztec world, feathers of birds were more precious than gold and feathered capes were of great spiritual and ceremonial value. Many of the world's mythologies have a place for ancestral spirits and soul flights.

Perhaps it is our indigenous histories that brought us together in the feather vestments, or perhaps it is our mutual struggle to overcome a shared colonial past that has driven us both at different times to reclaim these garments of power. Villa's work with feathers, blood, and paint was made while he was searching for his Filipino roots. It recognizes and refers to African, Indian, and New Guinean aboriginal elements. My cape is my attempt to reclaim a natural history, a *madre tierra* of the ancient world. Both of us find something resonant in the traditions of the past and in an archaic memory that might guide us in the present.

I have often reflected on my many conversations with Carlos Villa and on the spiritual and almost timeless understanding that joins us. Our capes, like all garments, possess a transformative quality that protects, adorns, and marks the power of the wearer. Villa's feather coats translate spiritual rituals into artist process in a natural extension. We share a context and an aesthetic. But more important to me is the bond of affection and faith we share, and our mutual commitment to the power of art to heal.

■ ■ ■

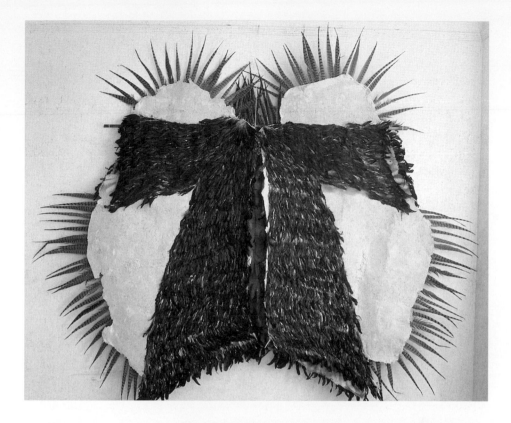

Figure 66.
Carlos Villa
Kite God, 1979. Paper pulp, gauze,
rooster and pheasant tail feathers,
87 × 109 × 2 in. Collection of the artist.
(PHOTO: CHARLES STEPHENIAN)

Part of a series of coats and
cloaks begun in 1971, *Kite God*
is a reflection of Villa's personal,
hybrid mythology. Canvas, feath-
ers, handmade paper, and other
natural materials have been pain-
stakingly layered and stitched to-
gether in a repetitive, meditative
process of delicate handiwork.
The result is a magical garment,
invested not only with the power
of the ritualized labor that went
into its creation, but with the
spiritual and animistic associa-
tions of the feathers, implying
flight, and a communion with
nature. However, the coat is lined
with taffeta, a material that Villa
associates with the ceremonial
garments of Catholic priests. By
including this man-made material,
Villa evokes the sense of ritual
and mystery familiar to him from
his upbringing in the Catholic
Church. The cruciform shape of
the coat is also a reference to the
influence and psychic significance
of Christianity. Encouraged by
his cousin, artist Leo Valledor, to
study the work of Henri Matisse,
Villa was strongly influenced by
Matisse's designs for and of the
Chapel of the Rosary in Venice,
including a paper maquette of
priestly vestments. By blending
these diverse traditions in a single
garment, the coat reflects not
only Villa's concern with the
mystical, but the hybrid and
syncretistic character of his Fili-
pino American identity. In fact,
the proportions of the coat are
based on measurements of his
own body. By essentially map-
ping powerful symbols from
various religious and artistic
traditions onto an image of his
own physical form, Villa creates
a portable emblem of his own
spiritual, cultural, and intellectual
mythology. The coat creates a
tangible relationship between
the spirit world and the body,
speaking not only of the tran-
scendence of Christianity and
the animism of shamanistic be-
liefs, but of a complete fusion of
the two.

Yasmin Ramirez

MARTIN WONG
Chino Malo

CHARLIE AHEARN'S INSIGHTFUL VIDEO *THE CLONES OF BRUCE LEE* CONCLUDES WITH a noteworthy incident that occurred during a dinner party held in Martin Wong's honor at a New York Chinatown restaurant. Amid the din of laughter and applause, graffiti artist Arron Goodstone, aka Sharp, is cajoled by the group to lead a karaoke version of "I Left My Heart in San Francisco," one of Wong's favorite songs. As Sharp takes the mike, he dedicates the song to "Chino Malo" (Bad Chinese Man), a singular nickname that acknowledges Wong's acquisition of a Chino-Latino identity with attitude.

I find the piecemeal way that Wong went about recovering his Latino heritage most touching. Although he has often said that he felt "like a tourist" in the midst of the mostly Puerto Rican community on the Lower East Side, his connection to *Latinidad* can be traced to a distant extended family member who was Mexican. However, no one in his immediate family spoke Spanish or imparted to Wong a sense of duty to recognize the Mexican roots of his family tree.

Wong's process of acculturating into the barrios of New York was therefore much the same as that of thousands of Chinese immigrants who landed in the Caribbean and Latin America in the mid– to late nineteenth century to work in mines, build railroads, develop agriculture, and act as tradespeople.

Wong started learning the language from scratch by picking up pidgin Spanish from neighbors and copying words for his paintings from Spanish-language plays, novels, comic books, signs, and paraphernalia. On the other hand, his knowledge of Latino art was fairly advanced. As a California resident during the 1960s and 1970s, he witnessed the rise of the Chicano art movement firsthand. His profound appreciation of pre-Columbian artifacts and popular art forms like murals and graffiti allowed him to assume that he shared certain aesthetic affinities with his neighbors.

Indeed, just as Wong has integrated aspects of San Francisco's Chinatown into his New York Chinatown paintings, his Puerto Rican subjects can sometimes be mistaken for Chicanos or Mexicans. Often it is only the depiction of an ethnic-specific item, such as a Puerto Rican flag, that discloses the sitter's identity. This is not a criticism of Wong's abilities as much as a recognition that his conception of the Latino body is syncretic and cross-cultural. "Authenticity" in a narrow sense is not his objective. A case in point is his persistent use of Arron Goodstone as his ideal Latino model. In fact, Sharp is not Latino at all but Black and Jewish.

How did Wong earn the tag Chino Malo? Both personally and professionally, he dared to cross boundaries. As my colleague Lydia Yee observes, his street scenes, which are populated by Latino homeboys, hip-hop dancers, boxers, firemen, policemen, and inmates, "defied what is typically expected, according to a reductivist logic, of an artist who is Chinese-American."[1] Credit for his paintings' unusual subject matter partly belongs to the late poet/playwright Miguel Pinero, who functioned as Wong's soul mate on the Lower East Side. A unique figure in Latino arts and letters, Pinero wrote his Pulitzer Prize–winning play, *Short Eyes,* while serving time in prison. Pinero's stories about underclass Puerto Ricans struggling to overcome poverty and drug addiction and his outrageous tales of daring stickups and brutal prison fights fueled Wong's imagination and led to the creation of a cast of urban characters that merges fact and fiction.

But as if granting himself poetic license to portray a group of firemen rescuing a boxer knocked out by his opponent or a homeboy making an escape through the heavens on his bike were not outlandish enough, consider the way Wong depicts a banal subject. *Sanja Cake* (1991) is a transitional painting that carries motifs from the Lower East Side paintings of the 1980s into the Chinatown series of the 1990s. Here a cake label imprinted with both Chinese and American lettering bears the stamp of two dark-skinned Latino firemen passionately kissing each other against a heart-shaped brick backdrop. An allusive self-portrait, *Sanja Cake* literally represents itself as the product of a gay Chino-Latino sensibility. It suggests that while Wong may have left his heart in San Francisco when he moved to New York, he found new love and a new identity on the Lower East Side.

. . .

Figure 67.
Martin Wong

Sanja Cake, 1991. Acrylic on linen,
30 × 32 in. Courtesy of the Collection
of Linda and Alan Bortman.

(PHOTO: ADAM REICH)

In *Sanja Cake,* Wong presents
a distillation of a completely
and uniquely American identity.
Ensconced in a brick-filled heart
at the center of a label for Chi-
nese American "Sanja Cake,"
two Latino firemen engage in
a passionate kiss. This image
is transgressive in several ways.
The same-sex kiss alone is a
challenge to heteronormativity
and common conceptions of
masculinity in both Latino and
Chinese American cultures; the

fact that the men are firemen,
civil servants and ultimate em-
blems of protective masculinity,
further intensifies this transgres-
sion. However, Wong has fully
integrated this challenging tab-
leau into the center of a brightly
colored commercial label for a
benign Chinese American prod-
uct. The heart-shaped frame and
heraldic banner create an upbeat
and celebratory setting for the
kiss, while the dual Chinese and
English lettering inserts it into a
distinctly Chinese American con-
text. The symmetry of the fire-
men's heads reinforces the over-
all symmetry of the label design,
further naturalizing the appear-
ance of the firemen on the label,
while the sweetness implied by

Sanja Cake reflects the ten-
derness expressed between
them. That the frame is a com-
mercial label for a consumer
product pushes the painting
into the realm of kitsch, calling
for a level of public recognition
and acceptance of its imagery.
The fact that it is a label for a
Chinese American product sug-
gests that this recognition oc-
curs outside of Anglo-dominated
mainstream culture, across two
marginalized American cultures:
Latino and Chinese. By insert-
ing a transgressive image into
a familiar commercial context,
Wong uses simple means to
assert and legitimize a com-
plex gay and cross-cultural
identification.

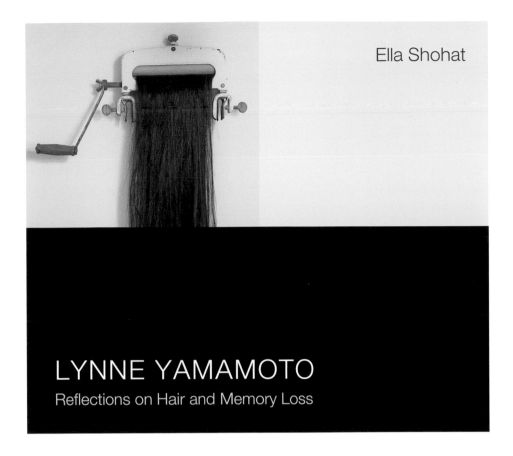

Ella Shohat

LYNNE YAMAMOTO
Reflections on Hair and Memory Loss

Redrawing American Cartographies of Asia

In a 1995 *New York Times* article, a reviewer wrote that Lynne Yamamoto "inscribes the biography of her Chinese grandmother, a laundress, on nails hammered into the wall."[1] The black-and-white Xerox of the article that Lynne sent me to read in preparation for writing this essay includes her handwritten correction in red pencil: *Chinese* is crossed out to read *Japanese*. How often, Lynne, have you had to correct that Asian-confusion syndrome of "they're all the same?" As I was looking into your work on the drudge labor of a laundress, I was wondering about our own work, yours and mine, both granddaughters of dislocated domestic laborers—how long can we go on rinsing, cleaning, and scrubbing our misrepresentations?

I am not concerned here simply with everyday orientalism. But in the context of multiple displacements—in Lynne's case, Japan, Hawai'i, the continental United States, and in my case, Iraq–Israel/Palestine, the United States—what does it mean to be or not be labeled as Asian American? The diverse cultures of Asia are condensed into a homogenizing label that erases their difference and complexity, whence the typical conflation of Japanese with Chinese. At the same time, some parts of Asia, namely West Asia (i.e., the Middle East), are simply dropped out of the continent, leaving these immigrants to America stand-

ing on insecure ground with regard to the continents on both sides of the hyphen. *East* and *West,* after all, are relational terms. In Arabic, the word for West *(Maghreb)* refers to North Africa, the westernmost part of the Arab world, in contrast to the *Mashreq,* the Eastern part. And what the West calls the Middle East is from a Chinese perspective Western Asia.

As an immigrant from Asia to the United States, I have often been bewildered to learn that despite my Iraqiness, I am not an "Asian." And as someone who grew up in Israel/ Palestine, and who was called Black there, I have also learned that I am expected to leave behind this conjunctural definition of Blackness. My family, like most Jewish-Arab families after the colonial partition of Palestine, became refugees from Iraq in the 1950s and ended up in Israel, due to what was styled a "population exchange" that massively swapped Palestinians and Jewish-Arabs across borders. Once in Israel, we became the *schwartzes* (Blacks in Yiddish) of European Israelis. Every aspect of our lives, whether at school, work, or hospital, was determined by checking that box on official documents: "Of Asiatic/ African origins."

In the United States, I found that my scars of partition and traumatic memories of crossing the borders from Iraq to Israel/Palestine have no relevance or are rendered invisible. I also learned that not all hyphenated identities are permitted entry into America's official lexicon of ethnicities and races. This corporeally inscribed hyphen, Iraq-Israel, produced ontological vertigo, and the hyphen immediately disappeared into an assimilable identity: "Ah, so you're Israeli!" Only one geography is allowed prior to disembarking—the made-in-U.S.A. predicament of the single hyphen. Here in the United States we disappear, subsumed under the dominant Eurocentric definition of Jewishness (equated with Europe) and Arabness (equated with Islam) as antonyms. Millennia of existence in Iraq are suddenly erased in the name of a mere three decades in Israel.

Apart from trying to put West Asia back on the U.S. world map, I ask myself, why am I willing to participate in this project? And what do a Japanese-Hawai'ian-American and an Iraqi-Israeli-American have to do with each other, apart from sharing residency in the United States?

Processed Memories

As a kind of homage, Lynne Yamamoto narrates her grandmother's life through the very act of producing the material of her installation. *Ten in One Hour* reflexively alludes to the artist's own rate of production of the soap objects. Reenacting her grandmother's intensive labor, Yamamoto creates a parallel rhythm between her repetitive artistic work and her grandmother's repetitive movements of washing, wringing, hanging, folding. But this analogy also calls attention to class dissonance. While Lynne's images, like my texts, are currently produced and consumed within cultural institutions inseparable from late global capitalism, we, the granddaughters of diasporic domestic workers, have traveled a long road to join another class of cultural workers. Our art or cultural production places us now in a different category than that of our grandmothers and mothers. In my writings I have often felt a survivor's desire to tell again and again about the "hidden injuries" of translocated class, race, gender, and sexuality.

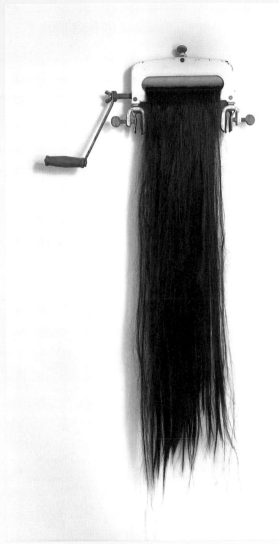

Figure 68.
Lynne Yamamoto

Wrung, 1992. Wringer, synthetic
hair, nails, string, 42 × 13 × 5 in.
Courtesy of the artist and
P.P.O.W. Fine Arts, New York.

(PHOTO: BRAD GODA)

In *Wrung,* Yamamoto reflects on
the labor of her Japanese Ameri-
can grandmother, who worked as
a laundress on a Hawai'ian plan-
tation. The long skein of black hair
that hangs listlessly from the grip
of the washing machine rollers is
a metaphor for the missing body
of the laborer as well as a sign of
racial difference. In replacing the
laundry with a stand-in for the
laundress, Yamamoto equates
the act of wringing the laundry
with an act of violence against the
laborer, in this case a violence
compounded (and allowed)
by the dehumanization effected
by and through racialization.
Wrung is not only a testament
to the backbreaking labor en-
dured by Yamamoto's grand-
mother, but an indictment of
the racist plantation system
that demanded, exploited, and
consumed it.

Our grandmothers worked as domestic servants in new countries, unfamiliar with new cultural and linguistic terrains: Hebrew-speaking Israel for my Arabic-speaking grandmother and English-speaking Hawai'i for Lynne's Japanese-speaking grandmother. In her installations *Night Waters* and *They All Fall Down,* Yamamoto uses archival photographs of Japanese women working as domestics for haole (European American) families in Hawai'i. *They All Fall Down* uses a continuous video loop of her aunt's hands polishing a silver tea bell. "The installation," writes Yamamoto, "is based on stories my aunts told me about working as domestics for haole families, and particular memories of how they were called in to change dishes for the next course."[2]

Soap to wash the dirt from the shirt. To wash the dirt from your body. Soap, cleaning for others, while being called dirty yourself. My dark friend Na'eema used to frantically scrub off her "dirty skin" in a violent cleansing ritual that never reached that promised inner layer of white skin she painfully desired. But it did leave her bleeding. In Israel we were called "dirty Iraqis." I can still hear the Hebrew words, "Erakit Masriha!" ("Stinky Iraqi"), shouted at me by a blond boy whose relatives in Europe were themselves turned into *sabonim*—bars of soap—by the Nazis.

My *seta* (Arabic for *grandmother*), who died recently in her mid-nineties, enjoyed cursing back. She washed their dirty laundry as she joyfully rolled out her Arabic obscenities. She never learned the language of the *al beitheen,* the whites. She put on several layers of *shaqsa* (the Iraqi name for female headwear) to wrap her graying braids, and she was amused by my sister's efforts to bleach her hair, the stubborn roots refusing to completely conceal their black past. And like many women of her class, my grandmother did not wash out of her dictionary dirty words reserved for those whose houses emitted unpleasant smells in the absence of her ever-bleaching hand.

Some of Lynne Yamamoto's work features old photos of Asian laborers in Hawai'i. I wondered how many of the photos actually belong to her family album. Images of immigrant and refugee laborers are often only distilled in colonial visual archives.

I flip through British collections of photos of Baghdad in an attempt to visualize my grandmother in the streets, houses, markets, carrying her *beqcha* (bundle) on her head. These processed images have become processed memories. Could it be that my endlessly deconstructed colonial images are now invading my own familial memories? I see the work of people like Lynne and myself as an effort to bring to life a frozen past captured in the colonial visual archive. We kidnap orientalist images of "the exotic" and re-narrate them for our private/public memories. But that sense of the elusive homelands of Asia persists even after moving to a new continent.

In the aftermath of Pearl Harbor, many Japanese Americans were forced to burn precious family possessions, including family photographs, to eliminate evidence of any links to Japan. Similarly, after the establishment of Israel, Iraqi, Egyptian, and Yemeni Jews were caught in the vice of two bloody nationalisms: Arab and Jewish. While European Israel, in its need to secure bodies to perform "black labor," had an interest in creating the terrorizing political climate that led to our mass exodus, Arab authorities added their own share of terror by suspecting us a priori of being traitors. At the same time, the two governments, under the orchestration of Britain, secretly collaborated in the effort to lift us

overnight from millennia in Mesopotamia. Although Arab Jews were culturally, racially, and linguistically closer to Muslim Arabs than to the European Jews who founded the state of Israel, their identity was seen by both national projects as being on trial. Even anti-Zionist Arab Jews ended up in Israel, for in the bloody context of a nationalist conflict, they could no longer enjoy the luxury of a hyphenated identity.

My parents had to burn our photos, leaving little photographic inheritance from Iraq. As refugees, we left everything behind. I cling to a handful of photos of my family in Baghdad, the city to which we still cannot return after four decades of traumatic separation.

Hairy Visions

In Lynne Yamamoto's *Wrung,* a long strand of artificial black hair hangs from a wringer taken from an old-fashioned clothes washer. Displaced from their original context, seemingly unrelated objects are brought together, evoking a process, a narrative, and an action: something is being wrung. The clamp-like wringer and the disembodied hair highlight the potentially violent overtones of quotidian materials. But the very image of wringing long hair stands out with a nightmarish beauty. For one thing, the long silky black hair of Asian women has often metaphorized the fragile and docile "orient." But here the image of the hair goes against the grain, intimating the pain and hardship of servitude, conjuring up the slow death of the female domestic laborer. The old wringer processes the hair like a meat grinder, as though devouring the woman whose body and face have been slowly consumed and worked over, as though the viewer is catching the last glimpses of her disappearance. The washing cycle evoked by Yamamoto's work becomes a synecdoche and a metaphor for the life cycle itself as experienced by a dislocated domestic laborer: "Arrive, marry, wash, starch, cook, boil, scrub, clean, wring, starch, fear, iron, fold, bleach, cook, iron, hope, rinse, whisper, boil . . . love, fear, weep, rinse, starch, fold, drown."[3] Playing off the visible hair against the invisible body, *Wrung* chronicles the bitter disappearance of an alienated Japanese laborer in the "picturesque" area of Kohala, Hawai'i.

In *Wrung* plentiful hair is attached to no-body. The pleasure and pain of looking at *Wrung* has to do with the subliminal specter of disembodied hair. In recent years interesting work has been done on fashioning hair and diasporic identity, but *Wrung*'s disembodied hair has also to be placed within a completely different tradition. The aestheticized quality of the flowing silk hair, often appearing in the orientalist erotic dream—from *The World of Suzie Wong* to Peter Greenaway's *Pillowbook*—in *Wrung* becomes nightmarish in the context of a different kind of visual archive.

Disembodied hair in this sense evokes the imagery of scalping on the American frontier—whether in the popular Western genre depiction of "Indian savagery" or in the critical Native American representation of European settler cruelty. In 1744, for example, the Massachusetts General Court declared a general bounty of 250 pounds; in 1757 the reward was raised to 300 pounds, more than the annual pay of many educated colonists.[4] Two centuries later, the American West witnessed the horror of another wave of detached hair: civilians gave accounts of hair loss by unsuspecting onlookers of nuclear testing in Nevada, Arizona, or farther west in the "oriental" Pacific Islands.

I remember watching *Hiroshima Mon Amour* for the first time: black-and-white im-

ages of the Hiroshima museum displaying piles of black hair, remnants of the modern American annihilation of two cities in Japan. The film links two victims through the motif of hair: French women scapegoated for a more general collaboration with the Nazis have their hair cut at the end of the war, are tonsured during the liberation in France. World War II also witnessed yet other piles of hair, in the concentration camps of Auschwitz, Dachau, Treblinka, and Bergen-Belsen, where it was recycled for productive purposes.

Iraqi, Yemeni, and Moroccan refugees in the 1950s were welcomed to Israel with white DDT dust, to cleanse them, as the official European Israeli discourse suggested, of their "tropical diseases." In the transient camps their hair was shaved off to rid them of lice. Children, some of them healthy, were suspected of having ringworm and therefore were treated with massive doses of radiation. You could tell those who had been treated by the wraps covering their heads, covering the shame of hair loss. The European Israeli authorities, wrapped in an aura of silence, marched on us to eradicate our Asian and African underdevelopment. Decades later, as the children became adults, they again experienced hair loss, this time due to radiation treatment for cancerous brain tumors caused by their early childhood "treatment" for a simple skin disease that they sometimes did not actually have.

Can memory exist apart from the desire to memorialize? Perhaps my writings, like Lynne's images, are no more than a monument to generations of our parents and grandparents who performed "hairy" escapes across hostile borders, muted by the everyday burden of hyphenated realities, their dreams mutilated. And so we weave hair into our images and texts as a kind of a memorial, a portable shrine for those who faded away. Mastering the language of Prospero, we curse back, Caliban-like, in the various Babylons that form our homes.

■ ■ ■

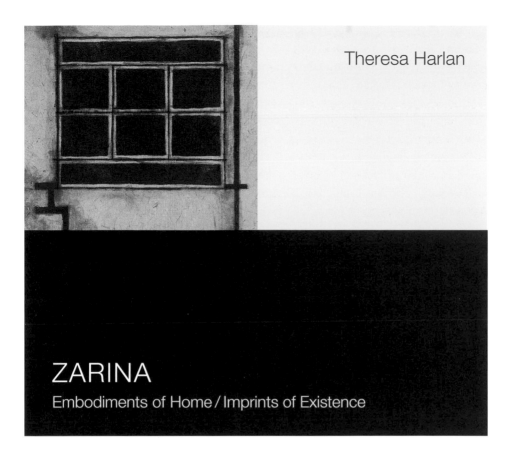

Theresa Harlan

ZARINA
Embodiments of Home / Imprints of Existence

*This is a geometry of memory which I have carried with me to
chart my journey and identify my place on this earth.*

—Zarina

HOMES I MADE: *A LIFE IN NINE LINES* IS COMPOSED OF ETCHED FLOOR PLANS—STARK
and architectonic—a quietly charted existence. Lines and spaces represent Zarina's oc-
cupancy in Bangkok, New Delhi, Paris, New Delhi (again), Bonn, Tokyo, Los Angeles, New
York, and Santa Cruz. Her careful, poetic descriptions—"Paris, 1963–1967: Watched the
Seine flow by and waited for him to come home," "New Delhi, 1968–1974: A room of my
own," "New York, 1976–1996: A space to hide forever"—are the only personal clues Za-
rina leaves for us.

Zarina's floor plans are a recollection of her movement between inside and outside
spaces—a cartography of her existence through location and memory. Each floor plan is
an imprint of her identity and existence.

I understood from a very early age that home is not necessarily a permanent place. It is an
idea we carry with us wherever we go. We are our homes.

Zarina's words reflect four decades of travel and nine homes since leaving her family's Muslim home in Aligarh, India, in 1958. As a child, Zarina witnessed a collision of national identity and religion when an independent and self-conflicted India was partitioned to create a Muslim Pakistan in 1947.

Home, an idea we carry with us wherever we go or do not go. Home, a word that can shelter multiple and conflicting meanings of personal, familial, ancestral, and national: history, identity, memory, and existence. Zarina's experience of home for most of her adult life has been an immigrant experience. As a Native American woman and not an immigrant, I can also understand home as not being permanent. I understand home as being held within our existence and the existence of others. I also have to link home with land. For indigenous people, the formation of identity and self-awareness is based on an occupancy and understanding of home as ancestral homelands.

I was born in California, a different place than New Mexico, the homeland of my birth parents and ancestors. I was adopted at birth and raised by my family in California. For me, homeland is a location I have occupied and not occupied. Home and homeland are separated by two family histories, identities, sets of memories, and existences. Although my identity is rooted to my sense of being an urban Native American woman at home in California, my identity is also undeniably linked to my ancestral homeland. This link, held in place by the existence of my family in New Mexico, enables me to understand that home and land are encoded in my skin—my existence.

Zarina remembers building mud houses in her family's flowerbeds when she was a child, imagining and creating her own space, her own home. I remember as a child imagining the space I occupied in my mother's belly, my first home.

Zarina's floor plans may seem a bit stark to some. I believe the starkness comes from not having to rely on accumulation to create a home, but rather on an understanding and acceptance that home is embodied in the soul.

■　■　■

My House 1937–1958 Zarina 94

Figure 69.
Zarina
My House, 1994. Etching
with chine collé, 22¹/₂ × 15¹/₂ in.
Courtesy of the artist.
(PHOTO: BAY PHOTO)

My House is part of a nine-print
series, *Homes I Made: A Life in
Nine Lines.* The floor plans in the
series form an autobiographical
record of the spaces in which
Zarina lived from 1958 (when she
left her parents' home) to 1996.
Reductive and spare in their sim-
plicity, the architectural forms
have been distilled to their bare
essentials, becoming minimalist,
abstract shapes that float in the
center of the paper. However,
with the exception of the Bang-
kok print (*Zarina's First Home*),
they are clearly shapes that have
been fought over and struggled
with. The etchings reveal the
marks of erasures and revision,
reflecting the uncertain process
of recollection. Their cryptic ele-
gance, combined with the spare,
evocative captions, reveals not so
much the personal history they
attempt to chronicle as the
impossibility of recapturing the
details and the experience of
that history. Their melancholy
emptiness suggests that despite
one's best efforts, one can never
truly return home. *My House* is
as much a document of the pro-
cess of remembering as it is a
record of actual physical spaces.
As such, it suggests that the
concept of home cannot be
embodied by a singular, speci-
fic place, but is rather a distil-
lation of barely remembered
traces.

Preface

1 Rina Benmayor, "Testimony, Action Research, and Empowerment: Puerto Rican Women and Popular Education," in Sherna Berger Gluck and Daphne Patai, eds., *Women's Words: The Feminist Practice of Oral History* (New York: Routledge, 1991), 165.

2 Arlene Raven, "Word of Honor," in Suzanne Lacy, ed., *Mapping the Terrain: New Genre Public Art* (Seattle: Bay Press, 1995), 161.

3 Benedict Anderson, *Imagined Communities: Reflections on the Origin and Spread of Nationalism* (London: Verso, 1983).

Foreword

1 Peter J. Taylor, *Modernities: A Geohistorical Interpretation* (Minneapolis: University of Minnesota Press, 1999).

2 Walter Benjamin, "Theses on the Philosophy of History," in *Illuminations*, trans. Harry Zohn (New York: Schocken, 1969).

3 Dilip M. Menon, "Caste and Colonial Modernity. Reading *Saraswativijayam*," *Studies in History* 13, no. 2 (1997): 291.

4 Raymond Williams first mentioned "structure of feeling" in his works *Culture and Society* (1958) and *The Long Revolution* (1961). Later, in *Marxism and Literature,* however, he greatly elaborated the concept to mean "social experiences in solution, not yet precipitated" in order to convey the sense in which literature captures the dominant and latent, the diverse layers of foreground and background, various elements of society at a given historical moment. He suggested that it included "specifically affective elements of consciousness and relationships," which he described as "not feeling against thought, but thought as felt and feelings as thought: practical consciousness of a present kind." For Williams, however, structure of feeling was a concept for investigating "Englishness," the national affect of English society. I believe we might delicately rework Williams's concept to "translate" structure of feeling for use in considering literature and culture generally as the mediation of when that literature and

culture appears to represent a partial perspective on that greater "worldliness" (Williams, *Marxism and Literature* [Oxford: Oxford University Press, 1977], 133–134).

5 Stuart Hall, "New Ethnicities," in Houston A. Baker, Jr., Manthia Diawara, and Ruth H. Lindeborg, eds., *Black British Cultural Studies: A Reader* (Chicago: University of Chicago Press, 1996), 165.

6 Gayatri Spivak, "Diasporas Old and New: Women in the Transnational World," *Textual Practice* 10 (Summer 1996): 247.

Introduction

I am grateful to Iyko Day, Allan deSouza, Maria Giulia Fabi, Eungie Joo, Jodi Kim, and Yong Soon Min for reading various versions of this essay and offering helpful comments and suggestions.

1 Asian labor was also used in photo enterprises for piecework in film developing and printing. See Peter E. Palmquist, "Asian American Photographers on the Pacific Frontier, 1850–1930," in *With New Eyes: Toward an Asian American Art History in the West* (San Francisco: San Francisco State University Art Department Gallery, 1995).

2 "Progress of the Arts among Us," *Daily California Chronicle,* June 8, 1854, p. 2, quoted in ibid., 16.

3 "The Easel," *San Francisco Chronicle,* February 2, 1877, p. 1, quoted in Palmquist, "Asian American Photographers," 16.

4 "Progress of the Arts among Us," p. 2, quoted in Palmquist, "Asian American Photographers," 16.

5 Karin Higa, "Some Notes on an Asian American Art History," in *With New Eyes: Toward an Asian American Art History in the West* (San Francisco: San Francisco State University Art Department Gallery, 1995), 13.

6 Edward K. Strong, *The Second-Generation Japanese Problem* (London: Oxford University Press, 1934), 233, 237.

7 Ibid., 241. In *Americans in Process,* William C. Smith suggests that a "Japanese face" would prevent a scholar in English from finding a teaching job in that subject but could prove to be an asset for obtaining a position teaching "oriental history" in America, as "it may create the impression that he is in a position to secure data on the Oriental which are not readily accessible to one with Caucasian features" (Smith, *Americans in Process: A Study of the Citizens of Oriental Ancestry* [New York: Arno Press, 1970; orig. Ann Arbor, Mich.: Edwards Brothers, 1937], 101). In the 1920s, an "oriental face" brought such job opportunities to young U.S.-born Asians as waiting on passengers on trains between San Francisco and Los Angeles or between the West Coast and the Midwest. Chinese American young women were hired as manicurists and Chinese American young men worked in the club cars. The Chicago and Alton Railroad used Japanese American young women dressed in kimonos as maids on the limited line between Chicago and St. Louis. Some San Francisco stores employed Chinese American girls wearing the Chinese cheongsam and Japanese American girls in kimonos to greet customers and operate elevators because, according to one Market Street merchant, their appearance attracted attention and business (ibid., 301).

8 In his essay about the second-generation Asian American performers at San Francisco Chinatown's Forbidden City Theater in the 1940s and 1950s, Anthony W. Lee analyzes the racial basis of the performers' appeal. The novelty, Lee argues, "lay in the assumption that the performers copied the entertainment of a culture that was not their own. . . . It never occurred to most patrons that the performers, most of whom were born in the United States, were simply exploring the acts of a culture they considered theirs by birth. Part of the audience's pleasure derived from observing how cultural and racial difference could be thematized and managed,

but that pleasure was only possible if the performances did not transgress or completely confuse the borders of difference" (Lee, "Crooning Kings and Dancing Queens: San Francisco's Chinatown and the Forbidden City Theater," in Stephanie Barron, Sheri Bernstein, and Ilene Susan Fort, eds., *Reading California: Art, Image, and Identity, 1900–2000* [Los Angeles: Los Angeles County Museum of Art and the University of California Press, 2000], 198–219). Singers were dubbed the "Chinese Frank Sinatra" or the "Chinese Sophie Tucker" in a way that "erased their own crafted skills, relegated their voices to imitation, and attempted to reaffirm the superiority and primacy of popular culture's acknowledged (non-Chinese) models" (ibid., 202–203).

9 Obata taught art at the University of California, Berkeley, where he served as a faculty member for more than twenty years between the early 1930s and 1954, with several years' hiatus during the Japanese internment.

10 Kimi Kodani Hill, ed., *Chiura Obata's Topaz Moon: Art of the Internment* (Berkeley: Heyday Books, 2000), xiv.

11 Hubert Howe Bancroft, *Essays and Miscellany* (San Francisco: History Publishing Co., 1890), 309.

12 Seeking to further cross-cultural understanding through art, Obata co-founded the East West Art Society in San Francisco in 1921. There were thirty-four other artists of Japanese, Chinese, American, and Russian backgrounds as members. A 1922 draft catalog manuscript for an exhibition of members' work expresses interest in "finding the way to a high Idealism where the East unites with the West" through the study of "Occidental and Oriental Arts" (Higa, "Some Notes on an Asian American Art History," 13).

13 I have previously discussed early Asian American writers as cultural ambassadors of goodwill between East and West in Elaine H. Kim, *Asian American Literature: An Introduction to the Writings and Their Social Context* (Philadelphia: Temple University Press, 1982), chap. 2.

14 Palmquist, "Asian American Photographers," 15–17.

15 Michael D. Brown, *Views from Asian California 1920–1965: An Illustrated History* (San Francisco: Michael Brown, 1992), 5.

16 Higa, "Some Notes on an Asian American Art History," 14.

17 Chinese had been excluded from immigrating and settling in the United States by a series of state and federal laws enacted mostly between 1882 and 1924. Like a number of other Chinese who were living in the United States during the 1906 San Francisco earthquake, Gee's father apparently claimed that he was a U.S. citizen whose official documents had been destroyed by fire. Thus the younger Gee was able to obtain his own U.S. citizenship.

18 Helen Gee, "Yun Gee's World: A Reminiscence," in *The Paintings of Yun Gee* (Storrs: William Benton Museum of Art, University of Connecticut, 1979), 10.

19 Yun Gee, 1940s brochure about diamondism, collection of Helen Gee, referenced in *The Paintings of Yun Gee,* 30.

20 According to David Teh-yu Wang, "Gee's effort to synthesize the Chinese tradition with Western modernism might have been inspired, on the one hand, by the mysticism which permeated Paris at the time, and, on the other, by an ambition to excel past the Japanese painters in Paris, especially Tsugouharu Foujita [who had] become famous in Paris by the 1920s with a style that used unerring lines on creamy, glossy surfaces—a charming lyricism that was expected from an Asian" (Wang, "The Art of Yun Gee before 1936," in *The Art of Yun Gee* [Taipei: Taipei Fine Arts Museum, 1992], 25).

21 "Yun Gee Speaks His Mind," undated essay, archives of the Museum of Modern Art, New York.

22 Yun Gee, "Art in the Chinese Republic," undated essay, cited in *The Paintings of Yun Gee,* 68 n. 1.

23 Joyce Brodsky, "Preface," in *The Paintings of Yun Gee,* 32.

24 Quoted in Hill, *Chiura Obata's Topaz Moon,* 46.

25 Ibid., 70.

26 Bernard Weinraub, "Pain and Loss Etched by a Prisoner of War," *International Herald Tribune,* March 31–April 1, 2001, p. 8.

27 Bruce Altshuler, *Isamu Noguchi* (New York: Abbeville Press, 1994), 18.

28 Apparently, Noguchi had not realized that no matter how well respected he was as an artist, to the authorities he was nothing but a Japanese American in the Poston concentration camp. Not subject to evacuation because he lived in New York and not within the boundaries of the Western Defense Command zone, Noguchi volunteered to be incarcerated at Poston in Arizona in 1942. Ostensibly subscribing to the popular orientalist ideas of the time, the artist wished to "contribute toward a rebirth of handicraft and the arts which the Nisei [had] so largely lost in the process of Americanization" (letter to Mr. Fryer, July 28, 1942, from the WRA case file of Isamu Noguchi, quoted in Karin Higa, "The View from Within," in *The View from Within: Japanese American Art from the Internment Camps, 1942–1945* [Los Angeles: Japanese American National Museum, 1992], 32). After only three months, Noguchi was already petitioning for release. Higa cites his predictable incompatibility with the nisei he had planned to "help," the desert heat and difficult living conditions, and the restrictions on his freedom (ibid.). At the same time, to the interned Japanese Americans, he was a complete stranger unconnected to the family and community networks that had served as their most crucial defense against anti-Asian movements in the West. Noguchi was denied permission to work in San Francisco on the basis of his ethnicity, despite being vouched for by such important persons as U.S. Attorney General Francis Biddle, Department of the Interior Commissioner of Indian Affairs John Collier, and Secretary of the Guggenheim Memorial Foundation Henry Allen Moe. He spent seven months at Poston and finally returned to New York in the spring of 1943.

29 Sam Hunter, *Isamu Noguchi* (New York: Abbeville Press, 1978), 56.

30 Ibid., 50.

31 Noguchi was so enraged by this review that he kept it for decades, publishing it in its entirety in his 1968 autobiography, *A Sculptor's World* (New York: Harper and Row, 1968), 20.

32 L.E., "Noguchi: Marie Harriman Gallery," *Art News,* February 2, 1935, quoted in Hunter, *Isamu Noguchi,* 50.

33 Hunter, *Isamu Noguchi,* 101–102.

34 Altshuler, *Isamu Noguchi,* 62.

35 Ibid.

36 Ibid., 67.

37 From a Japanese publication on Noguchi's ceramics exhibition; text in English and Japanese (Shuzo Takiguchi, Saburo Hasegawa, and Isamu Noguchi, *Noguchi* [Tokyo: Bijutsu Shuppan-sha, 1953]). Quoted in Hunter, *Isamu Noguchi,* 101.

38 Altshuler, *Isamu Noguchi,* 99.

39 Marita Sturken, "The Wall, the Screen and the Image: The Vietnam Veterans Memorial," in Nicholas Mirzoeff, ed., *The Visual Culture Reader* (New York: Routledge, 1998).

40 Ibid., 162–178.

41 *Maya Lin: A Strong Clear Vision,* film directed by Frieda Lee Mock, 1995.

42 Yong Soon Min, "A is for Autobiography: The *Other* Scarlet Letter," paper presented at the conference *The Third Movement: Imagining New Constellations in Race, Hierarchy, and Art,* Bard College, May 1997, p. 12.

43 Established in 1978, the Asian American Resource Workshop focused some of its attention on music workshops and performances and film screenings in the early 1980s.

44 Located on the edge of San Francisco's Chinatown, Kearny Street Workshop programs addressed many Chinatown and Manilatown issues, while Japantown Art and Media, which was founded in 1975 and operated until 2000, focused most of its attention on Japantown events, issues, and activities.

45 Telephone interview with Tomie Arai, August 20, 2000.

46 Karen Fiss, "When Is Art Not Enough? Art and Community," in Russell Ferguson, William Olander, and Karen Fiss, eds., *Discourses: Conversations in Postmodern Art and Culture* (Cambridge, Mass.: MIT Press, 1990), 156.

47 A certain fascination for Asian Americans blossomed in Asia in the 1990s as well. Seattle Chinese American singers were promoted as pop singers in Taiwan. Young Asian American VJs were featured on Asian MTV from Manila and Bombay to Taipei. Korean rappers from Los Angeles were among the hottest music groups in Seoul, where young Koreans frequented nightclubs featuring Los Angeles ambiance, complete with fake graffiti. By 1997, economic crises in Hong Kong, South Korea, and Southeast Asia reinforced for many the attractions of the diaspora culture: the United States was richer, more powerful, and more culturally influential than ever, and Asian Americans possessed at least a piece of that culture.

48 Conversation with Eungie Joo, Oakland, Calif., January 3, 1999.

49 The symposium series "Sources of a Distinct Majority" was held between 1987 and 1992, with proceedings published as *Worlds in Collision: Dialogues on Multicultural Art Issues* (San Francisco: International Scholar's Publications and the San Francisco Art Institute, 1994).

50 Maurice Berger, "Are Art Museums Racist?" *Art in America* 78, no. 9 (September 1990): 74.

51 Min, "A is for Autobiography," pp. 4, 6.

52 Alice Yang, *Why Asia? Contemporary Asian and Asian American Art* (New York: New York University Press, 1998), 90.

53 In June 1998, Godzilla members participated in the *Urban Encounters* exhibit at the New Museum, which featured installations on the genealogy of activist art from the mid-1960s to the 1980s. Other groups represented included the Guerrilla Girls, ABC No Rio, Repo History, and Bullet Space.

54 In December 1997–March 1998, the Queens Museum also presented *Out of India,* which was modeled after *Across the Pacific* and featured diaspora South Asian artists with those based in South Asia.

55 Eungie Joo, "Crisis to Collapse: Identity and the Racialized Subject," unpublished essay draft, 2001, pp. 6–7.

56 Yang, *Why Asia?* 97.

57 *Godzilla: Asian American Art Network* 3, no. 1 (Fall 1993).

58 Yang, *Why Asia?* 104–105.

59 Lisa Lowe, *Immigrant Acts: On Asian American Cultural Politics* (Durham, N.C.: Duke University Press, 1996), 86.

60 Young Chul Lee, "Culture in the Periphery and Identity in Korean Art," in *Across the Pacific: Contemporary Korean and Korean American Art* (Queens, N.Y.: Queens Museum of Art, 1993), 12.

61 Ibid., 10.

62 Thelma Golden, "What's White . . . ?" in *1993 Whitney Biennial* (New York: Whitney Museum of American Art and Harry N. Abrams, 1993), 28.

63 On October 16, 1993, in what was planned as a serious, semi-formal discussion between the Korean North American and South Korean artists participating in the *Across the Pacific* exhibition, "The South Korean artists staged themselves as authentic bearers of important issues, as compared with the Korean North American artists, who were viewed as being of sub-

ordinate value. We seemed to them to be tortured by our own identities. . . . I had been sincerely listening to see what we might have in common, only to be humiliated by the disrespect we were shown" (conversation with Jinme Yoon, January 30, 2001). The discussion, which was supposed to be in Korean and English, quickly devolved into being only in Korean, infantilizing and marginalizing the opinions of the English-speaking Korean North American artists.

64 Maxine Hong Kingston, "Cultural Mis-readings by American Reviewers," in Guy Amirthanayagam, ed., *Asian and Western Writers in Dialogue: New Cultural Identities* (London: Macmillan, 1982), 55.

65 Guillermo Gómez-Peña, "From Art-mageddon to Gringostroika," *High Performance* (Fall 1991): 51.

66 Lowery Sims, "The New Exclusionism," *Atlanta Art Papers* (July–August 1988): 38.

67 Michele Wallace, "Defacing History," *Art in America* 78, no. 12 (December 1990): 120–129.

68 Richard J. Powell, *Black Art and Culture in the Twentieth Century* (London: Thames and Hudson, 1997), 19–20, 22.

69 Quoted in ibid., 126.

70 Alicia Gaspar de Alba, *Chicano Art Inside / Outside the Master's House: Cultural Politics and the Cara Exhibition* (Austin: University of Texas Press, 1998), 10.

71 According to Stuart Hall, the diaspora experience is defined "not by essence or purity, but by the recognition of a necessary heterogeneity, diversity; by a conception of 'identity' which lives with and through, not despite, difference. . . . [Diaspora] identities [are] constantly producing and reproducing themselves anew, through transformation and difference" (Hall, "Identity and Representation," in Maybe B. Cham, ed., *Ex-iles: Essays on Caribbean Cinema: The New World Presence* [Trenton, N.J.: Africa World Press, 1992], 234).

72 According to Adrian Piper, "Colored artists themselves often vacillate between deploring the absence of biography in writings about their work and deploring its excess. On the one hand, a critical analysis that is insensitive to the artist's distinctive cultural heritage is almost sure to miss the full significance of the work in addition to implicitly belittling that heritage as unimportant to an understanding of it. . . . On the other hand, they do get sick of having their work reduced to manifestations of their ethnicity or symptoms of their audience's ambivalence about it; of being singled out for their racial identity rather than for their creative genius; and perhaps worst of all, of being considered an art-market liability—or worse, an art-market curiosity—because of their ethnicity. . . . [C]olored artists want their ethnicity, but without the stigma attached to their ethnicity—just as whites have theirs" (Piper, "Ways of Averting One's Gaze," in *Out of Order, Out of Sight, Volume II: Selected Writings in Art Criticism 1967–1992* [Cambridge, Mass.: MIT Press, 1996], 145).

73 Telephone conversation with Hung Liu, January 1999.

74 Min, "A is for Autobiography," pp. 4, 6.

75 Ibid., p. 10.

76 Susette S. Min, "Creative License: Walking through Asian American Cultural Productions," Ph.D. diss., Brown University, 1999.

77 See Kim, *Asian American Literature*, chap. 1; Gina Marchetti, *Romance and the "Yellow Peril": Race, Sex, and Discursive Strategies in Hollywood Fiction* (Berkeley: University of California Press, 1993); Darrell Y. Hamamoto, *Monitored Peril: Asian Americans and the Politics of TV Representation* (Minneapolis: University of Minnesota Press, 1994); Robert G. Lee, *Orientals: Asian Americans in Popular Culture* (Philadelphia: Temple University Press, 1999); and Sheng-Mei Ma, *The Deathly Embrace: Orientalism and Asian American Identity* (Minneapolis: University of Minnesota Press, 1999).

78 Daryl Chin, "Some Remarks on Racism in the American Arts," *M/E/A/N/I/N/G* 3 (1988): 19.

79 "Guerrilla Girls Bear/Bare All," in *Confessions of the Guerrilla Girls* (New York: HarperCollins, 1995).

80 Ibid., n.p.

81 Andrew Ross, *Real Love: In Pursuit of Cultural Justice* (New York: New York University Press, 1998), 147, 127.

82 Judith Wilson, "Art," in Donald Bogle, ed., *Black Arts Annual, 1987/1988* (New York: Garland, 1988), 3.

83 Howardena Pindell, "Art World Racism: A Documentation," *New Art Examiner* (March 1989): 32.

84 Quoted in Berger, "Are Art Museums Racist?" 70. Women artists have been almost as poorly represented in the American art world as artists of color. According to the Guerrilla Girls, in the 1985 exhibition *An International Survey of Painting and Sculpture,* only 13 of the 169 artists included were women, and there were no women of color. H. W. Janson's *History of Art,* the most widely used art history textbook in the United States, did not mention a single woman artist until Janson died, after which his son added 19—out of a total of 2,300 ("Guerrilla Girls Bear/Bare All," n.p.).

85 Pindell, "Art World Racism," 32.

86 Berger, "Are Art Museums Racist?" 70.

87 Chin, "Some Remarks on Racism," 29. The U.S. art world has rarely acknowledged African American artists who have engaged or modified traditional European cultural traditions, just as African American influence on American modernism, such as jazz culture's influence on modernist sensibilities, has so often been underestimated and misunderstood. For instance, in his critique of *The Blues Aesthetic: Black Culture and Modernism,* a show organized in the late 1980s by art historian and curator Rick Powell, Eric Gibson writes, "The reason 'The Blues Aesthetic' finally breaks down is that black culture's influence on modernism was at most one of spirit, not form. . . . In every case, when it came to making a work of art, it was existing modernist idioms—in particular cubism—to which they [the artists] turned" ("'The Blues Aesthetic': A Pretty Sad Selection," *Washington Times,* September 14, 1989).

88 Eleanor Heartney, "Identity Politics at the Whitney," *Art in America* 81, no. 5 (May 1993): 42.

89 Richard Ryan, "The Whitney Fiasco and the Critics," *Commentary* 96, no. 1 (July 1993): 54; Roger Kimball, "Of Chocolate, Lard, and Politics," *National Review* 45, no. 8 (April 26, 1993): 54.

90 Robert Hughes, "A Fiesta of Whining," *Time* 141, no. 12 (March 22, 1993): 68.

91 John Taylor, "Mope Art: Deconstructing the Biennial," *New York* 26, no. 12 (March 22, 1993): 16.

92 Arthur C. Danto, "The 1993 Whitney Biennial," *Nation* 256, no. 15 (April 19, 1993): 533.

93 Cited in Catherine Lord, "(An)other Panic: The Mainstream Learns to Bash," in Charles Gaines, *The Theater of Refusal: Black Art and Mainstream Criticism* (Irvine: Fine Arts Gallery, University of California, Irvine, 1993), 22.

94 Taylor, "Mope Art," 16.

95 Thomas McEvilley, *Art and Otherness: Crisis in Cultural Identity* (Kingston, N.Y.: McPherson and Co., 1992), 57.

96 Guillermo Gómez-Peña, "The Multicultural Paradigm: An Open Letter to the National Arts Community," *High Performance* (Fall 1989): 49.

97 *New York Times,* May 13, 1984, section 4, p. 22, quoted in Douglas Crimp, *On the Museum's Ruins* (Cambridge, Mass.: MIT Press, 1993), 275.

98 Maurice Berger, *How Art Becomes History* (New York: HarperCollins, 1992), 86.

99 Stuart Hall, "New Ethnicities," in *Stuart Hall: Critical Dialogues in Cultural Studies,* ed. David Morley and Kuan-Hsing Chen (New York: Routledge, 1996), 449.

100 Richard Fung, "Undressing Victim Art," *In the Mix* (Fall 1995): 43.

101 Press release for the *Style télégraphique* exhibition, Rosamund Felsen Gallery, Santa Monica, Calif., January 12–February 10, 2001.

102 Dorinne Kondo, *About Face: Performing Race in Fashion and Theater* (New York: Routledge, 1997), 4.

103 Theresa Hak Kyung Cha, artist's statement, after 1976 (Berkeley Art Museum and Pacific Film Archive, Theresa Cha Archives, Berkeley, Calif.).

Pacita Abad

1 Ian Findlay-Brown, *Pacita Abad: Exploring the Spirit* (Jakarta: Metropolitan Museum of Manila, Philippines, and National Gallery of Indonesia, 1996), 27.

2 *Art to Art,* video directed by Valerie Soe for Asian Women United, 1993.

3 Interview with Margo Machida, December 12, 1992.

Kristine Yuki Aono

1 Alice Walker, "In Search of Our Mothers' Gardens," in Henry Louis Gates, Jr., and Nellie Y. McKay, eds., *The Norton Anthology of African American Literature* (New York: W. W. Norton, 1996), 2381.

2 Interview, December 22, 1997.

3 Dorothy and Thomas Hoobler, *The Japanese American Family Album* (New York: Oxford University Press, 1996), 113.

4 *Continuum: Culture and Consciousness* (Washington, D.C.: Japan Information and Culture Center, 1993), 10.

Allan deSouza

1 Allan deSouza, quoted in Garry Hesse, "Introduction," in *AlterNatives: Allan deSouza and Yong Soon Min* (Syracuse, N.Y.: Light Works, 1997), n.p.

2 The phrase "discrepant cosmopolitanism" is from James Clifford, *The Predicament of Culture* (Cambridge, Mass.: Harvard University Press, 1988); the concept is further developed in Clifford's *Routes: Travel and Translation in the Late Twentieth Century* (Cambridge, Mass.: Harvard University Press, 1997).

3 Allan deSouza, artist's statement on the *Dick and Jane* series, 1997.

Jin Soo Kim

1 *Jin Soo Kim: University Gallery, University of Massachusetts* (Amherst, Mass.: The Gallery, 1994), iv.

2 Jin Soo Kim, letter to Lowery Stokes Sims, October 16, 1997.

Manuel Ocampo

1 Enrique Chagoya co-curated, with artist Rupert Garcia, Manuel Ocampo's *Paraíso abierto a todos* exhibit at the Mexican Museum in San Francisco in 1994. This chapter is an edited version of Chagoya's "Notes for a Nonlinear Interpretation of the Work of Manuel Ocampo," the catalog essay from that exhibit. *Paraíso abierto a todos (A Paradise Open to All)* (San Francisco: Mexican Museum, 1994).

Hanh Thi Pham

1 Unpublished interview with Margo Machida, May 1992.

Pipo Nguyen-Duy

1 All quotes are from an unpublished interview, March 1, 1998.

Shahzia Sikander

1 Edited excerpts from Homi Bhabha's side of the March 8, 1998, dialogue with Shahzia Sikander at the Renaissance Society in Chicago, with use of Robert McCarthy's edited transcripts.

Martin Wong

1 Lydia Yee, "Martin Wong's Picture Perfect Chinatown," in Amy Scholder, ed., *Sweet Oblivion: The Urban Landscape of Martin Wong* (New York: Rizzoli, 1998), 53.

Lynne Yamamoto

1 Holland Cotter, "Feminist Art, 1965 until Tomorrow Morning and International," *New York Times,* March 17, 1995.

2 Artist's statement.

3 In Lynne Yamamoto's *Untitled,* from her installation *Wash Closet,* the narrative unfolds through a sequence of these words inscribed on the heads of 280 nails, ending with *drown,* a reference to Lynne's grandmother, Chiyo, who committed suicide ten months after the bombing of Pearl Harbor by drowning herself in an *ofuro,* a Japanese bathtub.

4 Raymond William Stedman, *Shadows of the Indian* (Norman: University of Oklahoma Press, 1982), 255.

Painter **Pacita Abad** (b. 1946 in Basco, Batanes, the Philippines) arrived in the United States in 1970. Abad came to art relatively late: she earned a B.A. in law and history from the University of the Philippines in Quezon City in 1968 and an M.A. in Asian studies from the University of San Francisco in 1972. She studied painting at the Corcoran School of Art in Washington, D.C., from 1975 to 1977 and attended the Art Students League in New York in 1978. A recipient of the National Endowment for the Arts visual artist fellowship, she twice received the Washington, D.C., Commission on the Arts Award. Her work is contained in such collections as those of the National Art Gallery in Sofia, Bulgaria, the Museo Nacional de Bellas Artes in Havana, Cuba, the Museo de Arte Moderno in Santiago, the Dominican Republic, the National Gallery of Indonesia in Jakarta, the National Gallery of Fine Art in Amman, Jordan, as well as the National Museum of American Art in Washington, D.C. Abad's paintings been exhibited in solo and group shows in the Sudan, Algeria, Bangladesh, Sri Lanka, Thailand, Singapore, Australia, the Philippines, Taiwan, Hong Kong, South Korea, Japan, England, Germany, France, and in various U.S. cities, including San Francisco, New York, Boston, and Washington, D.C., where she lived for many years. Currently, she lives and works in Singapore. In her large canvas collages, Abad expresses responses to the cultural traditions she has encountered in her extensive travels in Asia, Africa, and Latin America.

Kristine Yuki Aono (b. 1960 in Chicago, Illinois) is a sculptor and installation artist. She graduated from Washington University in St. Louis, Missouri, in 1983 with a degree in art and attended the Skowhegan School of Painting and Sculpture in Maine in 1984. Aono is the recipient of grants from the National Endowment for the Arts Visual Artists / Public Projects, the Civil Liberties Public Education Fund, Art Matters, the Maryland State Arts Council, and the New Forms Regional Project. She has had solo installations at the National Museum for Women in the Arts in Washington, D.C., the Japanese American National Museum in Los Angeles, California, the Long Beach Museum of Art in Southern California, and the Washington Project for the Arts in Washington, D.C. Her sculpture has appeared in numerous exhibitions, including shows at the Bronx Museum of Art in New York, the Guadalupe Cultural Center in San Antonio, Texas, the University of Maryland in

College Park, and the International Sculpture Center and the Corcoran Gallery of Art in Washington, D.C. Aono's work explores themes of cultural and sexual identity, family histories, and the incarceration of Japanese Americans during World War II and often incorporates viewer participation and community contributions. She currently lives in the Washington, D.C., area.

Muralist, printmaker, and installation artist **Tomie Arai** (b. 1949 in New York City) studied painting at the Philadelphia College of Art in 1968 and intaglio at the Printmaking Workshop, Inc. and Teachers College, New York between 1985 and 1987. She became involved in the community murals movement in New York's Lower East Side in the 1970s and has designed permanent public works of art for the U.S. General Services Administration Art in Architecture Program, the National Endowment for the Arts, the New York City Percent for Art Program, the Cambridge Arts Council, and the New York City School Construction Authority. Her work is found in the collections of the Library of Congress, the Bronx Museum of the Arts, the Japanese American National Museum, and the Museum of Modern Art. In 1997, Arai was one of ten women nationwide to receive an Anonymous Was a Woman grant for achievement in the visual arts. In 2000, she was one of fifty artists nationwide to participate in the Artists and Communities: America Creates for the Millennium project, sponsored by the MidAtlantic Arts Foundation and the National Endowment for the Arts. Arai is interested in the relationship between art and history and in the role that memory plays in retelling a collective past. She engages in projects that encourage interaction between artists and non-artists and has collaborated with writers, historians, curators, and people whose stories are a rich resource for her art.

Sculptor and installation artist **Sung Ho Choi** (b. 1954 in Seoul, Korea) has lived and worked in New York City since 1981. He studied art at Hong Ik University in Seoul, Korea, and at the Pratt Institute in Brooklyn, New York. In 1994, Choi participated in the traveling exhibition initiated by the Asia Society Gallery, *Asia/America: Identities in Contemporary Asian American Art* and another traveling exhibition, *Across the Pacific: Contemporary Korean and Korean American Art,* which was started at the Queens Museum of Art in 1993. In 1996, he completed a permanent public commission for the new Intermediate School 5 in Elmhurst, New York. In 1999, he installed *Sand Point–Five Sites,* a permanent public artwork, for the new U.S. courthouse in Seattle, Washington. Choi has received numerous grants, including an Artists' Project Grant and the Pollock-Krasner Foundation Grant. Calling himself a bicultural artist, he is interested in bringing forth the experiences of otherness and in exploring the contrasts and complexities of interactions among the various cultures of the United States.

Albert Chong (b. 1958 in Kingston, Jamaica) is a photographic artist of African and Chinese ancestry. The last of nine children of merchant parents, Chong left Jamaica in 1977 to reside permanently in the United States. He attended the School of Visual Arts in New York from 1978 to 1981, when he graduated with honors. In 1991, he was awarded an M.F.A. from the University of California, San Diego. Chong has taught at the School of Visual Arts in New York, Mira Costa College in California, and the Rhode Island School of Design. He is currently Associate Professor of Art and Photography at the University of Colorado, Boulder. Chong's works are included in many private and public collections, including those of the Bibliotèque Nationale in Paris, the Museum of the National Center of African-American Artists in Boston, and the Yale University Art Gallery. His photographs and photographic art installations have been exhibited in twenty states as well as in Europe, Asia, and the Caribbean. He participated in the 1994 and 2000 Havana Biennale in Cuba and was selected to represent Jamaica at the First Johannesburg Biennial in South Africa, the 1998 São Paulo Biennale in Brazil, and at the 2001 Venice Biennale in Italy. In collaboration with visual artist Johnny Coleman, poet/writer Quincy Troupe, and performance group Hittite Empire, led by Keith Antar Mason, he presented *Black Fathers and Sons: A U.S. Perspective* at the Majestic Theater in

Brooklyn, New York, as part of the 1998 Next Wave Festival. Chong has received several artists' fellowships, including a Guggenheim fellowship, a Pollock-Krasner grant, and fellowships in photography from the National Endowment for the Arts and the California Endowment for the Arts.

Ken Chu (b. 1953 in Hong Kong) is an installation artist who immigrated to Los Angeles in 1959 and now resides in New York City. He studied communication arts at the University of San Francisco in 1971–72 and architecture at the City College of San Francisco in 1976–77 before earning a B.F.A. degree in film from the San Francisco Art Institute in 1986. Chu's work has been exhibited internationally, in major art institutions as well as in alternative art spaces. It has been included in exhibitions such as *Tong Zhi / Comrades: Out in Asia America* (2000*), Brenda and Other Stories: HIV, AIDS, and You* (1996), *42nd Street Art Project* (1994*), Asia/America: Identities in Contemporary Asian American Art* (1994*), The Decade Show, Frameworks of Identity in the 1980s* (1990*)*, and *Cultural Currents* (1988*).* Chu coordinated *Dismantling Invisibility: Asian and Pacific Islander Artists Respond to the AIDS Crisis* (1993*)* and *Public Mirror: Artists against Racial Prejudice* (1990*).* He was a panelist on *Out in the 90s: Contemporary Perspectives on Gay and Lesbian Art* (1991*),* the first forum on gay and lesbian issues in the arts sponsored by the Whitney Museum of American Art. He co-founded Godzilla: Asian American Art Network (1990–2001), a group of New York–based Asian and Pacific Islander visual artists and arts professionals who established a forum that fostered information exchange, mutual support, documentation, and networking through regular meetings, a newsletter, and exhibitions.

Y. David Chung (b. 1959 in Bonn, Germany) is known for his paintings, drawings, prints, multimedia installations, public artworks, and performances. Chung's work has been shown in exhibitions at the Boston Museum of Fine Arts, the Walker Art Center, the Corcoran Gallery of Art, the New Museum, the Asia Society, the State Tretyakov Gallery in Moscow, and at a solo exhibition at the Whitney Museum of American Art at Philip Morris. He is the recipient of a National Endowment for the Arts Fellowship, the Washington Mayor's Art Award, a Lila Wallace–Readers Digest Fund Artist at Giverny Fellowship, and the Rosebud Best of Show Film and Video Award and the Artslink Collaborative Project Fellowship in Kazakhstan. In 1998, he was artist-in-residence at Duke University. Chung has been a visiting artist at the Whitecliffe College of Art in Auckland, New Zealand, the University of Houston, Virginia Commonwealth University, Williams College, Wellesley College, and Longwood College. He has also presented his work at the University of California, Berkeley. Currently, he is assistant professor in the Department of Art and Visual Technology at George Mason University. Chung has been commissioned to design the monument for Koreatown in Los Angeles and permanent artwork for the Washington Metro System, the New York City Percent for Art Program, and various other public art projects. He has presented new multimedia work in Almaty, Kazakhstan, and participated in the 2002 Gwangju Biennale in Korea.

Allan deSouza (b. 1958 in Nairobi, Kenya) studied foundation art at Goldsmiths College in London and received a B.A. with honors in fine art at the Bath Academy of Art in Bath, England, in 1983 and an M.F.A. in photography at the University of California, Los Angeles, in 1997. He participated in the critical studies seminar of the Whitney Independent Studies Program in New York in 1993–94. Since the mid-1980s, deSouza has exhibited extensively in Britain and the United States, as well as in Canada, Cuba, Portugal, and the Philippines. His fiction and critical writings have appeared in various journals and anthologies, including *Third Text, Amerasia Journal, New Observations, Asian American Sexualities* (ed. Russell Leong), *On a Bed of Rice* (ed. Geraldine Kudaka), *Tracing Culture* (the Whitney Museum), and *Crossing Black Waters.* DeSouza currently resides in Los Angeles.

Michael Joo (b. 1966 in Ithaca, New York) earned a B.F.A. at Washington University in St. Louis in 1989 and an M.F.A. from the Yale School of Art in 1991. His work has been exhibited widely in

Europe and the United States, as well as in various biennials, such as the 1993 Venice Biennale, the 1995 Gwangju Biennale, the 1997 Johannesburg Biennial, and the 2000 Whitney Biennial. Joo has been awarded the Guggenheim Fellowship, the Joan Mitchell Foundation Painters and Sculptors Grant, and the Andy Warhol Foundation Prize. His work is in the collections of the Denver Art Museum, the Israel Museum in Jerusalem, the Modern Museet in Stockholm, the Musée d'Art Moderne de la Ville de Paris, the Henry Art Gallery in Seattle, the Walker Art Center in Minneapolis, and the Museum of Modern Art in New York. Along with Do-Ho Suh, Joo represented Korea in the 2001 Venice Biennale. He currently lives and works in New York City.

Jin Soo Kim (b. 1950 in Seoul, Korea), an installation artist, came to the United States in 1974 and currently resides in Evanston, Illinois. Kim earned a B.S. from Seoul National University in Korea. She studied at Western Illinois University and earned an M.F.A. at the School of the Art Institute of Chicago in 1983, where she is adjunct professor of art. Kim's work has been extensively exhibited in Chicago and across the United States, from Maine to Florida and from Los Angeles to New York, as well as in Europe and Asia. In 2001, she completed a permanent outdoor sculpture at Xiadu Sculpture Park, Yanqing, Beijing. She has received fellowships and grants from the Illinois Arts Council and the National Endowment for the Arts. Her work has been collected by the Walker Art Center in Minneapolis, the Madison Art Center in Madison, Wisconsin, the Museum of Contemporary Art in Chicago, and the National Museum of Contemporary Art in Seoul.

Painter **Hung Liu** (b. 1948 in Changchun, China) graduated from Beijing Teachers College with a degree in art and art education in 1975. She earned a graduate degree in mural painting at the Central Academy of Fine Art in Beijing in 1981, after which she came to the United States and earned an M.F.A. in visual arts from the University of California, San Diego, in 1986. Currently, Liu is the Joan and Robert Danforth Distinguished Professor of Art at Mills College in Oakland, California. Her work has been exhibited in fifty solo and more than eighty-five group exhibitions across the United States and in Asia, including in Bangkok, Beijing, Ho Chin Minh City, Jakarta, Shanghai, Singapore, and Tokyo, between 1985 and 2002. Her work is reviewed in hundreds of newspaper articles and scholarly essays. Liu has lectured and served as a panelist at universities, museums, and art and cultural studies conferences and symposia across the country and abroad.

Yong Soon Min (b. 1953 in Seoul, Korea) is a Los Angeles–based artist and independent curator. She earned a B.A. in 1975, an M.A. in 1977, and an M.F.A. in 1979 in art practice at the University of California, Berkeley, and was selected to participate in the Whitney Museum Independent Study Program in 1981. She served as administrative coordinator of the Asian American Arts Alliance in New York in 1985–86 and has been a member of the board of directors for the Asian American Arts Alliance, Women's Caucus for Art, Artists Space, the College Art Association, and the Korean American Museum. Since 1987, she has lectured at numerous colleges and universities, including Duke, Harvard, Michigan, Cornell, Williams, Wisconsin, Rutgers, Berkeley, and Parsons. Min has taught at the Rhode Island School of Design, the California Institute of the Arts, and Ohio University and has been invited to lecture at Ritsumeikan University in Kyoto, Japan, the 2000 Telstra Adelaide Festival in Australia, at the Emily Carr Institute of Art and Design in Vancouver, the United Nations NGO Forum in Huairo, China, and the Kae Won College of Art and Design in Seoul, Korea. Her work has been exhibited in Italy, England, Portugal, Canada, Cuba, Denmark, Germany, Austria, the Philippines, and Korea, as well as across the United States, including at the Museums of Modern Art in New York, San Francisco, and Los Angeles, the Whitney Museum, and the Studio Museum of Harlem. Her work has been discussed and reviewed in scores of popular media and scholarly journals. Min has received awards from the New York State Council on the Arts, the National Endowment for the Arts, the Warren Tanner Memorial Fund, the City of Los Angeles Cultural Affairs Department, and

the Rockefeller Foundation, as well as by the Anonymous Was a Woman fund. She was commissioned to curate an exhibition of Korean diaspora art for the Fourth Gwangju Biennial in Korea in 2002. Currently she is professor and chair of studio art at the University of California, Irvine.

Long Nguyen (b. 1958 in Nha-Trang, Vietnam) is a Los Angeles–based painter. He received his M.F.A. in painting and printmaking at San Jose State University. Nguyen's work, which has been exhibited both in the United States and abroad, can be seen in permanent collections at the Oakland Museum of Art and the San Jose Museum of Art. Nguyen has received visual arts awards from the National Endowment for the Arts, the Fleishhacker Foundation, and the California Art Council. His current body of work is a large series of paintings titled *Tales of Yellow Skin.*

Manuel Ocampo (b. 1965 in Quezon City, the Philippines) attended the University of the Philippines in 1984 and studied at California State University, Bakersfield, in 1985. His work was selected for the 2001 Venice and Berlin Biennales, the 2000 Biennale d'Art Contemporain in Lyons, France, the Forty-third Biennial Exhibition of Contemporary American Painting at the Corcoran Gallery in Washington, D.C., in 1993, and Documenta IX in Kassel, Germany in 1992. Ocampo's work has been included in group shows in Europe, Asia, North America, and Latin America, and in one-person exhibitions in Munich, Frankfurt, Cologne, Milan, Paris, Seville, Badajoz, Barcelona, Montreal, Mexico City, San Francisco, Los Angeles, and New York. Ocampo's painting can be found in public collections of the Museum of Contemporary Art in Los Angeles, the Museo Nacional Centro de Arte Reina Sofia in Madrid, the Sintra Museu de Arte Moderna in Lisbon, the Fonds National d'Art Contemporain in Paris, and the Asian Art Museum in Fukuoka, Japan, among others. In 1995, he was a visual arts fellow at the American Academy in Rome. Thereafter, he took up residency in Seville, Spain, for a period of three years, and then returned to the United States to live in the San Francisco Bay Area.

Hanh Thi Pham (b. 1956 in Saigon, Vietnam) came to the United States in 1975 and settled in Southern California. She earned a B.A. in art in 1982 and an M.A. in photography in 1984 at California State University, Fullerton. She has had one- and two-person exhibitions in New York, San Francisco, and the Los Angeles metropolitan area, as well as in Washington, D.C. She was featured as the tenth annual Fukuoka Asian Artist Today in Japan in 1997 in an exhibition titled *A Vietnamese: Her Body in Revolt.*

Pipo Nguyen-Duy (b. 1962 in Hue, Vietnam) earned a B.A. in economics at Carleton College in 1983 and an M.A. in photography from the University of New Mexico in 1992. He also received an M.F.A. in photography from the University of New Mexico in 1998. He was a fellow at the American Photography Institute at New York University's Tisch School of the Arts in 1995. Nguyen-Duy has received awards from the Ohio Art Council, the Oregon Arts Commission, the Lila Wallace–Readers Digest Award Fund, the National Endowment for the Arts, and the Getty Foundation. His work has been shown in solo exhibitions in South Carolina, Wisconsin, Oregon, Ohio, and New Mexico, as well as in New York and California and is included in public collections in Japan and Laos as well as in the United States. Nguyen-Duy has curated exhibitions for the Schneider Museum of Art in Ashland, Oregon, and the Galerie Vrais Rêves in Lyons, France. He is currently professor of art at Oberlin College.

Painter and performance artist **Roger Shimomura** (b. 1939 in Seattle, Washington) received his undergraduate degree in commercial design from the University of Washington in 1961 and his M.F.A. in painting at Syracuse University in 1969. He has had over 100 solo exhibitions of his paintings and prints and has presented his experimental theater pieces at such venues as the Franklin Furnace in New York, the Walker Art Center, and the National Museum of American History at the

Smithsonian. He is the recipient of four National Endowment for the Arts Fellowships in painting and performance art, a McKnight Fellowship, a Civil Liberties Public Education Fellowship, a Japan Foundation Grant, and a Kansas Arts Commission Artist Fellowship in Painting. Shimomura has lectured on his work at over 150 universities and art museums across the country. In 1990, Shimomura was appointed Dayton Hudson Distinguished Visiting Professor at Carleton College. In 1994, he was named University Distinguished Professor at the University of Kansas. A scholarship was named after him by the Urban League of Seattle in 1999. Most recently, the College Art Association presented him with the Artist Award for Most Distinguished Body of Work for his four-year, twelve-museum national tour of the painting exhibition *An American Diary.*

New York–based painter **Shahzia Sikander** (b. 1969 in Lahore, Pakistan) received a B.F.A. from the National College of Arts in Lahore, Pakistan in 1992 and an M.F.A. from the Rhode Island School of Design in 1995. Her work has appeared in solo exhibitions at the Whitney Museum at Philip Morris in New York, the Hirshhorn Museum and Sculpture Garden in Washington, D.C., and the Renaissance Society at the University of Chicago, among others. It has also been included in group exhibitions in Paris, Helsinki, Ottawa, Cologne, Mexico City, Lisbon, Queensland, and Islamabad, as well as in museums and galleries from New York to San Francisco. Sikander's work has been reviewed and discussed in such art publications as *Art, Art News,* and *Art Nexus,* in popular print media such as the *New York Times,* the *New Yorker,* and *New York Magazine,* and in scholarly journals like *Public Culture.* Sikander has received a number of grants and awards, including the Shakir Ali Award / Kipling Award for "highest merit" at the National College of Arts in Lahore, the Louis Comfort Tiffany Foundation Award, the Joan Mitchell Foundation Painters and Sculptors Grant, and the South Asian Women's Creative Collective Achievement Award.

Installation artist and sculptor **Do-Ho Suh** (b. 1962 in Seoul, Korea) currently lives and works in New York. Suh received a B.F.A. in 1985 and an M.F.A. in 1987 in oriental painting from Seoul National University. He graduated from the Rhode Island School of Design with a B.F.A. in painting in 1994 and earned an M.F.A. in sculpture at Yale University in 1997. His solo exhibitions have been shown at the NTT InterCommunications Center in Tokyo, the Lehmann Maupin Gallery, the Whitney Museum of American Art at Philip Morris in New York, the 2001 Venice Biennale, the Serpentine Gallery in London, the Seattle Art Museum, and the Kemper Contemporary Art Museum in Kansas City. His work has also been included in group exhibitions in Germany, Italy, Sweden, Japan, Hong Kong, Taiwan, Korea, Australia, Brazil, and Russia, as well as in many U.S. cities. Recently, he received the Joan Mitchell Foundation Painters and Sculptors Grant, the August Saint-Gaudens Memorial Award, and the Chanil Foundation Fellowship.

Painter **Mitsuo Toshida** (b. 1955 in Yokohama, Japan) came to New York in 1979 to study art. He earned a B.F.A. in 1983 and an M.F.A. in 1985 at the School of Visual Arts in New York. His work has been shown extensively in solo and group exhibitions in Japan and New York, as well as in Thailand and in cities across the United States. Toshida has lectured at New York University, the Tokyo Metropolitan Museum, the Ise Art Foundation, and the Parsons School of Design. He continues to live and work in New York.

Carlos Villa (b. 1936 in San Francisco, California) graduated from the San Francisco Art Institute in 1961 and earned an M.F.A. in painting at Mills College in Oakland in 1963. While living in New York in the 1960s, he exhibited minimalist aluminum sculpture before beginning to draw and paint with an airbrush. Villa returned to San Francisco in 1969 and began a new series of abstract works based on his interest in ritualistic art from Polynesia, New Guinea, and Africa. In the 1980s, he studied body casting, bronze, and glass. His work has been installed and performed in solo exhibitions in galleries and museums all over California and in group exhibitions in Honolulu, New York, Wash-

ington, D.C., and other U.S. cities. It has also been shown in Rome, Havana, Tokyo, and Slovenia. Villa is currently professor of art at the San Francisco Art Institute, for which he has organized national symposia and conferences on multiculturalism and art. He also serves as a mentor for Filipino American artists and a presenter and panelist at numerous art and cultural studies conferences.

Painter **Martin Wong** (b. 1946 in Portland, Oregon, d. 2000 in San Francisco, California) studied ceramics at Humboldt State College in California in the late 1960s, although he was mostly self-taught in art. In 1980, he moved to New York, where he learned to paint brick buildings and fire escapes. In 1984, he sold *Attorney Street Handball Court,* a large oil painting, to the Metropolitan Museum of Art. Between 1982 and 2000, Wong's work was exhibited in scores of New York museums and galleries, including MOCHA, the Studio Museum of Harlem, the City Gallery, Exit Art, as well as several Bay Area venues such as New Langton Arts, the San Francisco Art Institute, and the Berkeley Art Museum. His paintings were also exhibited in other U.S. cities as well as in Milan, Mexico City, Montreal, Tokyo, and Hong Kong. After Wong's death, P.P.O.W. Gallery in New York and the Humboldt State University Art Gallery sponsored retrospectives of his work. His paintings were also included in the 2001 *Five American Artists* exhibition in the Gaudi Building in Barcelona.

Lynne Yamamoto (b. 1961 in Honolulu, Hawai'i) presently lives and works in New York. She received a B.A. in art from Evergreen State College in Olympia, Washington, in 1983 and an M.A. in art from New York University in 1989. Yamamoto participated in the Whitney Independent Study Program in 1992–93, as well as in the Skowhegan School of Painting and Sculpture in 1996. She was selected for the National Studio Program at P.S. 1 in New York in 1991–92, the Urbanglass residency in 1992, the Banff Centre for the Arts residency in 1994, and the Sirius Arts Centre residency in Cobh, Ireland, in 1998. Yamamoto has had one-person shows at the Contemporary Museum in Honolulu (1996), Articule in Montreal (1997), P.S. 1 Contemporary Art Center (1997), Greg Kucera Gallery and George Suyama Architect Space, both in Seattle (1998), the Whitney Museum of American Art at Philip Morris (1999), the Museum of Art, Rhode Island School of Design (in collaboration with Mount Pleasant High School students, 2000), and P.P.O.W. in New York (2001). Her work has been exhibited in the United States at such venues as the Wexner Center for the Arts, the Museum of Contemporary Art, Los Angeles, and the Whitney Museum of American Art and internationally at the Louisiana Museum, Denmark, Leeds Metropolitan University, England, and YYZ in Toronto. Yamamoto has received numerous awards and grants, including the Diverse Forms Artists' Projects Grant (1992), New York Foundation for the Arts Artist-in-Residence Program award (1994), the Anonymous Was a Woman grant (1996), the Japan–United States Arts Program of the Asian Arts Council award (1999), and the Creative Capital Foundation Grant (2001). She currently teaches at New York University and the School of Visual Arts. Having worked for many years as a museum educator and artist-in-residence in the public schools, she is also a teaching artist at Long Island City High School.

Print artist **Zarina** Hashmi (b. 1937 in Aligarh, India) graduated from Aligarh Muslim University in Aligarh, India, in 1958 and studied at Atelier-17 in Paris from 1964 to 1967. She now resides in New York. Her prints have been shown in solo exhibitions in India, Greece, Norway, and Pakistan, as well as in New York and California, and she has been included in group exhibitions at the Queens Museum of Art in New York, the Victoria and Albert Museum in London, the Bibliothèque Nationale in Paris, and the Biennial of Graphics in Tokyo, among other institutions.

Homi K. Bhabha is Chester D. Tripp Professor in the Humanities at the University of Chicago, where he teaches English and art history. His publications include *The Location of Culture* (Routledge, 1994) and the edited volume *Nation and Narration* (Routledge, 1990).

Luis Camnitzer, an Uruguayan artist residing in the United States, teaches art at the State University of New York at Old Westbury. The author of *New Art of Cuba,* Camnitzer often writes for *Third Text* and *Art Nexus.*

Mexico-born painter **Enrique Chagoya** lives and works in California, where he teaches art at Stanford University. His artwork reflects his interest in popular culture forms. "I like to express my social concerns with a bit of humor," Chagoya says. "I am not interested in convincing anyone through my art. I just want to express myself freely" (personal conversation, 1994). Chagoya co-curated, with artist Rupert Garcia, Manuel Ocampo's *Paradiso abierto a todos* exhibit at the Mexican Museum in San Francisco in 1994.

Gina Dent has taught at the University of California, Berkeley, and at Columbia and Princeton. She is the editor of *Black Popular Culture,* an anthology of essays on race, feminism, and popular culture. She also co-curated *Trade Routes,* an exhibition of visual art addressing issues of globalization at the New Museum of Contemporary Art, New York. Her current research interests include definitions of African American culture in history and their relationship to the social sciences, popular culture, and radical social thought.

Ellen Gallagher is a New York–based visual artist well known for mixed-media work that incorporates rubber, paper, plasticine, oil, and other materials. She locates her art between the disciplines of painting, sculpture, and drawing. Gallagher's work can be found in collections at many prominent institutions, including the Guggenheim Museum, the Metropolitan Museum of Art, the Museum of Modern Art in New York, and the San Francisco Museum of Modern Art.

Theresa Harlan is a writer and curator of contemporary Native American art. She is the former director of the Carl Gorman Museum in the Native American Studies Department at the University of California, Davis, and is now an arts administrator for the California Arts Council.

Suk-Man Kim studied theater at the University of California, Berkeley, and New York University before returning in the early 1980s to Seoul, Korea, where he currently works in theater. Kim has produced *Chilsu and Mansu*. He directed *Mr. Han's Chronicles* and many other plays, both Korean and foreign. Most of his close relatives have immigrated to the United States and currently live in Los Angeles.

Arturo Lindsay is an artist-scholar who conducts ethnographic research on African spiritual and aesthetic retentions in contemporary Latin American cultures. Lindsay has lectured and written extensively on Latin American and Caribbean artists and art. His publications include *Santeria Aesthetics in Contemporary Latin American Art* (1996). He is currently at work on *Black Christs in the Americas.*

Born in rural Alabama, artist and activist **Rick Lowe** has exhibited his work in New York and Los Angeles as well as in Japan and Korea. In 1992, Lowe founded Project Row Houses, a Houston, Texas, public art project involving artists in neighborhood revitalization, historic preservation, community service, youth education, and the celebration of African American history and culture.

Based in England, **Kobena Mercer** has been a visiting professor in the Africana Studies Program at New York University and a guest lecturer in the 1998 Getty Summer Institute in Visual and Cultural Studies at the University of Rochester. He wrote *Welcome to the Jungle: New Positions in Black Cultural Studies* (1994) and is currently at work on a book-length study of contemporary art in the Black diaspora.

Amalia Mesa-Bains is an artist and the director of the Visual and Public Art Institute at California State University, Monterey Bay. Her work has been exhibited at the National Museum of American Art of the Smithsonian, the Whitney Museum of American Art at Phillip Morris, the Studio Museum of Harlem, and the San Francisco Museum of Modern Art, as well as the Kulterhuset of Stockholm, the Contemporary Art Museum of Santa Monica in Barcelona, and the Ikon Gallery in London. She is a MacArthur Fellow and has contributed to the documentation and re-innovation of altar art in the Chicano community. Her writings on museum studies, contemporary art, and art education have been widely published.

Painter / multimedia artist, curator, and writer **Odili Donald Odita** was born in Enugu, Nigeria, and earned degrees in art at Ohio State University and Bennington College. His work has been exhibited in Africa, Europe, and Latin America, as well as in various U.S. cities. He is a consulting editor at *NKA, Journal of Contemporary African Art,* and a contributing writer for *Flash Art International.* Odita is associate professor of painting at Florida State University.

Laura Elisa Perez is an associate professor in the Department of Ethnic Studies at the University of California, Berkeley, where she teaches and writes about Latina/o arts and the politics of emerging forms of spirituality. Her forthcoming book is *Altarities: Chicana Art, Politics and Spirituality.*

Griselda Pollock teaches art history and cultural studies at the University of Leeds, where she is professor of social and critical histories of art and director of the Centre for Cultural Studies. Her broad interests include nineteenth- and twentieth-century visual cultures, feminist film studies, and cultural difference and gender. Pollock's recent publications include *Looking Back to the Future: Essays from the 1990s* (1999), *Differencing the Canon: Feminist Desire and the Writing of Art's Histories* (1999), *Mary Cassatt* (1998), and *Generations and Geographies in the Visual Arts: Feminist Readings* (1996).

Yasmin Ramirez is a graduate of Columbia University and a Ph.D. candidate in art history at the Graduate School and University Center of the City University of New York. She is the curator of Taller Boricua in El Barrio, New York City, as well as a critic who contributes regularly to *Art in America* and *Art Nexus.*

Jolene Rickard is assistant professor of art and art history at the State University of New York, Buffalo. Recent exhibitions of her work include *Reservation X* (1998, Canadian Museum of Civilization, Hull, Quebec) and *Native Nations* (1998, Barbican, London). She is a member of the Tuscarora Nation. Rickard curated the exhibition *Border Crossings: Beadwork in Iroquois Life* at the McCord Museum, Montreal, in 1999.

Faith Ringgold, an African American artist and activist, was born in Harlem, New York, in 1930. Since the 1960s, she has worked in a variety of genres, including painting, sculpture, installation, performance art, story quilts, and children's books. Like Pacita Abad, she often utilizes textiles. In the 1990s she produced two major story quilts series, *The French Collection* and *The American Collection,* which were the center of her traveling New Museum exhibit.

Ella Shohat is a professor in art and public policy, Middle Eastern studies, and comparative literature at the Tisch School of the Arts, New York University. She has written extensively on the intersections of post/colonialism, gender, and sexuality. She has published books in cinema studies and multiculturalism in the media and is editor of *Talking Visions: Multicultural Feminism in a Transnational Age* (1999).

Lowery Stokes Sims is curator in the department of modern art at the Metropolitan Museum of Art. She has done extensive research and writing on artists of African, Native, Asian, and Latino American cultures. She received her Ph.D. in art history from the Graduate Center of the City University of New York. Her forthcoming book is *Wilfredo Lam and the International Avant-garde, 1923–82.*

Jaune Quick-to-See Smith was born on the Flathead reservation of the confederated Salish and Kootenai tribes of Montana. Her paintings, drawings, and sculpture, which combine abstract expressionist elements with traditional Native imagery and words and images from U.S. popular culture, have been exhibited nationally as well as around the world.

Hulleah J. Tsinhnahjinnie was born into the Bear and Raccoon clans. Her mother is Minnie McGirt of the Seminole and Muskogee Nations. Her father is Andrew V. Tsinhnahjinnie of the Diné Nation. Hulleah Tsinhnahjinnie was influenced in her formative years by some of the finest Native artists: her father Andrew, Fred Beaver, and Pablita Velarde. A strong indigenous artistic base, fused with her mother's commitment to community and protocol, helped form an artist of political conviction. Exhibited nationally and internationally, Tsinhnahjinnie claims photography as her primary language. Creating fluent images of Native thought, Tsinhnahjinnie's emphasis is art for indigenous communities. In addition to studying at the Institute of American Indian Arts in Santa Fe, New Mexico, and the California College of Arts and Crafts in Oakland, California, Tsinhnahjinnie has taught at the University of California, Davis, San Francisco State University, the San Francisco Art Institute, and the Institute of American Indian Art.

Robert Vazquez-Pacheco is a writer and community intellectual living in New York. A native-born Nuyorican, Pacheco has published his poetry in various journals, such as *The James White Review* and *Art & Understanding.* He is president for life of the Ken Chu Fan Club.

Deborah Willis is an art photographer and a historian of African American photography. She has curated many exhibitions, including *Visual Journal: Harlem and D.C. in the Thirties and Forties* (1996) and *Black Photographers Bear Witness: 100 Years of Social Protest* (1989). She edited *TechnoSeduction* (1998); *Picturing Us: African American Identity in Photography* (1994); *VanDerZee: The Portraits of James VanDerZee* (1993); *and Lorna Simpson* (1992).

Bert Winther-Tamaki teaches art history at the University of California, Irvine. He is currently writing *The Creed of East/West Difference: Japanese and American Artistic Nationalism.*

ILLUSTRATIONS

Figures

Plates

Details

Italic page and plate numbers refer to illustrations.